Traditional Symbols
and the
Contemporary World

Traditional Symbols and the Contemporary World

F. W. DILLISTONE

Fellow Emeritus of Oriel College, Oxford

BAMPTON LECTURES 1968

London EPWORTH PRESS

SBN 7162 0206 9

Inquiries for this book
should be sent to
The Methodist Publishing House
Wellington Road
Wimbledon
London SW19 8EU

Made and printed in Great Britain
by The Garden City Press Limited,
Letchworth SG6 1JS

ONE of Paul Tillich's best known books was entitled *The Shaking of the Foundations*. In his own system the integrating factor was undoubtedly his concept of the symbol. Nothing was more irritating to him than to hear the phrase 'merely a symbol'. Symbols he regarded as the supreme media through which levels of reality could be opened up to man, levels of the human mind could be opened up to reality.

Yet symbols like all things human are subject to change. Attempts have been made again and again to fix a particular symbol, to preserve it from the 'shaking' which may be affecting the foundations of human existence. But such attempts must inevitably fail. The more important task surely is to keep alive the very notion of the symbol in a time when powerful forces are seeking to embrace the whole of the world and social existence within the inflexible framework of quantitative forms and mechanical processes. The symbol, truly conceived, may be the most important of all human creations and fabrications. If the symbol disappears the power and the glory, it may be claimed, will have departed from the human scene. Man will have become a creature ruled either by blind instinct or by an inexorable machine.

Some years ago I tried, in a book entitled *Christianity and Symbolism*, to examine the place of symbolic forms in the general development of mankind and to draw illustrations in particular from the Christian symbols, Baptism and the Eucharist. The final chapter I entitled 'Are the traditional Christian symbols outmoded?' and although I have no reason to discard now what I then sketched as a possible answer, the question has remained with me as one demanding a fuller enquiry than was possible in the earlier limited context.

When, therefore, the opportunity arose to submit to the Electors to the Bampton Lectureship a theme which they might regard as worthy of investigation, this was the general subject which I proposed.

I am grateful for the opportunity which they allowed me to prepare the Lectures and to the audiences which gathered in the University Church to listen and encourage. In particular I remember with pleasure the discussions with those who spent time with me after the lectures in the hospitable surroundings of All Souls'.

Many series of Bampton Lectures have undergone considerable

expansion before appearing in printed form. This tradition I have followed and the chapters of the book now published do not in consequence correspond exactly with the lectures as delivered. I have tried during the process of expansion to make myself more familiar with the work of historians in the fields I have attempted to cover but I fully recognize how inadequate my treatment must appear to the expert in any particular section which I have touched. I have been concerned to see the broad picture of the establishment of certain symbolic forms in Christian history and then to point out how changes took place in periods which cannot be defined by exact temporal limits but which are none the less recognizable as one compares the institutions of an earlier and a later time.

It remains for me to express my gratitude to the College which elected me to a Fellowship some nine years ago and thereby provided me with an altogether congenial situation in which to continue my studies and to prepare these Lectures.

F. W. DILLISTONE

Acknowledgements

The Author expresses thanks for permission to use quotations from the following sources:

For the Union Dead and *Near the Ocean* by Robert Lowell published by Faber and Faber Ltd. and in the U.S.A. by Farrar, Straus and Giroux, Inc. of New York

The Necessary Angel by Wallace Stevens published by Faber and Faber Ltd. and in the U.S.A. by Alfred A. Knopf, Inc.

The Social Reality of Religion by Peter Berger published by Faber and Faber Ltd. and in the U.S.A. by Doubleday and Co., Inc. under the title *The Sacred Canopy*.

Contents

Those societies which cannot combine reverence for their symbols with freedom of revision must ultimately decay either from anarchy or from the slow atrophy of a life stifled by useless shadows.

A. N. WHITEHEAD

This is the great function of symbols: to point beyond themselves, in the power of that to which they point, to open up levels of reality which otherwise are closed, and to open up levels of the human mind of which we otherwise are not aware.

PAUL TILLICH

EXTRACT

FROM THE LAST WILL AND TESTAMENT

OF THE LATE

REV. JOHN BAMPTON
Canon of Salisbury

'. . . I give and bequeath my Lands and Estates to the Chancellor, Masters, and Scholars of the University of Oxford for ever, to have and to hold all and singular the said Lands or Estates upon trust, and to the intents and purposes hereinafter mentioned; that is to say, I will and appoint that the Vice-Chancellor of the University of Oxford for the time being shall take and receive all the rents, issues, and profits thereof, and (after all taxes, reparations, and necessary deductions made) that he pay all the remainder to the endowment of eight Divinity Lecture Sermons, to be established for ever in the said University, and to be performed in the manner following:

'I direct and appoint, that, upon the first Tuesday in Easter Term, a Lecturer be yearly chosen by the Heads of Colleges only, and by no others, in the room adjoining to the Printing-House, between the hours of ten in the morning and two in the afternoon, to preach eight Divinity Lecture Sermons, the year following, at St. Mary's in Oxford, between the commencement of the last month in Lent Term, and the end of the third week in Act Term.

'Also I direct and appoint, that the eight Divinity Lecture Sermons shall be preached upon either of the following Subjects—to confirm and establish the Christian Faith, and to confute all heretics and schismatics—upon the divine authority of the holy Scriptures—upon the authority of the writings of the primitive Fathers, as to the faith and practice of the primitive Church—upon the Divinity of our Lord and Saviour Jesus Christ—upon the Divinity of the Holy Ghost—upon the Articles of the Christian Faith, as comprehended in the Apostles' and Nicene Creeds.

'Also I direct, that thirty copies of the eight Divinity Lecture Sermons shall be always printed, within two months after they are preached; and one copy shall be given to the Chancellor of the University, and one copy to the Head of every College, and one copy to the Mayor of the city of Oxford, and one copy to be put into the Bodleian Library; and the expense of printing them shall be paid out of the revenue of the Lands or Estates given for establishing the Divinity Lecture Sermons; and the Preacher shall not be paid, nor be entitled to the revenue, before they are printed.

'Also I direct and appoint, that no person shall be qualified to preach the Divinity Lecture Sermons, unless he has taken the degree of Master of Arts at least, in one of the two Universities of Oxford or Cambridge; and that the same person shall never preach the Divinity Lecture Sermons twice.'

'NO MEANING ANY MORE'

IN 1949, the year of the inauguration of the People's Republic, there were more than 3 million Catholics and approximately 1 million Protestants in China. Twenty years later, perhaps half a dozen local congregations were still holding regular though inconspicuous services. The last surviving Protestant seminary had been recently closed. No issue of any Christian periodical had been seen outside China since 1964. And amongst Catholics all elements in the liturgy regarded as incompatible with the People's Government were being finally eliminated.

In 1950, at the time when Communist forces were assuming control in all areas, the following was a typical scene:

'The leaders of the student Christian fellowship gathered in a deserted courtyard to share with each other their perplexity. One young woman stood out at that meeting. She poured out with tears her bitter complaint for all her Christian teachers and pastors had failed to give to prepare her for that hour. She expressed all the lostness which was in everyone's heart, leaving us with nothing but prayer to a hidden God as we parted at midday.

'As we gathered again for the afternoon, the girl with regained composure was studying the classical paintings on the wall of the courtyard. "I learned to paint like that as a child", she explained to me. "Every stroke is a symbol and has its place in the structure of the whole. Each style has its history and expresses the culture and tradition of our land?" Then she turned. "But all that has no power to help us now. It has no meaning any more. It's all dead!" '[1]

In Chinese classical painting every stroke was a symbol with its place in the structure of the whole. In the Christian liturgy in which millions of Chinese were participating in 1950 every action was a symbol with its place in the structure of the whole. Yet within two decades traditional symbols, whether classic or Christian, had lost

[1] Charles C. West, *Communism and the Theologians*, pp. 9f.

their meaning. At least so far as outward observance and response were concerned they were *dead*.

Did this mean that every kind of symbolism had been expelled from the new People's Republic? Who among Western observers can easily forget the fanatical dedication of the Red Guards with their devotion to the red book containing the thoughts of Chairman Mao? Who has been unaware of the symbolic significance for the Chinese people of the new achievements in agriculturál and industrial production? On the new road to Lhasa running out of China there is a power station in a little town whose skyline was formerly broken by a famous Black Pagoda. This is how the Chinese poet Liang Shang-ch'iian celebrates the generator of a new kind of energy:

> *Gazing, from a distance I see*
> *Another Black Pagoda rising high against the old;*
> *Nearer at hand I recognize the power-station chimney*
> *Ceaselessly emitting its ink-swirls of smoke,*
> *Painting, in the darkness, lights like stars on the earth,*
> *Painting, in the daylight, a black peony in the sky.*

II

In America premonitions of the nature of the 'machine-age' came earlier but Christian words and images and symbols occupied a far more commanding position in the culture of the community. As long ago as the year 1900 Henry Adams spent the summer in Paris and devoted many hours to watching the great dynamos operating on the Champ de Mars. In a letter he meditated on the character of the new century. 'What we used to call electricity', he wrote, 'is its God.' And in a poem apostrophizing one of the Dynamos:

> *Mysterious Power! Gentle Friend!*
> *Despotic Master! Tireless Force!*
> *What are we then? the lords of space?*
> *The master-mind whose tasks you do?*
> *Or are we atoms whirled apace*
> *Shaped and controlled by you?*

More than half a century later Robert Lowell was to write still more impressively of the symbolic changes in American society. *For the Union Dead* contrasts brilliantly the old and well-loved Aquarium

in South Boston with its 'dark downward and vegetating kingdom of the fish and reptile' and the newly constructed underworld garage on the Boston Common.

> *The Aquarium is gone, Everywhere*
> *giant finned cars nose forward like fish;*
> *a savage servility*
> *slides by on grease.*

But not only has the animal kingdom been replaced by the empire of the automobiles, not only has the face of great cities been lifted and changed. Even in a remote township in Maine identical processes are at work. 'Waking Early Sunday Morning' the poet hears the new electric bells:

> *When will we see Him face to face?*
> *Each day, He shines through darker glass.*
> *In this small town where everything*
> *is known, I see His vanishing*
> *emblems, His white spire and flag-*
> *pole sticking out above the fog,*
> *like old white china door-knobs, sad,*
> *slight, useless things to calm the mad.*

'Vanishing emblems', symbols established on a thousand white churches on their small town New England greens: but now sad, slight and useless. For as Lewis Mumford has written: 'We live in an age which has not merely abandoned a great many historic symbols but has likewise made an effort to deflate the symbol itself by denying the values which it represents. Because we have dethroned symbolism, we are now left, momentarily, with but a single symbol of almost universal validity; that of the machine.'

The power-station, the nuclear-reactor, the space-ship, the computer—these, it appears, are the symbolic structures of the twentieth century, all utterly dependent upon the mysterious energy which we call electricity and which Henry Adams saw would be the god of the new age. How can traditional and time-honoured symbols any longer appeal to the human imagination. Hans Jurgen Schultz, Head of Religious Broadcasting in South German Radio, has expressed our situation tersely in a chapter entitled 'A world without religion': 'Yesterday truth was encountered in symbols which were an honest and useful basis for thought and action. Today these

symbols have become a burden to us. They were once integrating influences; today they have the effect of imposing a false dualism on us. What past generations took as much for granted as their mother tongue has now been reduced to mere metaphor, highly problematical and certainly affording no basis for action. It is not that we are honest, whereas previous generations were not, or that they were steeped in faith, while we are reduced to superficial rationalism. It is simply that we live in a different sort of world.'[1]

III

A different sort of world. Henry Adams in 1900 found himself torn between two worlds. One was symbolized by the Virgin of Chartres Cathedral: the other by the Dynamo of the Paris Exhibition. One was the medieval world in which virtually all things earthly could be regarded not as ends in themselves, not as objects to be observed and examined for their own sakes, but rather as pointers to heavenly realities, as potential instruments for the manifestation of the glory of God. The other was the modern world in which virtually all things earthly could be regarded as reducible to certain basic elements and as potentially useful for the furtherance of man's designs. The medieval world was pre-eminently a world of symbolism. The modern world is pre-eminently a world of technology.

Let us examine the symbolism of the medieval world in rather more detail. So far as man's natural surroundings were concerned there was comparatively little difference between the phenomena which were familiar in Britain from those familiar in Greece or Italy. Light and darkness, sun, moon and stars, rain and wind, fire and water, hills and valleys, caves and rocks, the sea and the river, the desert and the pasture, trees and plants, animals, birds and fish, bread, wine and oil—these were within the common experience of all who dwelt in Europe or the New East and moreover they had been common from Biblical and classical times. The same was true of the basic artifacts—the candle and the lamp, the tent and the boat, the house and the garden, the bridge and the ladder, the city and the temple, the wall and the gate, the well and the tower, the road and the wheel, tools and books, clothes and instruments: these too, though varied in form, were all constantly within the purview of those who lived between the Atlantic and the Urals, between the

[1] *Conversion to the World*, p. 35.

Mediterranean and the Hebrides. All this meant that most of the objects and activities mentioned in the Bible and in classical mythology and tribal legends were identifiable in the ordinary contemporary life of every man and could provide the material for the building up of an impressive common symbolic system.

In this system every object, every action had its own place and significance. Nothing was to be regarded simply as an end in itself. Rather, in an age saturated by religious feeling, the common sights and sounds of daily life pointed beyond themselves to heavenly realities. 'Of no great truth was the medieval mind more conscious', Johan Huizinga has written, 'than of Saint Paul's phrase: *Videmus nunc per speculum in aenigmate, tunc autem facies ad faciem.* The Middle Ages never forgot that all things would be absurd, if their meaning were exhausted in their function and their place in the phenomenal world, if by their essence they did not reach into a world beyond this. . . . About the figure of the Divinity a majestic system of correlated figures crystallizes, which all have reference to Him, because all things derive their meaning from Him. The world unfolds itself like a vast whole of symbols, like a cathedral of ideas. It is the most richly rhythmical conception of the world, a polyphonous expression of eternal harmony.'[1]

Thus the doctrine of the universe as symbolic form gained general acceptance. The aim of the learned was to gather together all knowledge within a unified structure which would be a true representation of the total symbolic system within which man lived and moved and had his being. This might be done in and through a book—a Summa: it might be done in and through a building—a Cathedral. In either case the construct would be a representation of the great Mirror of God's creative and redeeming activity which had been disclosed to the eye of man.

One of the most notable books of the Middle Ages is in fact called the Great Mirror. It is in four volumes and these are devoted respectively to Nature, to Instruction, to Morals and to History. The first deals with natural phenomena in the order in which they were created by God. The second takes its cue from the Fall of man and proceeds to show how knowledge in all its forms prepares the way for redemption. The third concerns itself with action rather than knowledge, setting the virtues over against the vices as a further preparation of man for grace. Finally the mirror of history brings

[1] *The Waning of the Middle Ages*, pp. 203f.

vividly to view the history of redemption, beginning with Abel's
sacrifice and continuing through Old and New Testaments to the
final establishment of the City of God. This was a written com-
pendium of the symbolic world. But equally there were compen-
diums carved in stone and bearing witness to that eternal order
whose perfect proportion and symmetry and harmony were never in
doubt.

Such in brief was the medieval view of symbolism. In so many
ways it is comparable to that of the Chinese girl for whom every
stroke was a symbol. Nothing, as Huizinga remarks, is too humble to
represent and to glorify the sublime. 'All things raise the thoughts to
the eternal; being thought of as symbols of the highest, in a constant
gradation, they are all transfused by the glory of divine majesty.'[1]
In such a system there is unity, there is order, there is stability,
there is rich variety through fuller understanding of hidden mean-
ings, there is boundless scope for earthly enjoyment of heavenly
delights. Why, then, did this symbolic system gradually lose its hold
upon the human imagination? What caused the vastly impressive
unity of the Middle Ages to begin to disintegrate? Why have sym-
bols which in the thirteenth century gained ready interpretation
become virtually meaningless today?

IV

To attempt a full answer to these questions would at this stage be to
forestall enquiries which must be made later in the book. But a few
general observations can be made. In the view of Huizinga the
symbolism of the Middle Ages declined because it became mechani-
cal, arbitrary and forced. Correspondences came to be sought simply
in number (twelve months must symbolize the twelve apostles) or in
qualities (five towns remaining faithful to a ducal house must
symbolize the five virgins) or in groupings (the articles of female
attire symbolize feminine virtues). The sense that all things were
related to one another because in the last resort they were all mysti-
cally related to God was a noble one and men were reluctant to
abandon it. Yet with the expansion of knowledge and experience the
connections of the new with the old became increasingly difficult to
define and this resulted in symbolism becoming a kind of intellectual
pastime, a solving of riddles, an attempt to gain control of one

[1] Op cit., p. 207.

mystery by the aid of another. As new knowledge began to flow in at an accelerating rate the medieval canons of symbolic interpretation proved inadequate to the task of absorbing it all within the traditional symbolic system. Sooner or later a major breakdown seemed inevitable.

A second reason for the decline of the symbolism of the Middle Ages was the gradual shift away from the Platonic framework within which it was set. If reality is invisible, eternal in the heavens, and if all earthly phenomena are approximate manifestations of perfect, transcendental forms, then a symbolic system becomes the natural medium for human understanding, But if forms are discoverable within phenomena themselves, if there is value in studying the structure of objects and events because of the possibility that already within them there are shapes which may control their entire subsequent development, then symbolism will at least be of a different kind. If all that is in the world of nature is being directed towards the fulfilment of a perfect end, then the potentialities already within nature may be spoken of as symbolic anticipations of that end; but this is a different conception from that of static objects in nature being regarded as symbols of pre-existent forms in which they participate but which they only imperfectly represent. While a sense of ultimate mystery remains, the symbol which even minimally participates in that mystery retains its interest and importance. When mystery is virtually excluded and all phenomena are regarded as belonging to one vast system of cause and effect, the 'symbol' takes on the character of an element in the system referring to or standing for or representing in potential form some other element or complex of elements within the same over-all system.

The change of which I have just spoken, and which is obviously connected with the renewal of interest in the philosophy of Aristotle from the end of the twelfth century onwards, became even more marked in the European outlook when the new concern for *history* captured men's attention towards the end of the fourteenth century. As we shall see, within a certain view of history there is a place for what may be called historical symbols and this being so it was still possible for symbols in general to play an important part in the social life of the sixteenth to the nineteenth centuries, even if in a somewhat different way from that of the Middle Ages. But towards the end of the nineteenth century a shift began away from the fundamentally Hebraic historic framework of interpretation to one

which can be varyingly described as scientific, empirical or secular. Events were decreasingly regarded as symbols of mysterious Divine purpose and intervention. Rather were they believed to be elements within a single ongoing process, symbolic in the sense of gathering up the results of past events or of foreshadowing the development of future events but all this as part of the one closed and indivisible whole.

This very general account of the growth and decline of symbolic forms within society must now be expanded in far greater detail. My central concern is with those symbols which have become firmly established in the life of Christendom during the course of the past 1900 years. I intend to make a brief enquiry about their origins and this will lead on to a more extensive description of the main stages of their later development. I shall then be in a position to ask how far these symbols have declined in significance and what hope there is of a rebirth of symbolism in our own time. Are the major traditional Christian symbols still able to stir the imagination and to convey meaning in the world of the twentieth century or must they be abandoned in favour of others? If not abandoned must they be drastically re-conceived and re-formulated in order that they may become a real power within the Christian society?

This is roughly the enquiry that I have in mind. As I attempt to carry it out I shall focus attention upon symbols as they operate in four broad areas. Normal human existence, I suggest, is determined by four basic categories or co-ordinates. These may be called the topographical, the chronological, the corporeal, and the psycho-linguistic. Every man is related first to a particular *place*. Its exact nature is for the moment irrelevant. The all-important matter is that existence is unthinkable apart from some location in space. Similarly man is related to a particular *time*. To describe this adequately is exceedingly difficult just because of our awareness of time's constant flux. Still in a general way it is obviously true that human existence is time orientated and that every man moves forward within a definable section of the total onward flow.

I choose the term corporeal to denote the patterns of *bodily* activities and relations which are characteristic of man as man. It is impossible for us to conceive, except in pure fantasy, what a disembodied human existence would be like. Moreover it is impossible to imagine a single body independent of all other bodies. Corporeal relations are of universal significance. Finally within the term *psycho-*

linguistic I intend to include all inter-relationships which are not directly dependent upon bodily connections. They may be called mental or intellectual or imaginative: they may be expressed by the aid of visual or verbal signals: they may be codified in varying language-forms. The all-important matter for the moment is that there is in every existence which we call human this extra dimension beyond the relatedness which is established through direct bodily structures and activities.

If this fourfold analysis commends itself as a reasonable hypothesis, then the possibilities of connectedness become immediately apparent. For if two human beings are related to one and the same locality they are at least potentially related to each other through this common medium. Equally this is true with a common time-period, a common organic pattern, a common psychic language. So man finds himself possessing four major structural systems which enable him to *connect*: spatial configurations, temporal coincidences, organic correlations and psychic communications. These constitute perhaps the most exciting aspects of the total human situation.

But a major question still remains. Are there structures which act as connectors not only between man and man but also between man and God? Are there localities where in some extra-ordinary way man becomes aware of the presence of transcendent power? Are there linguistic forms through which man hears a voice from beyond his ordinary social context of communication? In other words are there distinctive symbolic forms which serve in human experience to relate man to ultimate mystery?

Certainly in the earliest experience of the Christian Church, symbolic forms of this kind gained recognition and served to bind men to one another within a common relatedness to God through Christ. It is true that they underwent countless varieties of transformation in the succeeding centuries of the Church's life. But until comparatively recently they retained a significant place—some would say the most significant place—in the life and culture of Western civilization. The crucial question now is whether these symbols can any longer function as significant connectors in the modern scientific and secular world.

EARLY CHRISTIAN SYMBOLS

AMIDST many uncertainties about the way in which the earliest Christian symbolic forms took shape one fact stands out clearly. It is that Christianity did not, so to speak, start from scratch but that it took over a mixture of elements from two great symbolic systems and gradually re-moulded and re-invigorated them in conformity with its own distinctive newness. This newness was expressed through words (the good news) and through a pattern of community life (the new covenant). But this expression could not be independent of everything that had gone before. The words were those of already existing languages. The structure of community was built up out of already existing social patterns.

So far as language was concerned, the mixture assumed a quite remarkable form. During the life-time of Jesus Himself, and for a limited period after His death, either Hebrew or Aramaic must have supplied the linguistic symbols for communication within His new fellowship. Yet we possess no written records from early Christian sources in those languages. All that is to be found in the New Testament is a small collection of Aramaic words such as *abba* and *amen* which were evidently retained in worship-assemblies even in Greek-speaking areas. Whether for better or for worse the actual languages of Semitic origin played little part in the formation of the earliest Christian culture.

Yet the Hebrew scriptures themselves, and particularly what may in a general sense be called prophetic writings, obviously had a determinative influence upon the moulding of the earliest forms of Christian testimony. The events of Jesus' career were proclaimed as having happened 'according to the scriptures'. Though the language of proclamation within a very few years of Jesus' death was predominantly Greek, yet the frame of reference was the Hebrew scriptures which by a remarkable providence had been translated into Greek and so had become available to a wide audience. Thus almost from the beginning Christian *verbal* symbols were taken from the

great symbolic system of the Greek language but were repeatedly re-directed to the context of the Hebrew scriptures as their proper norm for interpretation and meaning.

In regard to social structure the evidence is far more complex. Within Palestinian Judaism there had been a stubborn resistance to the influences of Hellenism and the Rabbis were ever watchful to preserve the purity of life under the Law. But military movements, trading enterprises and visits to the homeland from Jews settled in foreign parts inevitably meant the introduction of at least a certain flavour of social customs characteristic of Greek and pagan communities. Still more was this the case where Jews of the Dispersion were living constantly in reach of, if not in touch with, Gentile neighbours. They might react strongly against the social practices of these neighbours and yet even when reacting they were often subtly influenced by them.

A structure of behaviour is in a real sense a language and just as our earliest Christian writings are in Greek so early Christian symbolic activities, in worship and in social relations, probably rapidly assumed the outward forms belonging to Greek culture. Yet again the essential frame of reference for their directing and testing was the system of ritual and ethical behaviour enshrined in the Old Testament. The love expressed in all its fullness through the total sacrificial activity of Jesus had to be related both to the existing social structures of the Hellenistic world and to the framework of love to God and the neighbour constructed in detailed form in Hebrew tradition.

I propose in this chapter to attempt a sketch of the Hebraic symbolic system within which Jesus Himself was born and to which His own words and acts were obviously related. I intend also to look at the first effects of the projection of Christian faith and life into the midst of the Graeco-Roman world. The emergence of more distinctive Hellenistic symbolic forms I shall reserve for consideration in Chapter 3.

II

The prophetic writings of the Old Testament had as their central concern the preservation of the pilgrim character of the chosen people. They renewed their hope for the future by recalling them to the critical events of redemption and to the commitment to their own

true God which they made in the primal covenant. In this concern the symbolic elements were few but exceedingly important. There was the story of redemption, the paradigm of what God had done in the past and was ready to do again in the future. There was the passover celebration, the remembrance through ritual solemnly enacted of their standing as a redeemed people. There was the recall to the pattern of essential social behaviour to which they had been committed within the covenant-bond. At times the situation seemed so dark and threatening that any ordinary renewal of the past seemed impossible. Then it was that the prophetic voice heralded a new exodus and a new covenant. But still the central symbolic forms remained intact. The story, the supper and the covenant-commitment were all important.

Yet this central strand of Jewish tradition comes at a very early stage into dialectical relation with another. Even Abraham first appeared on the scene out of the midst of an existing Mesopotamian civilization. Moses had been instructed in all the learning of the Egyptians. Israel was never able to exist in isolation. Even during the wilderness journey there were contacts with other tribes, and once the Hebrews had entered Canaan certain kinds of cultural interchange were inevitable. Prophets might denounce pagan symbols: rigorists might try to establish a complete cultural exclusiveness. But the influence of the Canaanite institutions upon what might be called the new Zionism can hardly be questioned.

Once a Hebrew tribe had gained possession of a hill of its own, the whole symbolic apparatus of the high place became a possibility. Life would be governed not by the exigencies of moving away from a threatening past towards a brightening future but rather by the necessity to defend a summit of achievement from threats to its stability and security. New symbols enter the Jewish vocabulary: the king, the palace, the temple, the priesthood, the festivals, the regular cycle of sacrifices, the detailed laws for the preservation of social harmony. The kingdoms of David and Solomon, each in its own way, assumed a special symbolic character: Jerusalem and Mount Zion: the burnt-offering and the sin-offering: priests and levites: the New Year and the Sabbeth: a new symbolic apparatus, hierarchically organized and legally sanctioned, came into being. There appears to have been no immediate sense of incongruity or incompatibility of the new with the old. But unless the histories recorded in the Old Testament are pure fabrications, strains be-

tween the wilderness and the kingdom symbolism, between the pilgrimage to the promised land and the ascent to the high place, between the covenant and the legal system were bound ultimately to be felt.

Nevertheless to emphasize this strain unduly, as has sometimes been done, in contrasting priest with prophet or sacrifice with moral rectitude in the writings of the Old Testament, can hardly be justified. Protests there were against tyrannous expressions of kingship, against elaboration of sacred buildings, against multiplication and formalization of sacrificial rites. But there are few indications that these were regarded as entirely wrong symbolic developments. Just because they belong more obviously to the realm of the external and the settled and the recurrent they are in constant danger of becoming formal and incapable of adjustment to changing circumstances. On the other hand the prophetic elements, when committed to written form and statutory observance were also in danger of becoming rigid and inflexible. It is one of the most remarkable features of the religion of the Old Testament that it does not allow itself to be reduced to a single coherent system. A strong case can be made for the priority in time and in the regard of the greatest of its leaders of dynamic, prophetic, time-oriented symbols but this is not to deny all value to cyclic, hierarchic, place-oriented symbols within the total context of the Old Testament. Certainly they occupy a notable place in the record and were destined to play an important role in the development of early Christian symbolism.

III

In the centuries immediately preceding the Christian era, the symbolic system centred in temple and sacrifice had maintained at best a tenuous existence, The destruction of the Temple with much of the surrounding city in 586 B.C. was a crushing blow. Nearly fifty years later a band of exiles returned and sought gradually to restore the religious and political institutions of their national life. But the task was difficult and in a real sense the centre of Israel's distinctive existence had moved away from land and city and temple and sacrifice to law and synagogue and reading and prayers. Faithful devotees might seek to honour the traditions of the past by setting up the altar and building the shrine but these were open symbols of potential independence. No great power would for long tolerate symbolic

forms which seemed to support religious and, by inference, political separatism. A second temple began to arise towards the end of the sixth century B.C. but it was repeatedly plundered and finally desecrated some three to four centuries later. And although in Jesus' own time an ambitious restoration was in process, all was finally destroyed in A.D. 70. King, temple, sacrifice became symbols of remembrance but not of living experience within the Jewish faith.

On the other hand the exile in Babylon had led to the establishment of a very different set of symbols. At the centre was a collection of writings, a prototypal *Book*. The focus of interest was the Ark (a wooden box) containing the Book (the scrolls). The purpose of assembly was to hear the words of the Book and to renew allegiance to its commands. The place of assembly was so designed as to make reading and hearing and common prayers possible and convenient. The day of assembly was the weekly sabbath. The essential symbolic officials were those who could give instruction in the requirements of the Law and where necessary interpret its meaning. It was this extraordinary and unique development amongst the Jewish exiles which was destined to preserve the religious and cultural distinctiveness of Judaism throughout the countless vicissitudes of the succeeding centuries.

In Jesus' own time the impact and influence of the symbolism of temple and altar and sacrifice seem to have been minimal. It scarcely figures in His teaching and there is no evidence that he shared in the sacrificial rituals of the temple courts. The Fourth Gospel emphasizes the significance of journeys to Jerusalem for the celebration of the great festivals, but even then Jesus' appearances in the Temple enclosure seem to have been of a controversial kind. For the time being, at least, symbolic forms related to hierarchical and organic structures had no place in His messianic community and there is no reason to think that the case was very different in Judaism at large. The Temple and its ministrations were honoured and regarded as necessary for the due implementation of the ritual requirements of the Law. The Day of Atonement in particular had its peculiar ritual which could only be enacted at the central shrine while synagogue observances on that day directed worshippers' thoughts to what was going on in Jerusalem. But there is little doubt that Judaism as a whole had become a religion of the Book and that the symbolic system to which Jesus Himself was most closely related was one of contractual obedience to the injunctions of a code. Pharisees taught

the Torah and interpreted its laws, guided the social and religious conduct of the people and set their hopes upon the future kingdom when God would restore the fortunes of Israel and set up His throne among the sons of men.

That there were movements within Judaism at the time which adopted particular symbolic forms to express their own peculiar emphasis or concern seems clear, but these were peripheral rather than central. Those who had withdrawn to the environs of the Dead Sea certainly employed ritual ablutions and celebrated sacral meals. More important in relation to Jesus' ministry, John the Baptist challenged men not so much to be more meticulous in the observance of the Law but rather to change their whole manner of life, to repent and turn to God and to symbolize the radical change by submission to baptism. Through this ritual, past sins could be removed and the disciple prepared to pass unscathed through the coming judgment. There appears to be strong support for the tradition that Jesus Himself accepted baptism by John, though there is some uncertainty about the precise significance that He attached to it. Whether or not He subsequently adopted this symbolic form into His own developing mission is by no means clear. It can at least be assumed that the record of Jesus' own baptism encouraged the adoption of this particular symbol as the initiatory rite for the later Christian community.

The earliest Gospel launches its readers into the opening phase of Jesus' distinctive ministry with the words: Jesus came into Galilee preaching the good news of the Kingdom and saying: The time is fulfilled and the Kingdom of God is at hand. The *place* which He chose may have a certain significance—not the Temple, the traditional centre of the sacrificial cultus, not even a synagogue, the conventional centre for instruction in the Law, but rather Galilee whose towns had been exposed to Gentile influences and whose populace may have been reasonably open to new ideas. In any case Jesus, it is said, went about the villages of Galilee, relating Himself to people where they were, in their homes, in the market-place, on the road. During the period of this itinerant ministry the only location that assumed symbolic significance was the secluded place on mountain side or lake shore, a place not totally withdrawn from the common ways of men but a place where there might be an openness to the call of God and a renewal of the true prophetic commitment.

In a secluded place of this kind, on more than one occasion, it

appears that a common meal of more than ordinary significance was celebrated. The symbolic reference to God's provision of manna in the wilderness in the time of Moses seems likely. Certainly later generations of Christians looked back on these meals as foreshadowings of their own eucharistic feasts. But this is the only corporate activity of a symbolic kind whose record has been preserved in the accounts of Jesus' own ministry. Not until the end, when opposing forces were closing in upon Him, did Jesus draw His disciples into a pattern of shared ritual activity which was to provide the supreme symbol of fellowship for the Church in succeeding centuries.

So far as other activities were concerned the evidence is mainly of a negative kind. Jesus was critical of existing methods of sabbath observance, of regulations relating to fasting, ablutions and racial segregation and of certain forms of public prayer. But He does not seem to have enjoined alternate symbolic observances. The whole emphasis, according to the Gospel records, was on teaching by word and action. He had come to proclaim the good news of the Kingdom of God and this He did by using new forms of communication and of saving activity. He had come to proclaim the good news to the poor: He had come to seek and to save the lost.

The new pattern of communication which occupies an altogether unique position in the Gospel records is the *parabolic form*. It is true that other teachers of that period were accustomed to use stories to clarify an authoritatively prescribed text or to enforce a rule of conduct. But Jesus' parables were of a different kind. They were vivid symbolic probes[1] which obliquely yet effectively challenged accepted patterns of thought by fastening upon a single, startling discongruity or contrast. The kingdom of God gains symbolic form as some crucial change is effected in a given situation. The settings are in no way unusual—home and farm and mart and trading and warfaring—and this fact promotes a ready initial acceptance of the story. But then comes the unexpected factor leading to an utterly surprising development. It is the Samaritan who has compassion: it is the prodigal who is welcomed: it is the man who shields his talent who is rejected. It is quite impossible to systematize the parables within any neat and tidy framework of interpretation. Instead each retains its identity as an invitation to faith in the reality and activity of that Kingdom whose symbol it is. Through forms of this kind (the

[1] A suggestive term which has become prominent in the writings of Marshall McLuhan.

contrast, the paradox, the metaphor, the Johannine 'proverb') the Kingdom drew near to the human imagination.

But the communication was not only through words. There were also saving actions through which the coming of the Kingdom gained symbolic representation. The gospel stories of exorcisms and healings and other 'mighty works' may well have received expansions and embellishments in their telling, but their central witness is impressive and coherent: it is that Jesus so poured Himself out into alienated and broken and deranged lives as to gain from them a creative response and so initiated healing and salvation in the midst of suffering and despair. He deliberately ate and drank with publicans and sinners. He invited Himself to the house of the outcaste Zacchaeus. He touched the leprous and the unclean. He grasped the hand of the palsied and the fevered. He addressed reconciling words to the frenzied and the insane. All these were not just casual happenings. They were events symbolic of His total mission pointing beyond themselves to the coming near of God's saving activity and His kingly rule.

Yet while it was through His new forms of teaching and healing that Jesus symbolized the advent of God's Kingdom amongst men, it becomes increasingly clear as the Gospel records unfold that a more inclusive, a more dramatic series of events will constitute the interpretive medium through which the mission and message of Jesus will gain supreme and definitive expression. It is in fact in the story which tells of His passion and death and resurrection that all preceding symbols gain their coherence and fulfilment.

In each Gospel this story is told with unparalleled attention to detailed event and dramatic sequence and with a quite unique sense of urgency and poignancy. The parable of the wicked husbandmen in the vineyard compresses into a few sentences the whole sweep of human history: Jesus' prayers in Gethsemane and on the cross throw vivid shafts of light upon the inmost mystery of God's dealing with the world's wrongs: the cries of the multitude on the first Palm Sunday coupled with those of the mocking onlookers at the cross constitute an ironic affirmation of His saving mission: the cleansing of the temple, the betrayal and the scourging, the stripping and the piercing, bring to a focus expectations which had been forming in prophetic minds through centuries of bitter experience. This story is not simply a faithful recording of memories originating from the arrest and trial and crucifixion of Jesus during the governorship of a

certain Roman official. Rather is it the central symbol of the Christian faith, the pattern of words and images in and through which the total human situation and its relation to the Divine economy can receive meaningful interpretation.

Yet within the one comprehensive story a special symbolic significance belonged to a solemn series of words and actions by which, on the very eve of His trial and crucifixion, Jesus gave ultimate significance to events which could be viewed as sad but inescapable happenings of human history. He bade two of his disciples prepare a meal comparable to that by which the Jewish people regularly celebrated their redemption from the bondage of Egypt. Then within the context of this meal He took a loaf and after thanksgiving made it the symbol of His body; after supper He took a cup of wine and made it the symbol of His shed blood. The disciples shared in the broken bread and poured out wine, they sang a hymn and went out into the night. These, it appears, were the fundamental elements in the actual performance of the dramatic rite. The possibility of a wide range of interpretation of the symbol is obvious. At the same time it is held within certain guiding controls. Almost certainly it was in the nature of a new passover, a celebration of deliverance from every kind of tyranny that holds back the human spirit from the true service of God. Further it was in the nature of a new anticipation of the Messianic Kingdom, a celebration of the ultimate fulfilment of the travail of the ages in a festal banquet within the Divine Presence. Yet again it was in the nature of a new covenant, a sealing of a common loyalty, so that the pattern of Jesus' own testimony in word and action could be reproduced in those who had covenanted themselves to Him. It was to prove an amazingly flexible symbolic form, assuming fresh nuances of meaning as it came to be celebrated in new cultural contexts. Of all the traditional Christian symbols it seems the one most likely to take on a new relevance and significance in our contemporary age.

IV

A strong sense of apocalyptic fervour pervaded the earliest period of the Church's life. There was little disposition to challenge the existing institutions of Judaism—the temple, Mount Zion, the synagogue, the law—for these would in any case soon be superseded in the new age. The new apocalyptic sect was simply concerned to bear

witness to the exaltation of Jesus as Lord and Messiah and to rejoice in the evidences that the powers of the coming age were already at work in their midst. Those who desired to identify themselves with this confidence and hope were required to give evidence of their convictions by submitting to a rite of baptism. The common life was sustained by prayers, often of an ecstatic kind and by participation in a common meal.

But was this to be the only or the complete interpretation of the events concerning Jesus? Even in Jerusalem there were synagogues in which Greek speaking Jews from the Diaspora assembled and these, it appears, were men who possessed a somewhat different outlook on the place of symbols in the religious life from that of orthodox Palestinian Jews. For the latter the temple and its sacrifices, the land and its hallowing were of the essence of their religion. As we have seen, historical pressures at times made it almost impossible to maintain the temple and its liturgy or to hallow the land, but then refuge was taken in the law, always with the hope that on the Day of the Lord the full symbolic apparatus would be restored. But for the Hellenists the question of the indispensability of the symbols in their actual concrete form was more open. Might not the inner spiritual significance of the symbol be more important than its form? And might it not be possible to retain the inward reality of spiritual worship even when no outward symbols were available or when the outward observance of ritual laws was not permitted?

For those Hellenists who had embraced the Christian message these questions must have gained added point. Had not Jesus spoken about the destruction of the temple and the spoliation of the land? If He had indeed been exalted as Messiah and Son of Man, did this not mean that temple and city and land were no longer essential for the Christian believer but that he could live already in dependence on the Christ of the heavenly places and could look forward in expectancy to eternal life with Him in the transcendent Kingdom of Heaven? As the Epistle to the Hebrews would show, believers could study the Old Testament Scriptures which told of the land which was the rest of the people of God and of the temple with its ritual for the cleansing away of sin and could therein see the patterns of the heavenly realities. But this was only in order to realize the more vividly that Jesus had taken possession of the true promised land, that Jesus the great High Priest had entered into the true holiest place and that in consequence those already living as citizens of the

Messianic age had a full right to enjoy its blessings even though the earthly representations were already passing away.

If this analysis is in any way correct it means that in the pre-Pauline Christian church two interpretations of the significance of the Christ-events, two attitudes to the place of symbolic forms within the life of religion were already present. Those whose roots were in the Palestinian homeland held that the land and Mount Zion and the Temple and the Altar of Sacrifice had been essential symbols of the presence and activity of God amongst men. So long as these remained, there was a visible symbolic system representing ultimate realities. But with the final coming of the Messianic Kingdom there would be a new Jerusalem and a new Temple. In the interim Christians could remain within the existing framework, confident that they were already experiencing the powers of the age to come and that these were the harbingers of the final establishment of the Rule of God amongst men. Then there would be no need of the symbols in their present form. All would be transformed in the new heaven and the new earth, where God Himself would dwell with men and they would be His People and He their God.

Those, however, who had become domiciled in the Diaspora and had begun to be influenced by Greek views of life tended to regard the Temple and the Holy City as impressive patterns of heavenly realities but not as indispensable in their visible and tangible form for the exercise of the life of religion. By referring to the words of the written Law they could in imagination join in the services of the Temple and experience the benefits which they were designed to secure. Even if city and temple were destroyed their faith would still be attached to the eternal realities which they represented. Much more then, those Jews of Hellenistic origin who had become convinced that Jesus had been exalted as God's Messiah could be independent of the earthly symbols of the heavenly order of things. Jesus had already brought them into the land of their heavenly inheritance, had already given them access into the sanctuary of the heavenly temple. They could draw near in faith, utterly dependent upon Him, with the assurance that they would in due course enter into full possession of their heavenly inheritance.

These two attitudes gain their fullest expression in the New Testament in the Apocalypse of John and in the Epistle to the Hebrews. In the former a rich and elaborate imagery derived from prophetic and apocalyptic writings celebrates the final triumph of *the Lamb*.

Jesus is the heroic leader who was slain but who is alive for ever-more. In the world of eternal reality a conflict is still in progress and for this reason His followers on earth are still subjected to violent opposition and persecution. Many indeed have been slain for the word of their testimony. But because of His triumph through the Cross their own vindication is certain to take place: the time in fact is short. War is in progress in heaven and there are still to be tribu-lations and woes. But finally the Lamb and His followers will reign on the earth, a new heaven and a new earth will come into being and God will wipe away all tears from off all eyes. This symbolism is an elaboration of the earliest Christian apocalyptic expectation. It centres upon Jesus as victor and king: it looks for a new city and a new society: its worship is expressed through vocal prayer and praise: its outlook is towards the future for even in the heavenly world a herculean conflict is in progress the outcome of which will determine human destinies.

The whole ethos of the Epistle to the Hebrews is different. Again there is an elaborate form of imagery but it is derived almost ex-clusively from the Temple liturgy. The Pentateuch and the Psalms provide the focal symbolic forms and the author is above all con-cerned to celebrate the work of Jesus as the eternal High Priest. In the world of eternal reality the supreme event has already taken place. Jesus having passed through a stern discipline of temptation and suffering and death on the earthly plane has gained God's final approval and vindication as the One worthy to act as High Priest on behalf of all mankind. He has entered in once for all into the Holiest place, the very presence of God, has presented His blood on behalf of the sins of the people and now ever lives to make intercession on their behalf. The all-important symbolic background is that of the Day of Atonement when year by year a total expiation was made for the sins of the nation. In the vision of the author to the Hebrews Jesus had made the one central expiation of all the ages for the sins of all mankind. There is no indication that there existed on earth either temple or altar or sacrifice for the Christian community. The Christian is enjoined to set his gaze on the heavenly reality, to fasten his faith upon Jesus as the great High Priest, to offer prayer and praise in union with those of His great representative and to live patiently in hope of entering finally into the rest of the people of God.

It is unlikely that the martyr-church of the Apocalypse or the Hellenistic-Jewish church of the Epistle to the Hebrews possessed

any earthly symbols representative of the heavenly symbols so vividly depicted in these writings. It is possible that in each case these books represent readings or expositions designed to accompany the onward movement of an early liturgy. But each expresses an attitude and an outlook which is virtually independent of representation in terrestrial symbolic forms. The heavenly world is depicted as overwhelmingly vivid and real. The earthly forms and experiences are shadows, types, foretastes. Man is a wayfarer or a warfarer whose life on earth is insignificant compared with the glories of the eternal reality which has been opened up to him through the career of Jesus and which will be consummated when he enters fully into his inheritance. There are however two other notable approaches in the New Testament to the place of symbols in early Christianity and to these I now turn.

V

The first may justly be called the mainstream of first century Christian development for it is represented by the Synoptic Gospels and the earlier Pauline Epistles. The second finds its chief representation in the Fourth Gospel though similarities may be found in the later and less certainly authentic letters of Paul.

The Synoptic authors, and Paul in his early Epistles, constantly bear witness to the new faith over against the background of Pharisaism and the religion of the Law. In the synagogues of the Diaspora the Law occupied an all commanding position. Worship consisted in hearing the words of the Law and making appropriate responses through prayers and blessings. To become a proselyte it was necessary to be circumcised and to commit oneself thereby to obedience to the Law. Whatever then was proclaimed as new through the coming of Jesus had necessarily to relate itself to the Law and to be seen as new in contrast to certain elements at least of the symbolic system of the Law. As we have seen, the newness is emphasized in the Synoptic account first through Jesus' form of teaching which, we are told, was quite different from that of the scribes and which proclaimed the actual coming of the Kingdom, and secondly in and through His saving activities by which the Kingdom gained its symbolic expression in human life. It is true that Matthew in particular represents Jesus as giving a new law, but even this is a very different kind of law from that of the synagogue. The whole emphasis of the Synoptics is on the Kingdom of God and on the utterly

dynamic way in which the Kingdom was symbolized through Jesus' words and deeds.

Paul, however, felt compelled to come to terms with the Law in the light of the good news about Jesus in an altogether personal and existential way. His life hitherto had been completely dominated by the Law. This was the symbol through which God's righteous rule was mediated to his understanding: this was the symbolic framework within which he sought to work out his detailed submission to the Divine authority. There is no evidence that he was greatly concerned about the cultus or about regular ritual observances, though where social custom seemed to demand it he was ready to conform. But with the Law and its demands it was a very different matter. This was a symbolic system within whose ambience were the very issues of life and death. To learn and to obey—these had become the ruling passions of his very existence. Only so could salvation be assured.

For a man whose whole outlook on life and destiny was governed by a single comprehensive symbol—the Law or Torah—no compromise or half-measure was ever likely to provide a satisfying way of change. If there was serious disillusionment in relation to the Law— and there are evidences that his central symbol was under attack both because of what he was seeing outwardly in the Christian movement and because of what he was experiencing inwardly in his moral conflicts—the only viable alternative was the discovery of a symbol completely superior to the Law in its demands and in its enabling. And it was precisely this that he found in the Christ; or to put it perhaps more accurately, it was the symbol of the Christ that suddenly laid hold of his whole being and became for him, in the striking expression of Professor W. D. Davies, a New Torah. 'Jesus Himself —in word and deed or fact is a New Torah . . . conformity to Christ, His teaching and His life, has taken the place for Paul of conformity to the Jewish Torah.'[1] One symbol has died and he, Paul, has died to that symbolic system. A new symbol has been born and he, Paul, will henceforth live in dependence upon the Christ, Who is the image (symbol) of the invisible God.

In the records of Paul's conversion particular emphasis is laid on the dazzling light which suddenly surrounded him and on the voice which he plainly heard. The suggestions of a new revelation comparable to that which had been given at Sinai are obvious. But now the light of the knowledge of the glory of God has been given in the

[1] *Paul and Rabbinic Judaism*, p. 148.

face of Jesus (2 Corinthians 4:6) the words of interpretation and command are from the mouth of Jesus (Acts 9:5). When it is remembered that in Rabbinic Judaism the Torah was constantly associated with light[1] the significance of the change in Paul's outlook becomes even clearer. As the whole passage 2 Corinthians 3–5 reveals, Paul experienced what could only be called a death to the old symbolic system—the letter, the covenant, the fading glory—and a rising again to that which was new—the Spirit, the new covenant, the increasing glory. The old had passed away. All things had become new. His overmastering concern was now to lead others to see 'the light of the gospel of the glory of Christ, who is the image [symbol] of God' (2 Corinthians 4:4).

How then did he do this through visible and audible symbolic forms? In the case of *words* the central and determinative form was the *gospel*, the *kerygma*. This gospel proclaimed the death and resurrection of the Messiah and in consequence both depended upon and superseded the revelation through the Torah. Jesus had died 'according to the scriptures—that is, His suffering, rejection and death had been no utterly novel and unanticipated development in God's economy but rather the climax of a nation's repeated rejections of God's righteous dealings on its behalf through His representative messengers. In the death of the Messiah human disobedience had reached its climax. Yet in His resurrection lay man's ultimate hope. The Gospel of the Messiah crucified and risen became the power of God unto salvation first for Paul himself and then for all who would accept and believe the good news. His total corpus of writings is the expansion and application of this key-symbol to every aspect of human experience.

In the case of visible, symbolic forms the very nature of Paul's itinerant ministry made it impracticable for him to think in terms of buildings or settled orders of ministry. Further his concern for the extension of the range of Gospel proclamation beyond the confines of Judaism led him to seek for an alternative to circumcision as the way of entry into the Messianic society—and such an alternative was ready to hand in the practice of baptism already used as part of the ceremony for the admission of proselytes. What, however, was to be his attitude to Sabbath and Passover and Day of Atonement? Though there are only hints to guide us, it seems reasonable to conclude that the first day of the week became a special occasion for the breaking

[1] Cp. Davies, op. cit.

of the bread within the new Covenant and that a special paschal celebration of the Lord's death and resurrection took the place of Passover. That the annual and the weekly celebrations gradually became adapted to one another in essential form seems likely and if this is so it means that there was a regular re-commitment to the new Covenant within the context of a renewed thanksgiving for redemption through the death and resurrection of the Christ.

In a quite remarkable way these varying symbolic forms were integrated and held together within one controlling image. Though there may have been earlier foreshadowings of this image it was Paul who worked out its detailed suggestiveness and implications. No temple was possible in the new dispensation but in place of the temple there was *the body*, a body of living members rather than a construct of lifeless stones, a body in which God's glory could be manifested constantly rather than within the limitations and restrictions which a fixed building imposed. Messiah had died but He had risen again and the earthly manifestation of His risen body could actually be seen. It was none other than the total assembly of those who were 'in Christ' by virtue of their identification with Him in death and resurrection. The Body, more than any other symbol, brought to outward expression all that was implied in confessing Jesus as the new Torah, the revelation of God's glory to all mankind.

With the Body as the controlling symbol, baptism was regarded as incorporation into the Body, as a death to former attitudes and associations and as a union with Christ 'in a resurrection like His' (Romans 6:5). New life in the Body was sustained by participation in the broken bread, the symbol of the broken body (1 Corinthians 10:16–17) and by sharing in the cup of blessing, symbol of the new covenant in the blood of Christ (1 Corinthians 11:25). In every symbolic activity the all-important thing was to 'discern the body' (1 Corinthians 11:29), a mysterious phrase which at least suggests that wherever the faithful re-enact the drama of the Lord's Supper the body is being re-invigorated and re-formed and all are being built up into the body in love. Initiation into the Torah and feeding upon the Torah were common enough images in Rabbinic circles. In the new order of things, baptism into the Body, participation in the Body through the bread and the wine, became the all-important symbolic forms and these were obviously entirely appropriate to a dynamic and growing society. The original pilgrim people of God

had been baptized into Moses at the Red Sea and had eaten and drunk from heavenly sources in the wilderness. These had been the focal symbols in their developing experience. Now for Paul (and in this he is in full accord with the synoptic authors) baptism into the Messiah and participation in the eucharistic feast were the all-sufficient symbols of the new life in the Body of Christ.

I have looked at the two strands of New Testament theology represented pre-eminently by the Apocalypse of John with its concentration upon the victorious Lamb in the heavenly arena and by the Epistle to the Hebrews with its concentration upon the eternal High-Priest in the heavenly temple: in each case the symbolism is in the realm of the imagination and no indication is given that it either was or could be externalized in earthly embodiments. Further I have looked at the strand represented by the Synoptics and the earlier Pauline writings with their concentration upon Jesus as the revelation of God to men in His life, death and resurrection: the revelation is through symbolic words and deeds and through a resurrection body which takes on symbolic form in and through the Church, the new people of God. In this case place is found for symbolic forms taking shape within the actual life of the Body. Baptism and the Supper form and sustain the Body in its growth until the eschaton. There is no elaboration of symbolism, for the context is still that of a time of expectancy. A pilgrim people travels light and is held together by a minimum of symbolic structures. But there is one other major strand of New Testament theology in which an altogether new attitude to symbolic forms begins to appear. This strand is represented primarily by the Fourth Gospel, though a similar outlook may be found in the Johannine Epistles and the so-called prison Epistles of Paul.

The altogether distinctive element in this fourth strand is the use of symbols which, though in perhaps every case possessing some Old Testament reference or even background, are *universal* in their outreach and appeal. The Apocalypse, the Epistle to the Hebrews, in part Paul and the Synoptics, rely directly on Old Testament symbolic precedents. But in the case of the Fourth Gospel we feel that such a reliance is by no means essential. It is of great interest to establish connections and to refer back to Old Testament stories and imagery, but the all-important matter now is that these symbols are capable of making an appeal to all men everywhere. Jesus is the light of *the world*, He is the saviour of *the world*, He is the bread that

comes down from heaven and gives life to *the world*. For this author it is not so much a matter of struggling to come to terms with the Law, but rather of showing that those who clung to the Law excluded themselves from Jesus' mission of salvation. If there is any system over against which the Christian symbolic system needs to be set it is the Greek system centred in the Logos. Yet for this author it is not sufficient to think in terms of a universal revelation through the Logos, the controlling and ordering principle of the universe. For him the Logos has come to the world in human form, has humbled himself, has yielded himself to the death of a cross. This is the *new* quality of a specifically Christian symbolism. But that this quality expresses itself through phenomena familiar to all men is his conviction and his claim.

Simply to draw up a list of materials and objects, activities and experiences referred to in the Gospel is to realize how universal is the scope of their application. Birth and death, light and darkness, wind and water, flesh and blood, waking and sleeping, paralysis and blindness, the shepherd and the fold, the house and the temple, the vine and the fig-tree, the lamb and the serpent, the fire and the fish—these are some of the evangelist's symbols, symbols because one rarely feels that objects or experiences of this kind find a place in his Gospel for their own sakes alone: rather they point to those transcendent realities which have come within the range of men's vision and experience because the Son of God took into His own grasp the common things of earth and directed them to their true end within the saving purpose of God.

Take water for example. Water already played a large part in Judaism (and indeed in other forms of religion) as a means of purification (John 2). It was associated with the processes of birth (John 3), of the refreshing and sustaining of life (John 4), of healing (John 5), of fruitfulness (John 7). This on the level of common experience. But when Jesus speaks about water there is an immediate sense that water has been lifted out of the realm of the ordinary and has been made a vehicle to suggest extraordinary even ultimate realities. The water of purification is transformed into the new wine of the Kingdom: the water from Jacob's well becomes the living water of the Messianic age: the water of the dedication festival becomes the stream flowing out to bring healing to the nations: the water issuing from the pierced side of the Crucified will become a life-giving sacrament in the new community. Water, a universal need and a universal blessing, becomes

a symbol of almost unlimited potentiality for the communication of distinctive Christian truth.

I have tried in this chapter to examine the chief symbolic forms inherited by Christianity from Judaism. The holy place, the Temple: the holy day, the Sabbath: the holy act, the Sacrifice: the holy writing, the Law. In official Judaism these had become indispensable symbolic institutional forms. Yet there were variations even within Judaism with particular groups finding their focus of interest in the synagogue or in lustrations or in festal observances or in the tradition of the covenant. Christianity, beginning as a sect within Judaism, followed the example of Jesus in refusing to be imprisoned within the symbolic structure of Law, Sabbath, Temple and Sacrifice. It did not immediately reject these institutions in any absolute way but sought to discover what changes and adaptations were necessary in the light of the conviction that Messiah had come and that after His passion and death He had risen again and been exalted as Lord and Saviour. The varying strands of development represented by the writings of the New Testament indicate that where Christians were living under threat of persecution their symbolic forms could only take shape in word and song—as is evidenced in the Apocalypse and the Epistle to the Hebrews. Where the Church was able to establish some kind of regular corporate life the ritual of baptism symbolized entrance into the community and the life of fellowship was nourished by the faithful meeting together on the Lord's day to celebrate the Lord's supper and to hear the Lord's words. The new community-symbol, capable of almost unlimited development within new situations and circumstances, was the Body of Christ: the new time-symbol was the Lord's Day: the new rituals were Baptism and Eucharist: the new verbal-symbol was the Gospel. There is a wealth of secondary symbolism. As we move forward into Christian history I shall try to show how these many potentialities gained shape in external forms.

EASTERN AND WESTERN CHRISTENDOM

Symbols of Hierarchy and Immortality

FROM the first two centuries of the Christian era we have inherited a collection of records written in Greek and in these we find a number of references to ritual celebrations of a symbolic kind. They appear to have taken place in locations where the necessary practical facilities were available—running water for baptism, a room in a private house large enough to accommodate those who wished to be present at the Lord's Supper. The order seems to have been quite simple and functional, certain men being authorized to interpret the writings and lead the prayers, others to preside at the eucharistic meal. Times and seasons in a few instances gained a new symbolic reference. The first day of the week, for example, replaced the seventh as the regular occasion for Christian worship: the Pasch, the high celebration of the Resurrection, took the place of the annual Passover.

Symbols, however, were so far of two main kinds—verbal on the one hand, dramatic on the other. There were furtive beginnings of Christian art—scratchings on ossuaries, engravings on stones, sketches on walls—but these were largely in the nature of secret signs whose meaning was known only to the faithful.[1] Assemblies convened in available houses, but these could not yet be given any permanent symbolic ornamentation. New verbal formularies gradually took shape and were esteemed as bonds of union in a common faith. But the total impression derived from the records of the first two centuries is that of scattered and loosely-organized fellowships, finding their symbolic unity in a corpus of treasured writings and in a regular cycle of common activities. Sacred buildings, an ecclesiastical calendar, formal creeds, orders of ministry, all belonged to the future.

[1] Cp. Jean Daniélou, *Primitive Christian Symbols*.

As we approach the end of the second century, however, we begin to notice signs of change. Christian writings are proliferating and the question of how they are to be assessed and interpreted becomes urgent. Worship forms are multiplying and the question of which expansions in word and practice belong to the true tradition also demands attention. Still further, translations into other languages are beginning to appear: Greek no longer holds the monopoly. The translation of Christian teaching into Latin, and of eucharistic rites into Syriac and Coptic, were developments of the highest significance. Cultures influence the formation of symbols as much or even more than symbols affect cultures.

Yet amidst all these changes none really compared in importance with the entry into the Christian movement of assumptions, conceptions and symbolic structures belonging to Rome and the Latin West. Hitherto Christianity had been pre-eminently an *Eastern* cultural phenomenon. In the first century the initial patterns of speech and action had indeed come from a Semitic source, though they had quickly been obliged to relate themselves to Hellenistic language and practices. After the final breach with the synagogue, however, Greek cultural forms seemed destined to mould the development of the new faith almost exclusively. Yet the distinctive influence of the Roman ethos gradually intervened. In the late second century Tertullian became a major figure in the life of the Church and applied the language and methods of the skilled jurist to the formulation of Christian faith and practice. From now onwards legal maxims and principles would have a place in the development of Christianity and the influence of the Latin West would be increasingly felt.

When, some two centuries after the time of Tertullian, Jerome performed the herculean task of translating the Hebrew and Greek Bible into Latin, he employed a host of terms and notions drawn from the sphere of legal practice. To a marked degree, the Bible came to be regarded, amongst peoples influenced by Rome and its language, as a supremely authoritative law-book, a revelation of the Divine will for the total organization of individual and social life. And thereby the idea which had first gained prominence in ancient Rome, an idea which has been called one of the most ambitious in all human history, seemed possible of attainment within a Christian context.

This idea, in its pagan form, declared that the Pax Augusta had brought to fulfilment a process which had begun at the very dawn of human history. Now, it was affirmed, a stable and lasting civilization

had been erected on the ruins of the discredited and outworn systems of the past. Man had subdued nature through his own efforts and virtue and organization. A visible order was in process of construction over the whole of the inhabited world. For Christians to have entertained any such idea of their own destiny would, until the conversion of Constantine, have seemed sheer madness. But, with the empire unified under a Christian Imperator, with the growing power of the Bishop of Rome, with the Church beginning to possess impressive institutional forms of ministry, buildings and liturgies and above all a divinely authorized Law-book, the vision seemed not to be so fantastic after all. These developing institutions seemed to be symbols of God's Kingdom establishing itself amongst men, His eternal laws now revealed being openly expressed through the symbolic structures of the Christian Church. But it became increasingly evident that the West would develop its symbols in its own characteristic way—a way which was in many respects different from that of the East. The gradual divergence between East and West in this respect constitutes perhaps the most interesting and significant aspect of Christian symbolism in the first millenium of the Church's history.

II

The earliest gospel and the earliest corporate celebrations of Christian devotion issued from a Palestinian source. At the end of the second century Tertullian could utter his famous cry 'What has Athens to do with Jerusalem, what the Academy with the Church?' But Athens had already contributed its symbolic forms in language and patterns of social life and soon Rome was to contribute still more through its own language and its patterns of social organization. Christianity began as a primarily eschatological faith: Graeco-Roman culture was dominantly concerned with the abiding structures of the world and human society within a transcendental framework. To express a primarily eschatological faith through dominantly ontological symbolic structures has constituted possibly the thorniest problem in the whole history of the Church.

Yet even in the New Testament period the symbolic transposition was beginning to be made, particularly in the Fourth Gospel. Baptism was not simply a symbol of acceptance into God's final Kingdom: the water itself, the material element in baptism, possessed a symbolic significance. The breaking of the bread was not simply a symbol

of sealing within the new Covenant: the bread itself, the material element, was symbolically related to the flesh of Christ. Was this a betrayal of the essential Christian faith? Again and again reformers have arisen to claim that indeed it was, that these beginnings of hellenization were already blunting the edge of the Gospel's sharp alternative to any kind of this-worldly religion. I shall not here attempt to argue the case for or against. All I am concerned at the moment to point out is that the early Christian movement did in fact gradually adjust itself to its environment through its symbolic forms, for even when the outward symbol appeared to be taken over from the Palestinian background in a relatively unchanged form, the interpretation and application appropriate to the Greek or Roman context as the case might be proved ultimately to be a means of transforming the symbol in its direction and its meaning and its social effectiveness.

Because of its great importance in the development of symbolic forms in the Christianity of the first millennium of our era the distinction between East and West deserves special consideration. In the East, from time immemorial, man has been powerfully aware of mysterious agencies and potencies and relations which lie hidden in the universe of *Nature* to which he belongs. As early as the sixth century B.C. in Ionia he was committed to the quest for a reasoned understanding (*logos*) of nature (*physis*). What was the primary stuff of which the world was constituted? How do changes take place that bring about its manifold appearances? One of the deepest convictions that gradually established itself in the Greek outlook was that *physis* is not just a haphazard collection of disparate entities: nor is it simply a surface appearance of changing images: rather is it a marvellous medium through which ultimate reality manifests itself through infinitely varied forms, all of which cohere within a universal system. External observable objects and structures are symbols pointing to and sharing in eternal realities. Through contemplation of these symbols, through participating in the outward forms, man can not only penetrate to inward significance but can also enjoy communion with the divine.

The concern with nature was also a concern for *life*. Nature seemed to possess the secret of the renewal of life. Whereas through the passing of the seasons or the return of night or the incidence of drought life might seem to decline and even to be swallowed up by death, still it revived and new potencies appeared. How could man then be assured that he too would pass through death to a renewed,

even to a fuller life? Could he in some way be so identified with the secret potencies within the natural order as to gain through them the immortality for which he yearned? Long before the beginning of the Christian era religious cults promising eternal life through participation in rituals of a mysterious or ecstatic kind had flourished. Thus the way was already prepared for a new religion at whose heart was the symbolic representation of a dying and rising Redeemer. This was the sacramental mystery through which the church had been constituted and through which it was constantly being renewed. The mystery included both initiation through the baptismal bath of regeneration and renewal through the eucharistic gifts which were the very medicine of immortality. For Christians in the East nothing compared in wonder with the symbolic drama which showed forth the coming of the Son of God into the very midst of earthly humanity, His passion and death, and then His glorious resurrection and ascent to His former estate. By sharing in this central mystery men were illuminated, transfigured and sealed for life everlasting.

One other characteristic of the Eastern outlook may be mentioned, especially as it was destined to exercise a marked influence on the development of symbolic forms. This was the love of symmetry and harmony. At least from the time of Plato mathematics and music had been accorded a kind of mystic pre-eminence in disciplined studies, for they seemed to be the sciences of pure form, the nearest approach that man could make to the divine mind itself. Whereas man's body belonged to the world of matter, his soul belonged to the world of mind. From this world of mind ideal forms could communicate themselves through the soul of man into matter and thereby create coherent harmonies and symmetries. These creations could then in turn become vehicles through which the whole universe could ascend towards the divine in contemplation and praise. Man's noblest calling was to act as the intermediary between matter and mind moulding matter into symbols of harmony in which the divine was immanent and through which man himself could rise to the transcendent.[1]

[1] 'The sound in a Byzantine hymn', Gervase Matthew writes, 'the gestures in a liturgy, the bricks in a church, the cubes in a mosaic, are matter made articulate in the Divine praise. All become articulate through becoming part of a rhythm. In the world of matter they have become echoes of harmonies in the world of mind. This could explain the crucial importance of mathematics for Byzantine aesthetics.

'For the Byzantine mathematician the theory of numbers and pure geometry

In contrast to this widely diffused outlook compounded of Hellenic and Egyptian and Oriental elements (though the language and traditions of Greece exerted a controlling influence) stands another, the Roman or Western which, first coming into prominence within the limited confines of the Roman republic, succeeded ultimately in imposing itself on much of western and northern Europe. Until the first century B.C. Rome was essentially an agricultural community and the typical unit was the peasant farmer with his plot of land, his home and family, his servants and animals. He was obviously concerned with nature, but for him it was above all a matter of organizing his total life, at home and on the farm, to conform with the *laws* of universal order. There were laws governing the successful cultivation of crops and the continuing fertility of animals: there were laws governing the distribution of property: there were laws governing the coherence and harmony of the total society. To learn these laws, to express them by the aid of appropriate symbols, to obey them and to live by them—this was the whole duty of man. And when with the growth of trade and the increase in numbers of those accorded Roman citizenship the possibility of an imperial system emerged, it was still obedience to a given order which constituted the outstanding characteristic of the empire, as it had been that of the lowliest farmer.

With this concern for law, the Roman showed no comparable interest in what might be called the ultimate mysteries of the universe. He was prepared to adopt mythologies and philosophies from extraneous sources (pre-eminently from Greece), but laws governing the actions which must be performed were very much his own preserve. His genius was severely practical. He noted the rhythms and regularities of life, expressed them in appropriate symbolic structures and then organized his own activities in such a way as to conform with these unchanging patterns. Such activities, however, were related not only to the tasks that had to be fulfilled on the land and in the social order: they were also related to the unseen powers who controlled each his own department of terrestrial affairs and needed to receive due recognition and obedience. Correctness of symbolic observance could only be assured by due deference being paid to those who were authorized to interpret the divine prescriptions in these matters.

belong to the world of *noetos* (mind), the art of calculation, applied geometry, of optics and mechanics to that of *aisthetos* (matter). Material was moulded inevitably by the laws of mind.'—*Byzantine Aesthetics*, p. 24.

The leading symbolic forms of the imperial system were the Latin language, majestic in its disciplined structure and controlled rhythms: the imposing body of laws governing property, contracts and social duties: the buildings designed for practical communal purposes, but increasing in splendour as larger numbers had to be accommodated: the hierarchical social structure with the Emperor as its centre and its crown: the religious ceremonies, meticulously ordered to cover every exigency of individual and social life. All of these forms had one common element—they were the outward expressions of laws believed to belong to the very structure of the universe. Language, ritual, architecture, times and seasons, all depended upon legal sanctions which had been determined by heavenly guardians and must be implemented by their earthly agents.

How then could the Christian Gospel find an entrance into this virtually totalitarian system? At first, it would appear, by presenting itself as a new kind of law—the law of the spirit of life in Christ Jesus. Paradoxically this was a law of liberty, for it set men free from the law of sin and death which was inherent in the universe as well as from the law of ordinances which had been set up as the only way to win the approval of God. Yet it is clear that as the Church in the Empire passed out from its days of struggle and tribulation into a more settled era of regulated, communal life, the desire grew for symbolic forms which would do for the new Christian society what the legal ordinances of the empire had done for the old. Just as in ancient Rome the various religious symbols—emperor, priesthood, temples, calendar, above all the sacrificial system—were regarded as the prescribed forms by which the empire could maintain its unity, its continuity and its health, so at an early stage in Roman Christianity the all-important symbols came to be those which represented the ordered structure of God's new creation. There needed to be a canon of belief, a canon of conduct, a canon of worship, a canon of discipline.

The first important formulation of Christian doctrine and discipline in the West was the work of the great advocate and orator Tertullian who employed juristic concepts and principles current in Roman law. The earliest liturgical manual of the West was the Canons of Hippolytus. Legal terms, legal symbols had secured a prominent place in the Western Church. The translation of the Bible into Latin at the turn of the fourth and fifth centuries gave these terms a commanding influence in all future development. And when

the legal prescriptions of the sacred text were externalized in visual form, whether through painting or through ceremonial rites, the effect upon the pagans of northern Europe was immense. Here were symbols that made a concrete appeal to the senses and provided a clear indication of the way in which they should walk. The more sophisticated ideas and symbolic forms of the East would have meant little to the illiterate and uncivilized. But Rome, with the vulgate, the episcopal authority and the simplicity of the Mass, succeeded in winning to the Christian allegiance the greater part of Western Europe.

III

At the end of Chapter 1, I suggested that four basic co-ordinates determine human existence and provide possibilities of connectedness between individuals within society. I propose now to examine briefly the form these took as the Christian message and discipline made their impact upon the two ancient cultures of Greece and Rome.

(1) *Topographical*. Though there is abundant evidence that house-churches existed in the Roman Empire before the conversion of Constantine and that they had begun to be arranged and furnished in distinctive ways, it was only after the Edict of Toleration that church building began in earnest. In all probability the shape then adopted was but little different from that of the large room which had been occupied in the house church. Rectangular, with an apse at one end, it provided all that was essential for the worshipping assembly. The president had his seat at the centre of the semi-circle in the apse, the eucharistic table was between him and the congregation. So long as these basic requirements were met there was no need to elaborate except by expansion and ornamentation. Just as a room was set apart within the house, so the basilica was now set apart from other buildings in the interior of the city. This was entirely in keeping with the practical outlook of the Roman tradition. Space had to be organized to meet particular needs. The Christians needed a central place of assembly. Let structures be built large enough for each particular community and suitable for the activities in which they wished to engage!

Many of the basilicas thus built in the West were splendid symbols of an ordered simplicity and a practical efficiency. Usually a smaller building stood near by, containing a fountain of living water

for baptismal ceremonies. Its octagonal shape was determined, it appears, by a symbolism of number, but again the all-important matter was that it should serve efficiently for the performance of the first part of the liturgy. And when expansion and elaboration became possible, it was natural that the walls and the dome of the font should be decorated by vivid mosaics depicting scenes associated in some way with the ceremony of baptism. In contrast the apse and the walls of the basilica were adorned with pictures representing stages in the total history of man's salvation. The Roman genius organized space for liturgical purposes and through its pictures anchored the imagination of the Christian to definite locations where the great drama of salvation had been pre-enacted.

In the East the same basic pattern of the church building was adopted for the same basic liturgical needs of the community had to be met. But it was not long before the style of the basilica attained its own distinctiveness as the specifically Greek and Oriental traditions made their influence felt. Within this general outlook an enclosure and a building were regarded not so much as a setting apart of an area for a particular function and purpose as a consecration of space to manifest a new form and beauty. The building was designed, as it were, to grow out of its natural surroundings in order to become their crown and fulfilment. This was done by exploiting the potencies inherent in any situation—potencies of geometrical form and proportional relation and above all of luminosity—to produce structures of symmetry and harmony and controlled light. One direct result of this striving for organic wholeness was that the rectangular shape of the original basilica tended to be compressed towards a circular or octagonal form in the East, a form which revolved easily around a centre rather than concentrated attention upon a distant wall or window or tableau. The light of heaven could be focussed upon the centre, the ceaseless round of earth's worship could revolve around the centre, the objects and structures of the world could be drawn towards this centre and from it rise up to heaven. The apse was not abandoned and the circle was attained only in proximate form. But the style is characteristic of the East and is far removed from the elongated rectangular forms which were to be adopted in northern Europe.

In the earlier period (sixth and seventh centuries) in the East the overall concern for geometrical balance and for the manipulation of light was paramount. But by the ninth century increasing attention

was being paid to symbolic correspondences and interpretations in detailed parts of the building. From three points of view the church could be regarded as symbolizing eternal realities—as a microcosm of heaven, as a representation of the successive locations of Christ's life on earth and as an image of the successive stages in the liturgical year.[1] It was a splendid conception. In its finest form a Byzantine church was a majestic symbol of the ordered harmony of the total Divine creation as well as of the perfect cyclic movement through which the Divine becomes man and man becomes divine.

(2) *Chronological.* The evolution of the Christian calendar has been a complex process in which the attempt has constantly been made to relate the celebration of specifically Christian events to the calendrical regularities established in the jewish, the pagan and the secular world. I have already mentioned the Hebrew Sabbath and the annual Passover celebration. There is strong evidence in the New Testament that Christians at an early stage chose a day of their own, the eighth day which was also the first day, the day of the Lord, the day of resurrection for the celebration of their eucharist. Though at times in Christian history sects have sought to repristinate an observance of the seventh day, even to the extent of making the seventh the symbol of Creation and the eighth that of Resurrection, the establishment of Sunday as the weekly commemoration of the Lord's death and resurrection has held firm throughout Christian history. Secular and sacred calendars have found little difficulty in agreeing upon a week of seven days with one regarded as a day of special celebration.

The matter becomes much more complex however when particular seasons of the natural order and particular commemorations of the historical order need to be celebrated. Seasonally there are variations in different parts of the world; every culture has its own distinctive memories to recall. I can refer only briefly to one striking contrast in the development of calendrical symbolism in East and West.

It can perhaps best be stated in this way. Both in the realm of nature and of history the West was concerned with specific days which could be related to particular events. In the cycle of agriculture the object had been to mark on the calendar the precise day in winter which was the turning-point from darkness to light, the day in spring which was propitious for sowing, the day in summer for reap-

[1] Cf. Gervase Mathew, *Byzantine Aesthetics*, pp. 106f.

ing. This concern was extended to the determining of the proper day to build a house, to go to war, to join in matrimony. Further there were days to commemorate outstanding events of past history. When therefore it became possible for Christian celebrations to gain public recognition within the secular calendar, it was natural for the emphasis to be laid on the day when the Christ was actually born, when He actually died, when He actually ascended into heaven at the close of His earthly career. Further, events in the history of martyrs and saints were to be remembered on particular days. It was a matter of organizing the Christian life in such a way that appropriate actions were taken at appropriate times and that a proper relation between sacred and secular might be constantly maintained.

If, however, we look to the East we find much less disposition to concentrate upon precise events. The mid-winter season which saw the reversal from deepening darkness to increasing light, the spring which saw the renewal of the life of vegetation, the early summer with the first fruits appearing—these were the notable periods of the year. They could be anticipated through an extended preparation and their actual celebration could continue beyond the central day. When Christianity began to come to terms with this general tradition it fastened upon three main festivals for its own celebration— Epiphany at the time of the renewed effulgence of the light, Easter at the time of the re-birth of nature, Pentecost at the time of the first fruits. With these seasons were associated the Lord's nativity and baptism, His death and resurrection, His ascension and bestowal of the Spirit respectively. Each of these seasons had periods of preparation, involving fasting and self-scrutiny, each had following periods of continued thanksgiving. The year was gathered together into a threefold unity of enlightenment, regeneration and inspiration. Time and eternity were held together within a total time symbolism of which the eucharistic celebration was a type and a norm. Whereas the West organized its calendar around fixed times commemorating particular critical events, the East preferred to celebrate movements in the cycle of salvation by sharing in which man could enjoy the experience of eternity in the very midst of time.

(3) *Liturgical.* Liturgy, a term which was originally applied to any kind of public activity, has in the context of worship come to include various cultic practices. But in Christian history it has been used above all to describe the combined rite of baptism and eucharist with special emphasis upon the eucharist itself. In its earliest form

the eucharist was essentially action. Jesus took a loaf, broke it, distributed it. The disciples prepared the meal, received the elements, ate and drank. Words, of course, accompanied the actions, but action was primary. A pattern of bodily activities dramatizing this form of Divine service soon took shape in the Church and when in the fourth century worship-gatherings became large, regular and undisturbed it was natural that liturgies themselves should take on a more formal character with explicit directions concerning what was to be said, what was to be done.

It is a striking fact that there has been no major change in the basic structure of Christian liturgy since the fifth and sixth centuries of our era. There have been many changes in language and ceremonial but in all parts of Christendom the aim has been to re-enact the procedure of which the drama which once took place in an upper room constitutes the norm. Yet when we examine the way in which the actions-pattern has been interpreted as the central symbol of the faith we find that as early as the sixth century a certain divergence between East and West was beginning to appear.

In the East the liturgy is regarded as the supreme means by which the mysterious processes, operating in the created order and potentially brought to their destined fulfilment through the all-embracing work of Christ, are in fact being constantly directed towards their true end. The Church constantly identifies herself with the eternal Logos, celebrating His incarnation and death and resurrection through the symbolic drama of the Holy Mysteries in which Christ Himself, the great High Priest, is always present. In one sense the celebrant stands in the tradition of the apostles who were appointed by Christ to continue His teaching and sacramental ministry. In another sense, however, time and succession are transcended. It is the one Christ who eternally proclaims the one truth and in the one Liturgy gathers His Body into renewed communion with Himself, its living head. The one truth, sacramentally mediated through the Scriptures, is patient of being applied to new situations through the process of spiritual interpretation: the one life, sacramentally mediated through the Liturgy, is capable of re-vivifying the faithful by the agency of the life-giving Spirit. This symbolism, in its primary forms, points to the unchanging unity of God in His transcendent being, the eternal high-priesthood of Christ for ever operating in and through the Holy mysteries, the living energies of the Holy Spirit constantly acting to establish the Church in unity, holiness and truth.

It is a symbolism characteristically Eastern, Platonic, mystical, universalistic.

But this is clearly not the characteristic interpretation of the symbolic acts which belongs to the West. For far back in this tradition a much sharper distinction between sacred and secular was posited than ever existed in the East. The typical Roman citizen was profoundly aware of boundaries between the sacred and the profane. If profane objects and events were to be sacralized a well-defined procedure had to be followed. The right thing must be done in the right way and the all-important thing to be done was to offer *sacrifice*. For every exigency, for every emergency, a particular form of sacrifice had been prescribed and this must be carried out with scrupulous care. It is not surprising that at least from the third century, when for example we find Cyprian of Carthage (A.D. 250) affirming that 'The Lord's passion is the sacrifice we offer', the Christian sacrifice of bread and wine should have come to be regarded as the central and all-important ritual action needing to be constantly performed.

As in earlier forms of sacrifice, the Christian liturgy made provision for acts of purification to prepare that which was to be redeemed from the world, acts of consecration to unite it with the one sacrifice of Christ by which all creation and all mankind had been potentially saved, acts of application so that what had been redeemed could be appropriated to a holy purpose. Every liturgy served to reconstitute the sacrifice symbolically and to mediate its saving energy to the particular profane context for which it was intended. It was an open and public act directly related to the open and public act on Calvary. The symbol does not primarily serve to re-enact the great Mystery. Rather its function is to apply to concrete objects and particular historical circumstances the one great sacrificial act which God in Christ offered for the world's salvation.

(4) *Linguistic*. When in the seventh century Arab nomads attacked and thereby came into intimate contact with Christians of the Eastern Empire, they described them as 'the Men of the Book'. Not the buildings nor the bodily activities but the book. It is an interesting testimony to the place of honour that the Holy Scriptures occupied everywhere within the Christian world of the post-apostolic age.

By a remarkable historical coincidence, the end of the era of persecution occurred at the very time when the codex, the bound book,

was first coming into general use. Many of the Church's manuscripts had been destroyed in the time of Diocletian, but now men could set .to work in earnest to make the Scriptures available in a far more convenient form. Codices in Greek and later in Latin were written by hand and often beautifully illuminated. The sacred text was studied, read and sung in the services of the Church and interpreted in sermons; its scenes became the inspiration of artists and craftsmen who decorated the walls of the churches with mosaic and paint. No one seriously doubted that this book was the unique revelation of God to men, the symbol of His gracious concern for the salvation of mankind.

Yet once again we discern a difference between East and West in their attitude to the book. For Christians of the East the book was surrounded by an aura of *mystery*. In its pages divine secrets lay hid. Its scenes were not just vivid tableaux representing historical events and encounters. Rather were they timeless dramas typifying the interactions which take place constantly between God and man, between man and his fellow-creatures. For example the Old Testament seemed to be a treasure-store of records of marvellous deliverances—Jonah from the deep, Daniel from the lions' den. To recount these, to re-enact them by means of sermons and hymns and wall-paintings, in short to commend the Bible as the supreme Symbol of Divine Truth expressed through human language-forms—this was the task of Eastern interpreters.

On the other hand it would be truer to say that in Christians of the West the book produced a sense of reverential awe. They regarded it as bearing the authority of God Himself. At some of the great councils the seat of the presiding bishop was not occupied by the legates of the Bishop of Rome but by a codex of the Gospels regarded as the insignia of Christ Himself: the codex in fact was a symbol of the authority of the invisible head of the Church.

What this meant in practice was that the explicit rules and the regulative patterns which the symbol enshrined must be studied and compared and codified in such a fashion as to provide clear guidance for the Christian way of life. The ordinary man needed direction as he sought in this world to prepare himself for the next. He required an ordered system of rules of behaviour for the home as well as for the Church, for his life in society as well as for his relations with God and the saints. To commend the Bible as the supreme symbol of Divine Law expressed in human language was the abiding task of Christian interpreters in the West.

IV

In no period of Christian history have symbolic forms played a more prominent part in the total life of the community than in the Medieval Age. Objects were of little importance in themselves, but chiefly as symbols of heavenly realities. Events similarly were significant only because they could be regarded as symbols of divine activities. In a very real sense men lived in a symbolic universe: 'through symbol to reality', was the watchword governing the outlook of the whole society.

In this outlook the primary emphasis was on given-ness, on the outward expression of inward Being rather than upon progression or causality (though the influx of Aristotelian doctrines in the thirteenth century would inevitably lead to changes in this emphasis). What was constantly looked for was likeness, correspondence, association, similitude. When these could be discerned it was an obvious deduction that behind the likeness shared by two objects there was a single inner essence or connection. So like was compared with like and gradually a vast system was built up whose origin was found in the mind of the One by whom all things had been created and who had graciously made Himself known through the revealed Word of Scripture. No man could see God as He is in His eternal Being. But through the phenomenal world man had been presented with a mirror of reflection, a glass through which he could see darkly. It was in fact a vast coherence of symbols all related to and referring to the one God who is their source and their creator.

In such a world, man's highest calling was not to study things in themselves but to penetrate beyond them to the inner significance which they possessed within the mind of God Himself. And for this deeper penetration man had been given the aid of a second mirror, the mirror of *history*. History, however, was conceived in terms not of mere successiveness nor of a bare sequence of cause and effect but rather of a totality of human experience where patterns of events were seen to bear likenesses to one another and so to have a common likeness to that archetypal symbolic pattern revealed through the history of the Christ Himself. Of the general history of mankind comparatively little was known. But the Old and the New Testaments told of the history of the elect people of God and later stories recounted the experiences of the saints who lived after Christ. Together these formed a second collection of symbols through which

God had made Himself known in ways beyond what could have been learned through the mirror and the laws of Nature alone.

Again there is no suggestion of *progress* in symbolic forms. It is one and the same truth of eternal Being which is revealed both in Old Testament and New. But in the Old Testament this truth is veiled. In the New it shines forth in all its splendour. Or to use a medieval description, in the Old Testament we see truth as by moonlight, in the New in the full light of the sun. The synagogue was represented as blindfold. It is the Church that rejoices in the vision of the true light. Admittedly this truth was open to varying levels of interpretation—the literal, the allegorical, the tropological and the anagogical—but that was its richness and its fascination. Seeing that God was the author it was not for man to set limits to revealed truth. The only final criterion was to be found in the God-Man through Whom the world had been created, through Whom the world had been redeemed. All Old Testament records of redemption prefigured His mighty act. All creation in some way bore witness to His wisdom.

V

Space. It is in no way surprising that the overwhelmingly impressive symbols which we have inherited from the Middle Ages are those hewn and shaped and carved out of rock and stone. It was Victor Hugo who wrote that in the Middle Ages men had no great thought that they did not write down in stone. Rock was strong and durable: it was the material out of which the mountains, God's high places, were made: in countless ways it was a symbol of Christ and His apostles: it lent itself to the construction of hierarchical models, the most stable of any known to men. And because medieval man not only saw the natural world as symbolic of the heavenly order but also longed to express every idea of his own in a concrete image, he built great churches as majestic integrative symbols of that which is eternal in the heavens, the house of God not made with hands.

According to this type of imagery God Himself is the original architect (frequently He is depicted with compasses in his hands) and it is man's highest privilege to learn the secrets of the Divine geometry—symmetry and proportion, relation and balance, function and form—and to express them through the medium of stone. A text from the Book of Wisdom was constantly quoted: 'Thou hast ordered all things in measure and number and weight.' And the

response of builders and worshippers alike was to think of their great church as beautiful because it mirrored, as closely as man can mirror, the effortless labours of the Divine Architect Himself.

It is hardly necessary to speak in detail of the wealth of symbolism which the Cathedrals and Abbey Churches contained. There was a sacred language of art, so that every aspect of invisible reality—divinity, bliss, providence—together with every regularity of the natural order, had its appropriate symbolic expression. The orientation of the building, the manipulation of light, the grouping of figures all had their symbolic conventions. Above all the sign of the Cross made by the transept separating choir from nave, a sign which was also the pattern of man himself, stamped upon the spatial environment the mark of God's eternal sacrifice. In the house of God men gained a foretaste of heavenly splendour. Indeed it is recorded that when in 1130 the new choir of Canterbury Cathedral was dedicated, the ceremony seemed to contemporaries more splendid than any other of its kind since the dedication of the temple of Solomon. And as the assembly chanted 'Truly this is the house of God and the gate of heaven', King Henry swore with his royal oath, 'truly this sanctuary is awesome'.[1]

Yet although through its intense concentration on symbolism the Middle Ages may be regarded as possessing a highly unified outlook, a certain change of attitude may be observed in the period between early and late Gothic. In the earlier stages the authority of St Augustine was still pre-eminent. His concern for order, proportion, shape and above all number, his writings on music and geometry and mathematics all influenced the medieval artist as he sought to express in visible concrete form the realities which transcended human experience. The square, the circle, the equilateral triangle: the numbers six and seven and twelve: ratios and conjunctions and harmonies—all these were of immense significance for they could lead the mind of man beyond the variegated world of appearances to the ultimate divine order.

[1] Otto von Simson, *The Gothic Cathedral*. p. xviii. Cp. 'With its cruciform shape and orientation toward the East, its stained-glass windows and carved choir screens, the building was designed to lead the worshipper beyond the world of sense and mortality. Medieval churches have been called silent sermons and religious dramas in stone. The names are apt: the foundations of the church bore more than a load of masonry. They groaned under symbolic meanings.'—Peter Gay, *The Enlightenment*, p. 249.

Besides number and geometrical pattern, light in all its manifestations played a supremely important part in the Augustinian-Platonic tradition. Light is the least material of all experienced phenomena. Light dispels confusion. It is associated with purity and growth. Light radiates from some primary source of radiance and glory and brings beauty and clarity in its train. So whatever else it was, a building had to be a place in which men could behold the wonders of light and could be caught up into an increased awareness of and enjoyment of the mystical reality of which all natural light was a sacrament and an analogy.[1]

These were the all-important emphases of the early Gothic architects and craftsmen. But by the time of the appearance of the High Gothic style the influence of Aristotle was beginning to be felt both in theology and in architecture. The sacred building could now be regarded not so much as the copy of a transcendent form but rather as the outward structure through which the organizing and unifying Divine Spirit could find expression and manifestation. Every individual element must be integrated into the organic whole while at the same time maintaining its own identity. There could be no easy merging or compromising synthesis. Elements which appeared to be contradictory must still be allowed to make their particular contributions to the construction of a strong and stable and functional building. To a man imbued with the scholastic habit, Panofsky writes, 'the panoply of shafts, ribs, buttresses, tracery, pinnacles, and crockets was a self-analysis and self-explication of architecture much as the customary apparatus of parts, distinctions, questions and articles was to him a self-analysis and self-explication of reason'. All was directed towards a 'clarification of function through form'. Thus in later Gothic the elements of a building were still symbolic, but less as pointing towards unseen enduring heavenly forms, more as pointing towards the life of the total Divine organism of which the cathedral-building was a magnificent clarifying model.[2]

Time. The ideal of the Middle Ages following the pattern of St Augustine's mystical theology and supported by centuries of monastic life and experience was to enjoy the bliss of eternity here and now. And eternity, according to a famous definition of Boethius, is the simultaneous and complete possession of infinite life. So St Augustine in his *Confessions* had embraced the conception of all

[1] Cp. von Simson, op. cit., p. 55.

[2] Cp. E. Panofsky, *Gothic Architecture and Scholasticism*, 59f, 69f.

time, past and future, existing in the mind of God, and Boethius had imagined God as viewing everything as though it were taking place in the present. Aquinas uses an illustration which seems particularly apt in the light of modern experiences of journeying through space: 'He who walks on a road does not see those who come after him, but he who looks at the whole road from some height sees at once all those who are walking on the road.' This in fact was the ideal, both spatially and temporally: to ascend to an exalted peak of vision from which space could be viewed in true proportion and time could be experienced in the perfection of simultaneity.

The ideal of sharing in the unchanging timelessness of God governed the unending cycle of prayer and praise which was characteristic of all religious communities. In the secular world there was, Marc Bloch has written, a vast indifference to time. There seems to have been little or no sense of historic sequence or causation, no recognition of manners or customs as belonging to a particular period in human development. Men were aware of the daily rising and setting of the sun, of the regular cycle of the seasons, of the successive stages of mortal life. These could be regarded as in some way symbolic of God's providential ordering of His universe. But little attempt was made to attain precision in the measurement of the flow of time. Cumbersome water-clocks were in use: the calendar was inaccurate: the only notable time-signals were bells which at least in towns seemed to be constantly ringing. Not until the invention of the mechanical clock at the end of the thirteenth century did medieval man begin to grow conscious of time as moving inexorably onwards with something like majestic regularity.

As far, then, as the symbolism of time was concerned the all-important forms were those which directed men's minds and imaginations towards the perfect cycle of God's own orderliness. In the dominantly Platonic conception the Sabbath-rest of contemplation symbolically represents the sanctification of all human life. In those areas where men were becoming familir with a more Aristotelian outlook every section of time devoted to the *opus Dei* could be regarded as a symbol of the total movement of the whole created order toward its true destiny in God Himself. The mystic sought to rise above all earth's variabilities and to enjoy the timeless contemplation of perfect form; timeless moments were to him symbols of eternal timelessness. The 'religious' sought to order all his life on earth in such a way as to share in the perfect rhythmic life of the Divine. A

time-sequence could include tension and even disharmony but the end would bring resolution and integration: such a sequence was a symbol of the totality of God's operations in the world. In scholastic theory and practice there was more sense of movement in and through time than was the case in the Neo-Platonism of Plotinus and Boethius. But the movement is that of an ordered sequence of liturgical experience which is regarded as a symbol of the total life of God in relation to His world.

Action. One of the most remarkable developments between the eleventh and the fifteenth centuries of our era was the growth of dramatic performances related to but expansive of the actual sacramental rites. By the end of this period the annual calendar was filled with special celebrations, tropes, miracle and morality plays, pantomimes, all related in some way to sacred tradition and the Church's worship. And every part of this activity was held to be symbolic of the endless sequence of events taking place in the world beyond man's ordinary senses: by its performance the life of the earthly society was lifted towards conformity with the blissful activity of the heavenly society while the soul of the individual was regenerated, shriven, healed, strengthened, sanctified and finally sent forward to enjoy its true destiny in the heavenly sanctuary.

At all times, indeed, the Mass retained its pride of place as the most important and most significant of all the Church's rites. This was the occasion when the one Sacrifice of Christ was re-enacted and scarcely any one doubted that only through the offerings of this Sacrifice could the sins of mankind be removed. But increasingly every detail of the liturgy came to be invested with some symbolic significance. As early as the year 1100 Honorius of Autun was writing in vivid language, comparing the setting and actions of the Mass with the theatre and its performance of tragedy. The silence of the celebrant symbolizes Christ's own silence when led away to slaughter. The stretching out of His arms symbolizes the Christ upon the Cross. His singing of the Preface symbolizes the cry from the Cross and so on. In the thirteenth century this interpretation of the Mass as symbolizing in every detail some element of the Christian revelation was taken up by successive writers until in the exposition of Durandus of Mende in the latter part of the century it reached its climax. For him the building in which the Mass was celebrated, the walls, the windows, the altar, the very mortar between the bricks, the sculpture: above all the office of the Mass itself are replete with

symbolism in every tiny detail. Every sentence and every cere-
monial act is charged with saving power. By exposing himself to or
by participating in the sacramental ceremonies man can be trans-
ported into the eternal world. In this way his true being can be
realized, for at least temporarily he becomes related to eternal Being.[1]

But this dramatic symbolism was not confined to the Mass and
the other regular sacraments of the Church. At special seasons of
the year—Christmas, Epiphany, Palm Sunday, Good Friday, Easter
Eve or Easter Day, Pentecost, to name only the most important—
dramatic interludes were added to the regular ceremonies, all de-
signed to heighten the impression which belonged to each of these
occasions in its own right. Such episodes as the running of the
shepherds to the manger, the adoration of the Magi, the Palm
Sunday procession, the deposition of the body from the Cross, the
journeys to the sepulchre on Easter morning, were all joyfully or
solemnly re-enacted and their perennial significance re-experienced.
The cycle of the ecclesiastical year like the cycle of the seasons came
to be regarded as regular and unchanging and men delighted to share
again in the familiar ceremonies which formed a stable framework
for their lives.

Gradually the interludes were expanded until they became ela-
borate ceremonies in themselves. The Deposition and Elevation
became increasingly realistic as a gilded crucifix or the host was first
taken to the Sepulchre on Good Friday and then recovered with
dramatic splendour on Easter morning. The popular ceremony of
the Paschal Candle provided unlimited scope for dramatic effects
with the extinguishing and rekindling of lights. So the process con-
tinued by which what had originally been choral accompaniments or
symbolic reinforcements became full scale plays. The cycles from
Chester and Wakefield and York and Coventry constitute some of
the most remarkable of the legacies we inherit from the Middle
Ages and reveal even more vividly than the stained glass the kind of
cosmic framework within which men of that period lived their
lives.[2]

[1] Cp. H. F. Dunbar, *Symbolism in Medieval Thought*, pp. 400–16.

[2] 'Everything in the dramatic play which grew out of the liturgy during the
Middle Ages is part of one—and always of the same—context: of one great
drama whose beginning is God's creation of the world, whose climax is Christ's
Incarnation and Passion, and whose expected conclusion will be Christ's second
coming and the Last Judgment. The intervals between the poles of the action are

Thus both in style of building and in patterns of ritual action a gradual change took place between the eleventh and the fifteenth centuries from a relatively plain and formal representation on earth of the perfect sanctuary with its eternal sacrifice in heaven to an increasingly elaborate and variegated symbolism in which terrestrial objects and events played an ever more prominent part, being expressive, as they were, of the structures of the total Divine organism in and through which man is integrated into the perfect life which knows no end.

Language. Professor C. S. Lewis once characterized medieval culture as overwhelmingly bookish and clerkly.[1] Manuscripts were treasured, studied, illuminated, laboriously copied. They were accorded absolute authority and it was the task of scholars to enter into the mind of an author and to interpret his insights to their contemporary world. Words used in these texts were regarded almost reverentially: they were symbolic expressions of ultimate realities which they could never entirely encompass but which they could, at least in their nobler forms, approach and represent.

As we have seen, the two supremely important books which men of the early Middle Ages studied were the Book of Nature and the Book of Holy Scripture. In the task of interpretation the chief

filled partly by figuration, partly by imitation of Christ. Before his appearance there are the characters and events of the Old Testament . . . in which the coming of the Saviour is figurally revealed: this is the meaning of the procession of the prophets. After Christ's Incarnation and Passion there are the saints, intent upon following in his footsteps, and Christianity in general—Christ's promised bride—awaiting the return of the Bridegroom. In principle, this great drama contains everything that occurs in world history. In it all the heights and depths of human conduct and all the heights and depths of stylistic expression find their morally or aesthetically established right to exist; and hence there is no basis for a separation of the sublime from the low and every day, for they are indissolubly connected in Christ's very life and suffering. Nor is there any basis for concern with the writers of time, place or action for there is but one place— the world: and but one action—man's fall and redemption. To be sure, the entire course of world history is not represented each time. In the early periods we have only separate fragments, most frequently Easter and Christmas plays which arose from the liturgy. But the whole is always borne in mind and figurally represented. From the fourteenth century on, the full cycle appears in the mystery plays.'—Erich Auerbach, *Mimesis*, p. 158.

[1] *The Discarded Image*, p. 5.

guiding principle was that of *levels of significance*. On the lowest level words could denote objects or events quite literally: rock stood for hard, visible material: Jerusalem for a city in the Middle East outside whose walls Jesus had been crucified. On the next level words could be used to convey important truths allegorically: a rock represented the stability of Christ, the Rock of ages, Jerusalem represented the church on earth, the community within whose embrace all could find safety. On a third level words possessed a tropological significance. Peter had a rock-like character, Jerusalem is the unified city of man's soul. Finally, and highest of all, words express truth anagogically, they lead up to ultimate truth: the rock is the foundation of the Kingdom of Heaven, Jerusalem is the perfection of eternal bliss. Through words preserved from the wisdom of the ancients man could ascend in imagination the mount of God and move through symbol to more adequate symbol and so towards the apprehension of ultimate truth.

Yet as during the twelfth and thirteenth centuries a new enthusiasm for learning began to appear, as man's confidence in his own powers of criticism and questioning increased, as he endeavoured to find ways of reconciling apparent contradictions in the works of ancient authors, the method of allegorical interpretation gained the greatest popularity of all. Allegory could be employed to interpret hard passages in Scripture and could also be used to build up edifying sermons and poems and plays. From the relative simplicity of the early Middle Ages we go forward to a period in which an intricate maze of allegorical correspondences takes shape, though the attempt is constantly made to hold the many detailed conceits within the one cosmic story of Creation, Fall and Redemption. By a skilful use of allegory almost any details in the books of Nature and of Scripture could be interpreted as elemental symbols of the one majestic divine organic life.

Interpretation was one major problem; memorization was another. Manuscripts were few and precious. The capacity to read was rare. How to remember accurately and comprehensively was a question which taxed the ingenuity of the scholars of the Middle Ages. Perhaps the one principle which proved most influential in this respect was that of always setting the parts within the context of a whole. To break a subject up into parts was helpful to memory, but only if the parts could be visualized within the total framework. Once an order could be seen, holding the parts together within the

whole, then the task of memorization could be greatly simplified.

What was constantly sought was the language-form which could be regarded as a 'corporal similitude'. The most familiar examples of parts-within-a-whole were the human body and the finished building. The more the language-construction could correspond to one or other of these 'wholenesses' the more easily could it be retained in the memory. Whether it were a lecture or a sermon or a great poem (the *Divina Commedia* is an outstanding example)[1] or a summa, knowledge of the parts could be corporealized in memory, they could then take on the character either of the members of a body or of visual images set in a great cathedral or of the actual structural parts of the cathedral itself. Before the coming of the printed book to serve as a supreme and readily available aid to memory, language had so far as possible to be 'structured' in visual form. Memory-room was a common term: a cathedral could be envisaged as a vast store-house of memory.[2]

For his interpretation of the world and of Scripture Augustine had drawn the visual forms of his total language structure chiefly from Platonic sources: in the later Middle Ages Aquinas drew his forms and methods from a more Aristotelian background. But in both cases language abounded in 'corporal similitudes', though in Augustine's case the focus of interest was the Divine attraction, in Aquinas' the Divine causation. In Augustine the similitudes are set in a kind of picture-gallery. Picture-language in Aquinas is taking on something of the character of the cinema.

[1] 'If one thinks of Dante's poem as based on orders of places in Hell, Purgatory and Paradise, and as a cosmic order of places in which the spheres of Hell are the spheres of Heaven in reverse, it begins to appear as a summa of similitudes and exempla, ranged in order and set out upon the universe.'—Frances Yates, *The Art of Memory*, p. 95.

[2] 'If Thomas Aquinas memorized his own Summa through "corporal similitudes" disposed on places following the order of its parts, the abstract Summa might be corporealized in memory into something like a Gothic cathedral, full of images in its ordered places.'—Yates, Op. cit., p. 79. In this section I have drawn on Dr Yates's fascinating volume.

RENAISSANCE AND REFORMATION
Symbols of Purpose and Communion

IN the thirteenth century, life in Europe had attained a remarkable degree of unification. Architecture, painting, music were all inspired by religious convictions: science, economic relations, political theory were all constructed within an avowedly religious framework. The system of images by which men represented the order of nature and the order of social relationships was entirely dependent upon and related to the transcendent world which constituted the ultimate reality. All that men saw with their eyes and heard with their ears on earth was mutable, perishable and mortal. Yet all in some way symbolized the unchangeable and the immortal. Man had the ability to classify, to connect and to systematize. What he had no power to do was to *change* in any radical way. God had created all things for His pleasure. It was for man to achieve his own true destiny by passing beyond the contemplation of the symbols to participation in the eternal reality to which they pointed.

The period between 1350 and 1750, however, was a period of major transition. The unity of the medieval world was disintegrating: the seemingly endless variations and diversifications of the modern world began to appear. It was a period marked by increasing facilities for travel and so of the gradual widening of the horizons of human experience. At the same time it was a period marked by a steady movement towards residence in towns and so of the gradual narrowing of man's acquaintance with the life of nature. The land, the all-important index of life and prosperity in the Middle Ages, lost some of its significance as trade and commerce increased and the towns became centres of collection and exchange. Moreover the whole realm of imagery associated with the life of the natural world—rocks, streams, birds, beasts, trees, flowers—began to be supplanted by more formal verbal structures appropriate to the bonds, contracts, transfers, commitments associated with an ordered urban commercial existence.

So far as movements of thought and imagination were concerned two influences became pre-eminent. What we have come to call the Renaissance in European life and letters was clearly inspired by the rediscovery of the splendour of the law and literature and architecture and visual art of ancient Greece and Rome. What is called the Reformation was equally clearly inspired by the rediscovery of the divine authority of the law and literature and verbal imagery of Israel and the apostolic church. The first led to a new emphasis upon the dignity and potentiality of man as *created* by God, the second to a new emphasis upon the calling and destiny of man as *redeemed* by God. The two movements shared in common a new hope and concern for man as such, but whereas the first thought more in terms of raising man to his proper dignity by leading him to the contemplation of the beauty and the goodness which had characterized a golden age of the past, the second thought in terms of restoring man to his proper destiny by calling him to renounce all false aims and allegiances and to find his true life in the knowledge and service of God alone. Yet the very fact that each was concerned with man and his life in the world made it possible for links to be forged with the aspirations and ambitions of the urban and commercial groups to which I have already referred.

I have set out these contrasts in what appears to be sharp opposition. Yet there were constant points of contact between the two movements and in certain places it would be hard to determine which had the greater influence. Nevertheless I believe that the new symbolic forms which captured men's imaginations during the period of transition from the medieval to the modern world derive their power *either* from their association with the culture of Greece and Rome *or* from the fact that they belonged to the world-picture of the Bible. And whereas in the former case the new symbols were in the nature of variants on those already established as familiar, in the latter symbolic forms came into being which so far as the experience of Western man was concerned were radically new.

The Reformers were seized with a compelling ambition and constraint: it was to restore church and nation to the pattern once for all set forth in the Word of God. In this pattern certain leading symbolic forms were readily discernible. The king, the covenant, the law, the sabbath, the house of God, the sacred meal—these were not just minor elements in the Biblical record: they obviously played an essential part in the organization of the common life. It is true that

amongst the Reformers there were differences of opinion about the degree of permanence to be attached to these symbols. But all were agreed that Scripture was the final authority and that this authority was not to be undermined by any appeal to allegorical interpretation such as had gained such popularity amongst scholastic theologians.

So far as reform itself is concerned we may conveniently draw out the distinction between the two main theories which came to be adopted by looking first at the symbolic pattern of a reformed *nation* with its dependent church and secondly at the pattern of a reformed *church* with its dependent commonwealth.

For the newly emerging *nations* the Biblical pattern of a society united under the leadership of a divinely-sanctioned symbolic figure—the king, the Lord's anointed—seemed exactly to meet the need of the corporate imagination. God had called a people to His obedience and set a king over them: in the Book of Psalms this king was eulogized and idealized in glowing terms: in the New Testament the Messiah Himself was given regal titles and regarded as the kingly ruler of the people of God. Here then was a symbol which appeared to possess full Biblical authority. If a nation was to be reformed according to God's plan the king or prince must obviously be given the place of supremacy and be made the focus of unity. He must hold sway over bishop and baron, priest and layman alike. He must issue laws consonant with 'God's Word written' for the due ordering of his realm.

Thus a new image had been set up and had gained wide acceptance—one king, one realm, one people, one royal law, one order of common worship, one pattern of doctrine—all dependent on the one book which had been recognized as of final authority for faith and conduct. The place however where this symbolism was immediately vulnerable—and Reformed Christianity has never been able to surmount this vulnerability—was in its assumption that the Bible itself provided a single symbolic system capable of providing a comprehensive and unified pattern for individual and social life. It soon became clear that other Reformers were equally devoted to and dependent upon the Bible and yet were drawing from it symbols for the control of social order very different from those, for example, which had been adopted in England.

For a second body of Reformers the reform of the *church* was the primary necessity: the civil community must pay heed to the law of God expounded by His ministers in His church and must direct

its pattern of life accordingly. To these Reformers the key-symbols of the Bible were the elect, the covenant, the sabbath-rest, the word spoken through prophet and minister, the new Jerusalem. Puritanism came to expression in Europe later than the philosophy of kingly supremacy. But each of these theories was designed to provide symbols of cohesion and purpose for societies seeking their own identity and freedom in face of immensely powerful forces operating within and outside of Christendom. One theory upheld the godly nation with the king as its central symbol, the other the commonwealth of the saints with the covenant as its central symbol. Each theory was formulated by men who appealed to the Bible as providing the ultimate sanction. The fact was that *both* were to be found in the Bible: it was simply a question of how, having chosen the one, the rejection of the other could be justified.

II

If there was one factor more than any other which promoted the vast changes in the European outlook which I have briefly described as Renaissance and Reformation it was the invention of printing and the new enthusiasm for literature. In order to explore the treasures of antiquity a knowledge of ancient languages was essential: in order to communicate the wisdom of antiquity to the common people translation into the vernacular was essential: in order to make translations widely and rapidly available printed copies were essential. So from pouring energies into building in stone men turned to the new enterprise of editing versions and translating into printed forms. And so far as the world of religion was concerned, although certain symbolic-forms were influenced by Renaissance studies, by far the greatest changes in symbolism took place as a result of the Reformation. It seems to me possible to distinguish four major patterns of symbolism emerging in the sixteenth to seventeenth centuries and I shall attempt to sketch each of these in turn. In spite of the great changes which began to appear in the seventeenth century these Reformation and counter-Reformation systems have retained an astonishing hold upon the human imagination. Without suggesting anything in the nature of watertight compartments I propose the following distinctions.

1. After the severe shocks of the sixteenth century the Roman Church set about the task of re-establishing its authority with

astonishing vigour. Not only did the Counter-Reformation see the removal of many abuses, it also saw the requickening of religious life in strict conformity with the general pattern laid down in the Middle Ages. The Pope was to gain new eminence as the acknowledged Head of the Church; the sacred ceremonies and usages were to be restored and elaborated: the dogmatic theology set forth by St Thomas Aquinas was to be re-studied and re-affirmed. A new discipline was to be enforced and the new order of St Ignatius Loyola would take a prominent part in the enterprise. Particularly in Spain and Italy men of enthusiasm and devotion would bend all their energies to the making of God's glory visible on earth through the splendour of the renewed life of the Body of Christ.

This was in essence the inspiration of the counter-Reformation. There were no serious doubts about the doctrine and ritual which had attained such impressive formulation in the thirteenth century. What needed to be remedied, men believed, were the greed, the laxity, the indifferentism, the luxury, which had marred the lives of individuals even in high places in the Church. And these would be overcome if there could be a new outburst of enthusiasm for Christ and His Church, a new determination to consecrate all human gifts so that the ultimate mysteries of the faith might be manifested before the eyes of men. To represent the authority and the glory and the immutability of God through visible and triumphal images became the overmastering concern of the leaders of the counter-Reformation. Buildings, paintings and sculptures, the mass and its music, processions and sacramental devotions—through structures and actions in which the divine order became visible through the very domination and manipulation of the material order a revival of true religion, it was believed, could be assured.

The most obvious illustration of the *building*, with its accompanying paintings and sculptures (and with its superb environmental approach) is the basilica of St Peter in Rome. All that confines and debases human life seems here to be symbolically overcome. The eternal world of radiant light and harmonious colour and proportion and design seems here to be revealed in one monumental symbol. The most obvious illustration of the ceremonial *action* is the total movement which by stages embraces the whole life of the community and in the climax of the sacrificial offering transforms that life through the symbolic change of the bread and wine into the Body and Blood of Christ. The *theory* of symbolism is in no way different

from that of the Middle Ages. The *practice* is more concentrated, more intense, more defiant. The whole conception of the changeless glory of the eternal God becoming visible to the eyes of men had been challenged and even denied. The leaders of the counter-Reformation, with the help of some of the greatest artists of all time, determined to re-assert the right of the earthly symbolic system—the Pope, the great basilica, the mass—to be regarded as the channel through which the transcendent life of God Himself is mediated to mankind.

In such an outlook symbolisms of time and of language partake of the same general character, though in a less obvious way. There are innumerable days of special celebration and yet in a certain sense all days are the same for all are days on which the sacrifice is re-enacted, the sacrifice which gathers to itself the virtue of the one Sacrifice enacted on the central day of the world's history. Similarly there are innumerable constructions of human language and yet again in a certain sense all language derives its virtue and meaning from the one Word spoken at the same central point of the world's history: 'This is my Body; This is my Blood.' In every respect the symbolism bears witness to unity and immutability and consequently to authority and high dignity.

2. The most imposing system established at the time of the Reformation in opposition to medievalism and the Roman authority was that of John Calvin. In place of a symbolism in which every familiar object and event in ordinary life was regarded as pointing to the realities of an unseen world, in which every thought of the divine sought expression through an image visible to the eye, Calvin developed a symbolism in which every part of Holy Scripture was regarded as pointing to the God who had declared His will and purpose for mankind through His Word, in which every thought of the divine sought expression through a word, written or spoken. Calvin's great achievement, Principal T. M. Lindsay once wrote, was 'to make the unseen government and authority of God, to which all must bow, as visible to the intellectual eye as the mechanism of the medieval Church had been to the eye of sense'. The book which, since the invention of printing, could be seen and handled and read by all in their own tongue was itself the supreme symbol of the God Who speaks; its words were all sacred symbols waiting to be interpreted and applied to the ordering of every aspect of human life.

I have spoken earlier of the way in which the teachers and artists

of the Middle Ages recognized *two* Books as the supreme media of
God's revelation—the Book of Nature and the Book of Scripture.
Whereas, however, the first was open to all men's eyes, the second
could be read only by the few: its substance could be transmitted to
the many only through the aid of pictures, stories and dramatic
actions. For Calvin the situation was entirely reversed. The Book of
Nature, he believed, had been constantly misinterpreted and dis-
torted and had ultimately been used as the excuse for unlimited
falsehood and superstition.[1] This being the case, man's situation is
hopeless unless there be some 'better help' to direct him aright, some
'light' to illuminate his darkness. But this indeed there is!

'Just as old or bleary-eyed men and those with weak vision, if you
thrust before them a most beautiful volume, even if they recognize it
to be some sort of writing, yet can scarcely construe two words, but
with the aid of spectacles will begin to read distinctly: so Scripture,
gathering up the otherwise confused knowledge of God in our minds,
having dispersed our dullness, clearly shows us the true God'.
Therefore to hear the Word, to read the Word, to be instructed in
the Word, to be led by the Word, to grasp the doctrine of the Word,
to be obedient to the Word—this is the chief and all-sufficient end
of man. The likeness of God, 'imprinted upon the most beautiful
form of the universe', has been 'insufficiently effective' to lead man
to the 'pure contemplation' of the divine. Yet now there is the Word
'where God is truly and vividly described to us from his works, while
these very works are appraised not by our depraved judgment but by
the rule of eternal truth.'[2]

Once Calvin had laid down these basic principles, the conse-
quences for symbolic representation and action immediately fol-
lowed. The words of Scripture were the only reliable symbols for
the mediation of the knowledge of God. Images of any kind were

[1] 'The fact that men soon corrupt the seed of the knowledge of God sown in
their minds out of the wonderful workmanship of nature—must be imputed to
their own failing: nevertheless, it is very true that we are not at all sufficiently
instructed by this bare and simple testimony which the creatures render
splendidly to the glory of God. For at the same time as we have enjoyed a slight
taste of the divine from contemplation of the universe, having neglected the true
God, we raise up in his stead dreams and spectres of our own brains, and
attribute to anything else than the true source the praise of righteousness, wis-
dom, goodness and power.'—Calvin, *Institutes*, I.5. 15.

[2] Ibid., 1.6.1–3.

forbidden by the Second Commandment. No buildings could be regarded as the dwelling-places of the Most High. No sacramental actions could be deemed to possess any efficacy of their own. Rather every outward form, every ceremonial action must be kept in complete subservience to the Word, to 'the ministry of the heavenly doctrine', to 'the preaching of the Gospel'.

What then is the significance of a church building? It is needed simply as a place of assembly, for God by His word has ordained that common prayers should be made by believers. There must be a convenient place where men can both hear the Word and make response together in their prayers. The *form* of the building is a matter of indifference so long as nothing detracts from the central dignity accorded to the throne of the Word of God. Normally the pulpit was set up in the place where all could see the supreme symbol and could hear its message. In this way, through a minimal use of visual symbolism, 'esteem, love, reverence and dignity' could be accorded to 'the ministry of the heavenly doctrine'.[1] And so far as sacraments were concerned those ordained in the Gospel must obviously be performed but always with the understanding that they were to be regarded as confirmations of a preceding verbal promise, as pillars resting upon the pre-established Word of truth, as mirrors of blessings pre-ordained for man by God's merciful declaration. 'As our faith is slight and feeble unless it be propped on all sides and sustained by every means, it trembles, wavers, totters, and at last gives way.' So through outward bodily actions faith in the soul may be confirmed and sustained. But they are not to be regarded as symbols of any other divine actions than those already disclosed by the Word of God.

Calvin's attitude to Sunday is entirely consonant with this complete dependence upon the Word. Seeing that the Ten Commandments have not been abrogated so far as their moral demand is concerned, Calvin regards the fourth as still mandatory, primarily to ensure that for all men a weekly day of rest is provided. (He makes special reference to 'servants and workmen'.) This day of rest is necessary for believers in order that they may 'lay aside their own works to allow God to work in them'. There is no special mystical significance in the day. It is part of God's provision so that decorum and order may be maintained in the church, the regular seventh day being used for corporate assembling together to hear God's Word

[1] Ibid., 4.1.5.

and to be trained in piety. In other words special days have no symbolic significance in themselves. They are simply useful functional devices to separate the ministry of the Word and rest from worldly recreations and work.

The worship of Reformed churches in the Calvinistic tradition consisted almost exclusively of verbal exercises—the reading of the scriptures, expository preaching, the singing of psalms, prayer with thanksgiving, religious oaths and vows. The only exception was the administration of the Gospel sacraments, each of which was regarded as a sign and seal of the covenant of grace. The Lord's Supper in particular was regarded as the bond and pledge of the communion of believers with Christ and with one another. Such a view of worship conformed entirely with the general pattern of secular life which so many of the Reformers pursued. This was a life of trade, commerce, exchange, banking, within the framework of civil law. In this context bonds, securities, agreements, contracts, were of paramount importance. In general these were established by spoken or written words but periodically they would be confirmed by the solemnity of sealing or the exchange of documents. Such imagery could easily be taken up and applied to God's dealing with men and to man's relations with God and his fellows. Out of the Reformed tradition have come confessions, constitutions, formulae of concord, books of common order, codes of ethics. Within the covenant there is, so far as man is concerned, no higher or lower in status. All stand before God to pledge their word to Him and to one another and thereby society is constantly renewed in an ordered stability. Once the book which bore witness to the nature of God's covenant with men had become available to all, an ordinary citizen could stand before rulers or kings with the assurance that he and they were equal within the terms of the divine economy and that no greater safeguard of liberty could be devised than a mutual bond expressed in words.

3. The counter-Reformation sought to re-affirm the triumphal symbols of the Middle Ages—the splendour of the Church's building, the timelessness of the Church's institutions, the all-embracing efficacy of the Church's sacrifice, the authority of the Church's formulation of doctrine. But what was to be the attitude of those who, while rejecting the sovereignty of the Papacy and the centrality of the Mass, wished nevertheless to preserve important structures from the past and to work out revised forms for use in the future? Of all the new nations of Europe, none developed a solution strictly

comparable to that of England. Partly this may have been due to its island character, partly to its distinctive language, partly to its particular social structure. At any rate in England the period between 1600 and 1900 was to witness a remarkable continuity in the life of the Church (with the one brief experimental break in the days of the Commonwealth) with slow adaptations to changing circumstances and with a slow evolution of symbolic forms related to the new knowledge becoming available through scientific and historical discoveries. Christianity in its Anglican form assumed the charater of a Reformed Catholicism sometimes veering more towards the emphasis of Catholicism on continuity with past traditions, sometimes more towards the characteristic emphasis of the Reformers upon renewal through the re-discovery of the Gospel. Through all changes it was held together and sustained by what could be regarded as its own distinctive symbol—the Book of Common Prayer—more than by any other single agency.

The attitude of the Church of England to church buildings was set forth in a definitive way by Richard Hooker. He agrees in a measure with Calvin that churches are to be regarded as places of assembly for the due participation of the faithful in common prayers. But whereas Calvin had been relatively indifferent to the 'atmosphere' of the building, Hooker constantly stresses the notes of solemnity and majesty, the care of external appearance, the holy and religious use for which the building is intended, the associations with the invisible presence of celestial powers, in short the beauty of holiness which to him is all-important. He sums up what could be regarded as a characteristically Anglican attitude in this striking way: 'Albeit the true worship of God be to God in itself acceptable, Who respecteth not so much in what place as with what affection He is served and therefore Moses in the midst of the sea, Job on the dunghill, Ezechias in bed, Jeremy in mire, Jonah in the whale, Daniel in the den, the children in the furnace, the thief on the Cross, Peter and Paul in prison, calling unto God were heard, as St Basil noteth, manifest not withstanding it is, that the very majesty and holiness of the place, where God is worshipped, hath *in regard of us* great virtue, force and efficacy, for that it serveth as a sensible help to stir up devotion and *in that respect* no doubt *bettereth* even our holiest and best actions in this kind.'

Hooker's appeal is not to any *theory* of symbolism but rather to the manifest power possessed by certain symbolic forms to elevate

the spirit of man and lead him to true devotion. A sense of majesty, a sense of beauty, a sense of holiness, a sense of apartness—these to Hooker are essential if the place is to serve as a real stimulus to prayer. *How* this sense is to be created he does not specify with any exactness. Perhaps the chief specification, which has brought many dangers to the development of religion in England, is the emphasis upon the severance of the building from all common uses. In this way the conviction has grown in the heart of the English that a building must 'look like a church', 'feel like a church', 'be set apart as a church'. Its relation to past experience thus becomes determinative: relatedness to present problems and demands can all too easily be evaded.

The history of English church architecture since the Restoration (and little had been attempted in the sixteenth and early seventeenth centuries) has been mainly one of revivals. Neo-Classical and what has been called 'domesticated Italian'[1] in the first part of the period, Neo-Gothic and what might be called transposed medieval in the second part. One man, Christopher Wren, dominates the late seventeenth and early eighteenth centuries, the Tractarians' influence became all-important in the nineteenth. Whereas Wren was inspired by the Reformed emphasis upon the centrality of the Word, the Tractarians sought in every way to recover the total ethos of sacramental worship. At its best the Anglican church-building has presented in visual form a combination of fidelity to the traditions of the past with adaptability to the demands of every new age.

The Anglican attitude to special days has been in some ways comparable to its view of special buildings. On the one hand there was a reaction against the medieval multiplication of fast days and feast days, of days associated with particular patrons and miraculous events: on the other hand there was an unwillingness to go all the way with the Puritans in their strict sabbatarianism, their ban upon Sunday recreations and upon all holy days other than Sundays. The characteristic way of the Anglican establishment was to insist upon attendance at divine service on Sundays and to allow reasonable recreation to be taken afterwards. It was the general *atmosphere* of the day that mattered. It must be different from that of work days but not too strictly bound within negative rules. To exercise the soul in divine worship and the body in lawful recreations—this was a sabbath well spent which would bring a week of content. And

[1] Horton Davies, *Worship and Theology in England*, III. 42.

although it was man's general duty to be thankful for God's mercies on all days of the year, yet it was also fitting that a small number of particular days should be set apart in the annual calendar to celebrate God's special mercies with thanksgiving and joy. Time in fact is to be regarded not in a strictly mechanical clockwise fashion. Particular days may have particular associations and it is only fitting that they should be celebrated and not swallowed up in a monotonous organization of man's total existence.

Symbolic actions and language have maintained a remarkable continuity by virtue of their dependence upon an authorized translation of the Bible into English and upon the Book of Common Prayer. Varying translations of parts or the whole of Scripture had been made in the fifteenth and sixteenth centuries by individual scholars, but it was the peculiar good fortune of the English that a final translation into their tongue was made after the new knowledge of Greek texts and Latin forms had been absorbed into their culture. In this way the definitive translation, produced by a representative group, could be regarded as an outstanding example of the influence of the new learning. Its rhythmic sentences, its balanced statements, its mixture of Latinity with the vernacular, are all in the tradition of the Renaissance. It became the supreme symbol, expressed in the language of the nation at a critical moment in its cultural development, of God's self-revelation to man. At the same time the Book of Common Prayer became an outstanding symbol to express the way by which man, in response to this revelation, could reach 'ripeness and perfectness of age in Christ' according to the will of God.

Anglicanism has its roots in the land and has sought to relate itself to the life of the whole nation. It has emphasized *growth*—in knowledge, in character, and above all in devotion. It has refused, in spite of many pressures, to limit religion unduly to exercises in the Word—to reading and preaching and praying and singing. It has sought to provide for the whole man—for eye and ear, for intellect and emotion, for worship and ethic. At an early stage in its history it declined to regard Sacraments simply as extensions of the Word or as merely visible media of instruction. Rather they were to be valued as (in the fine words of Hooker) sensible means by which it has pleased God to communicate to men those blessings which are incomprehensible. This did not mean that the unlimited range of medieval symbolism was to be retained. There must be a certain

limitation and control and the supreme agent for this control must be Holy Scripture. It was held that nothing in the Book of Common Prayer was contrary to Scripture. But symbolic forms—whether buildings, holy-days, ceremonial actions, prayers and sermons and hymns—were held within a controlled pattern provided partly by the Bible, partly by the teaching of the Fathers, partly by liturgical tradition, partly by the regularities of the natural order. The heritage of the past was to be pruned, purified, reduced, simplified, but by no means to be cut away, root and branch. Organic life is continuous, the symbols of organic life have a dependent continuity. So the ideal in Reformed Catholicism has been to live within a symbolic framework which allows for growth and a degree of change but which emphasizes the value of familiar symbols to procure sanctity and stability in community life.

4. Amidst the fierce reactions of the sixteenth century against what were regarded as the enormities of the medieval Church, there was a marked tendency to dismiss all its symbolic forms as a hindrance to true religion. The gulf was already appearing (which later was to gain theoretic formulation) between body and soul, between flesh and spirit. This was evident, not only in the outbursts of the Anabaptists but also in the more sober reflections of scholars such as Erasmus and Zwingli. Calvin, as we have seen, held firmly to the Word as the massive symbol of God's authority and purpose for mankind. The Spirit would operate only in and through the Word. But in the view of sectaries, the Spirit could operate freely, in wholly new ways, overturning existing institutions and bringing into being a new order in exact and literal conformity with that enjoined by certain selected texts from the New Testament. Erasmus and Zwingli on their part decried all use of externals in religion—Zwingli made much of 'The flesh profiteth nothing'—and sought to promote what they believed to be the pure spiritual religion of the New Testament itself.

To Luther the Word of the gospel of the grace of God was all-important and to this extent he was in firm alliance with Calvin. Yet it is clear that Luther and his successors in what might be called Evangelical Protestantism, presented and interpreted the Word in more varied and more comprehensively symbolic ways than was the case at Geneva. Whereas Calvin was sober, logical, severely intellectual, a master of abstract, legal language, Luther was fervent, vivid, strongly emotional, a master of the telling metaphor and of the

colourful language of everyday life. Whereas Calvin's concern was to build up an imposing system of authoritative regulations based upon the direct commands of God expressed in Scripture, Luther's ambition was to proclaim by every means available the Word of God's grace to broken and sinful men. For Calvin the Word had gone forth to call out the elect and to order their lives unto holiness: for Luther the Word had come into the midst of human life to proclaim forgiveness and the promise of eternal life to all who believed.

I have spoken of the 'feel' of Anglicanism for organic wholeness. A building, a liturgical performance, a prayer or sermon can symbolize harmony, dignity, integration and gather the total worshipping body within the experience. The genius of Luther on the other hand was to symbolize the resolution of inner conflict, the reconciliation of divergent interests, the correlation of past and present through words and through music. The building and the occasion were secondary to his major concern—how to represent in vivid and compelling language (whether verbal or musical) the total salvation which had been declared through Christ. If the building was hospitable to the human voice so much the better: if the day gave a space of freedom for the hearing of God's Word that was a great advantage. But these were secondary considerations. All his energies were poured into the discovery of word-patterns and voice-patterns which would symbolize the coming of God to men and would at the same time provide a symbolic path by which men could run to God.

To this end Luther projected himself in a new way into the actual experiences of the men of the Bible. He dismissed the allegorical interpretations of the Middle Ages as arbitrary and often meaningless. He entered into the struggles of Paul, of Jeremiah, of the Psalmist and felt them on his own pulses—the elation and dejection, the aspiration and defeat, the hope and despair. At the same time he entered into the lives of the common folk of his own day—the housewife, the miner, the peasant, the children. He then fused together in new and creative symbolic forms ancient languages and the vernacular, the experience of the Biblical protagonist and that of contemporary man, the salvation wrought by Christ and the deliverances wrought in ordinary human affairs. Everything was in dialectical terms, everything was expressed in the language of living interchange. Whether in lecture or sermon Luther was concerned to bring the good news of salvation, to which the Bible bore constant

witness, into the thought-world and the language-world and the feeling-world of the common man.

In this task no symbolic form seemed more directly powerful and serviceable than that of *music*. His is a different kind of music from that of Byrd and Tallis. It is the music of tension and struggle, of light and darkness, of clamour and gentleness. It may be heard in the very words which he used in preaching and lecturing but still more in the music which he composed or chose for use in the liturgy. 'Music', he said 'is a fair and lovely gift of God which has often wakened and moved me to the joy of preaching. . . . Experience proves that next to the Word of God only music deserves to be extolled as the mistress and governess of the feelings of the human heart.' He gave special attention to settings suitable for the Gospel and the Epistle in the Liturgy and arranged for polyphonic chorales to be sung by the choir. 'Music', he wrote in 1538, 'is to be praised as second only to the Word of God because by her are all the emotions swayed. Nothing on earth is more mighty to make the sad gay and the gay sad, to hearten the downcast, mellow the overweening, temper the exuberant or mollify the vengeful. . . . He who does not find this an inexpressible miracle of the Lord is truly a clod and is not worthy to be considered a man.'[1]

In music Luther found a symbolic form which could appeal to different religious and social traditions and could leap over national barriers. He was happy to take over good music from whatever source it might come. And by composing and collecting hymns he became, as Roland Bainton calls him, the father of congregational song. 'This was the point at which his doctrine of the priesthood of all believers received its most concrete realization. This was the point and the only point at which Lutheranism was thoroughly democratic.'[2] Obviously there was the constant danger that the exercise of religion would become confined to the feelings and would gradually lose touch with the hard realities of everyday life. There was the danger too of mass-enthusiasm in song with little relation to the realities to which the words of the song were related. Yet at its best in the succession marked by such figures as Luther, Bach, Zinzendorf, Wesley and Schleiermacher, music has served as the invaluable partner with language in the symbolic dialogue between God and men. God's

[1] These quotations are taken from Roland Bainton's excellent account of Luther's attitude to music, *Here I Stand*, pp. 340ff.

[2] Ibid., p. 344.

salvation comes as 'music to the sinner's ear'. The sinner responds:

> *My comfort is in what I heard.*
> *There will I hold forever.*

Or as Schleiermacher was to put it: 'What the word makes clear, music must make *alive*.'

Though the troubles of the seventeenth century allowed little scope for the development of static and settled symbols such as buildings and regular rituals, the preaching of the Word and the creating of new musical forms continued unceasingly. These were the characteristic symbolic activities of Evangelical Protestantism throughout the eighteenth and nineteenth centuries. Preaching, linked with other verbal exercises such as translating, expounding and story-writing: hymn-singing linked with other musical exercises such as the Passion and the Oratorio—through these the Word of God's judgement, forgiveness and grace and man's response in repentance, acceptance and faith were being constantly symbolized. It was a period during which man's alienation from his home-land, from familiar cycles of the natural order, from his traditional society, were becoming ever more apparent and acute. He needed re-assurance, warmth of a new fellowship, the challenge of new tasks. These, to a marked degree, the symbolism of Evangelicalism pro-vided. It brought the Gospel of early Christianity into the changing conditions of modern life through story and drama and song.

But it did this more by symbols of *contrast* in language and ritual-form than, as in Anglicanism, by symbols of *similitude*. The Anglican at his most characteristic emphasizes the total organism into which the child is grafted and in which the whole life of nature and of man is sanctified and fulfilled. In particular the Church in the Eucharist draws nature into its offering and receives afresh the life of God Himself to sanctify the community and its natural environment. Within the Lutheran tradition the emphasis has rather been upon the state of reconciliation which has been effected by God through Christ—through a sacrifice effective for all men and all situations. Man and nature have been redeemed through Christ. Now not only through the spoken word but also through water, bread and wine man can participate in the effects of that sacrifice. If the promise of redemption were proclaimed through word only it might be con-cluded that the reconciliation was directed only to the *mind* of man. But the Gospel is also concerned with man's body and the created

order on which he depends. Creation as well as man has been set free through the sacrifice of Christ. In Baptism and the Eucharist the total reconciliation is prefigured. Man and creation receive the Word of reconciliation simply yet dramatically and as man responds in faith a total harmony is momentarily restored.

Four large-scale symbolic systems established themselves in Christendom as a result of the great upheavals of the sixteenth century—what I should summarize as the monumental, the contractual, the organic and the covenantal. Each corresponds to a total world-view. Each possesses an impressive record of correspondence with community needs over the past four centuries. The question remains how far they correspond to the needs of today.

THE MODERN WORLD

Symbols of Experience and Fellowship

THE rise of modern science in the seventeenth century seems so important that it is possible to exaggerate its initial impact. Actually the symbolic system of Medieval Catholicism continued to dominate much of Europe, having come to renewed expression in the Age of Baroque and in the triumphalism of St Peter's in Rome. The Reformed Churches upheld an alternative system in which the Bible was the inspiration of all patterns of thought and conduct and symbols were legitimate and valuable only so far as they enabled the individual to relate himself to the purpose of God therein revealed for His faithful elect. The new studies in *history* and in *language* helped to strengthen this second system. Symbols could either point backwards to the works of God accomplished for man and his salvation in history or they could point forward to the predestined goal in the Kingdom of God. But though at first the new determination to observe, to examine, to understand and where necessary to experiment with the phenomenal world was confined to comparatively few, this was the enterprise which was destined to make such spectacular advances in the next three centuries that by the twentieth it was occupying a position in men's general outlook not very different from that held by religion in the thirteenth. Science and its partner technology provided the 'total backcloth' to human activity.[1]

What place could symbols occupy in this new kind of scientific enterprise? The whole object now was to determine quantity, measurement, paths of motion. For this purpose the symbolic codes of the Middle Ages and the images of the Bible were inadequate and inappropriate. It was the conviction of Galileo that the language-system to which the whole universe corresponded was the language of mathematics. Mathematics, then, must constitute the new sym-

[1] Cp. H. Butterfield, *The Origins of Modern Science*, p. 190.

bolic system of the scientist. To attain mathematical coherence must become his highest ambition.

Two famous passages from the writings of the seventeenth century make this clear. 'Philosophy', Galileo affirms, 'is written in the grand book, the universe, which stands continually open to our gaze. But the book cannot be understood unless one first learns to comprehend the language and read the letters in which it is composed. It is written in the language of mathematics and its characters are triangles, circles and other geometrical figures without which it is humanly impossible to understand a single word of it; without these one wanders about in a dark labyrinth.'

Numbers and figures—these are the 'symbols' by the use of which the universe can be represented, understood and manipulated. This is the new 'symbolism' whose importance will steadily increase in the new scientific era.

To give another example. Leibniz was convinced that the entire system of Nature was capable of being logically explained if only an adequate system of symbols could be invented. He therefore tried to formulate a calculus consisting of signs or symbols to be used in logical combinations for the solution of all problems related to the structure of the universe. This system he called the 'characteristica': his concern was to calculate, to quantify and so to explain. 'Leibniz's profound originality', Frances Yates has written, 'consisted in representing by appropriate signs, notions and operations for which no notation had hitherto existed. In short, it was through his invention of new "characters" (i.e. signs) that he was able to operate the infinitesimal calculus, which was but a fragment, or specimen, of the never completed "universal characteristic".'[1] No longer were mathematical symbols confined in their reference to static numbers and forms: they were now able to deal with speed and motion and position and to represent the laws of a mechanical universe.

Since the seventeenth century the importance of mathematics has steadily grown until today instead of theology (as was the case in the Middle Ages) mathematics has been given pride of place as Queen of the Sciences.[2] The relation between the abstract processes in the mind of a mathematician and the physical operations of a calculating machine has become steadily clarified: the correspondence between mathematical relations and physical operations in the universe

[1] *The Art of Memory*, p. 384.
[2] C. F. A. Pantin, *The Relations between the Sciences*, p. 4.

at large has become ever more accurately defined. It is true that Newton's ideal of exact configuration and quantification may seem to have been made impossible of attainment because of the recognition of indeterminate and random processes in nature. Yet in a remarkable way mathematics has proved competent to represent even these processes in manageable forms and remains the indispensable instrument for the control of probabilistic situations.

All this means that over the past three centuries a whole new world of 'symbols' has come into existence, linking the world of nature, of whose structures and energies man has become increasingly aware, with his own mental processes. These symbols (at least in the ideal and intention of their users) are of *universal* application—they cannot be regarded as the preserve of any particular human society: they are *unambiguous* in their reference—they cannot be regarded as varying in subtle nuances according to the whim of individual mathematicians. Mathematics is constantly in process of revision and extension; at times it may seem to be primarily a brilliantly executed abstract performance bearing little relation to the world which man observes and manipulates. Yet the urge to quantify and control phenomena by the aid of mathematical 'symbolization' shows no signs of slackening. Indeed the skilled mathematician is probably the key-figure in the technological world of the twentieth century. To speak of God as the Supreme Mathematician or as the Supreme Programmer of the Universal Machine seems the only way of meaningful discourse if we are trying to affirm the Divine origins of the universe as we have come to understand it in modern terms.

II

But whereas Galileo's and Newton's enthusiasm for mathematics as being the one essential language needed to represent and interpret public space and time led to scientific developments of incalculable significance, the urgent question still remained as to what was the relation between the seemingly private sensations of any particular individual—colours, smells, musical sounds—and the constituent elements of the public space and time which had been defined as mathematical and absolute. The concentration on mathematical laws and mechanical principles tended to set a Divine Mind over against matter, fashioning it and directing it in the way that man fashions and directs a machine. The material parts of the universe were

viewed as moving in vast empty spaces through paths determined by Divine Laws. This was a public open spectacle, enacted in a space and time which is the same for all, God and men alike.

But every individual also has his own private space and time in which he is affected by the impressions which impinge upon his own senses according to his own particular circumstances. The mind of God is primary and responsible for the creation of the laws which govern the whole of the universe and man on his part has the ability to apprehend these public laws with his mind and express them in mathematical 'symbols'. But in the other circumstances which belong to his life, in the midst of the multitudinous impressions which strike his senses, he seems to stand alone as an individual. He sees, he hears, he smells, he feels, but there is no guarantee that his experience of what may be called the secondary qualities of nature is precisely the same as that of his neighbour. The hard, measurable, primary qualities may be the same for all. The kaleidoscopic secondary qualities seem to vary from individual to individual.

Man's experience of the accidents or secondary qualities of natural objects had long constituted a major philosophical problem and it was to remain with him for many years to come. What, in any external object, may be regarded as its essence, its core, its public, measurable, dimensions in contrast to its variable, imprecise, privately apprehended characteristics? Are there innumerable atoms moving about in space quite independently of any human observer? And are there also innumerable units of mental substance in man which on being exposed to the material substances in space become conscious in various ways of heat, light, colour, sound and react with varying degrees of sensitivity to the impressions which they receive?

Although it took a long time for these questions to be formulated the general idea gained ground that two kinds of substance do in fact stand over against one another—the hard, impassive, objective material substances of the universe and the sensitive, impressionable, subjective mental substance of the individual. The universe of material substances, it was inferred, was subject to rigid, mathematical laws governing all its motions. In contrast the mental substance of the individual was independent of the existence of other persons and able to react to the external world in its own appropriate way. But there was no *essential* relationship between spirit and matter, between mind and body. The individual was at liberty to investigate the properties of matter and use them to construct his own mechanical

models. He was also at liberty to work out congenial patterns for the organization of his own personal life. But that the structures of the material order *necessarily* affected his spiritual state or the state of his society seemed unproven. There was no symbolic relationship between the two departments of his universe. Hard matter of fact and inexorable causation were the dominant constituents of the external world: in the internal world the soul could be awakened, improved, educated or it could be corrupted, perverted, lost.

All this meant that an ever increasing emphasis came to be laid on the individual human consciousness. Is this the repository out of which 'symbolic' forms emerge when stimulated by material substances? Are the colours, sounds, odours, temperatures which appear to the individual to be in some way constituent elements of his external world in reality 'symbolic' responses made by his own consciousness to the stimulus of the material substances belonging to public space and time? If so (and this theory has exercised an immense attraction to individuals who have in some way become conscious of their separation from the world of nature, as for example when imprisoned in urban and industrial environments), then in contrast to the public universal unambiguous 'symbols' of mathematics there emerges a new world of private, independent, arbitrary 'symbols' of the individual imagination. They gain particular expression in the most solitary of artistic activities—poetry, painting, and musical composition. In these the artist seems to be alone. He expresses his innermost feelings or consciousness through structured sounds and images. These may convey meaning to others, they may not. If they do, there is no clear or necessary relation to any phenomenon in the external world. The symbols employed are, it seems, products of the individual consciousness: there are no authoritative canons of social interpretation. Another individual is free to respond or not to respond to the symbol entirely in accordance with his own mood or whim.

An extreme individualism such as I have sketched cannot be accepted as a total interpretation of man and his world. Its most important element of truth, it may be suggested, is to be found in its emphasis upon the fact that every individual produces *some* distinctive symbolic form in the course of his human existence and makes it possible for this to be integrated into the totality of the world's symbolism. Just as every individual has a distinctive fingerprint, so he has a distinctive bodily structure: just as every individual

has a distinctive vocal spectrum, so he has a distinctive bodily energy. The structure and energy possessed by the individual are in part the product of his distinctive genetic code, in part of his response to his distinctive environmental conditioning. In all normal circumstances this structure and energy will gain symbolic expression through the particular pattern of his life revealed in action and in speech. This is inevitably integrated into the total symbolism of humanity even though in the case of the ordinary individual the effect and influence of his contribution may appear to be minimal. But the very development of techniques of human communication has made the potential influence of an individual style immensely greater than ever before. Today over against the skilled mathematician stands the skilled projector of some individual style or rhythm within the world of human communication. Over against the universal abstract 'symbols' of mathematics stand the individual, intensely explosive, 'symbols' of mass-culture. Here are two remarkable extremes, the one derived from the world-outlook of Newton, the other from the psychology of Locke, two geniuses in the scentific revolution of the seventeenth century.

III

The scientific and philosophic revolution of the seventeenth century was slow to make its influence felt in society at large. First individuals, then small groups, embraced the new theories but even then were slow to abandon the religious and social traditions to which by inheritance they belonged. The new ideas, being mainly concerned with nature and man's relationship to the universe, did not immediately relate themselves to man's life in society, though as attention came more and more to be directed to the consciousness of the *individual*, accepted patterns of social structure and behaviour were bound to be affected. How could a particular religious dogma or a particular social system be regarded as of eternal validity if full allowance had to be made for the consciousness and conscience of the individual? If man was gaining confidence to explore his world and the heavens and his own inner consciousness, could he not similarly explore the past and present organization of societies? If the old order had been breached, as had clearly been the case, what new theories of *social* order, what new symbols of *social* cohesion were available to take its place?

As we have seen, two main attitudes to man's historical past emerged in the sixteenth century. One was concerned to preserve the existing hierarchical order but to purge it of excesses and corruptions which had accumulated during certain dark periods of human history. The other was concerned to abandon an order which had proved repressive and reactionary and to substitute for it the divine ordering of society which it was believed had been once for all disclosed in the Biblical record. The first inclined to the view that social order was intimately related to the order of nature—to its stabilities and proportions and organic continuities: the second inclined rather to the view that social order depended upon men's willed consent to regulate their communal behaviour according to certain given patterns which, having been once expressed in archetypal form, could later be applied to every new eventuality which might arise.

These attitudes, first gaining general acceptance in the sixteenth century, began to be worked out in more detailed fashion as and when tools for investigating past history and techniques for making knowledge more easily communicable became available in the seventeenth. The former, stressing continuity, was able to make use of a reliable calendrical framework and to show how through a vast span of time, as it seemed, certain institutional symbols—the king, the priesthood, sacraments, the festal seasons, the essential laws of conduct—had remained constant in spite of all kinds of external change in the world around. Historians were continually collecting fresh information about past ages and the general picture of humanity's development in time was becoming ever clearer. But Catholic Christendom remained convinced that its traditional symbols were essential for the sustaining of unity and continuity within society. And even when the independent state sought to establish additional symbols of a secular kind in order to strengthen the fabric of social order, the religio-social symbols were rarely rejected at once, though they might through sheer neglect become obsolescent.

In the case of the latter of the two views which I have outlined, continuity was of far less importance. Adaptability to new circumstances was regarded as essential and this required willed cooperation on the part of all concerned. History revealed that periods of crisis and change had often occurred in the life of mankind—migrations, deliverances, exiles, re-formations, missions—and that when men found themselves torn away from familiar surroundings or unable to engage in regular ceremonies their communal life could

still be held together by their commitment to certain basic and simple symbolic forms—the Law, the Covenant, the Vow, the Sabbath, the Scripture, the Prayers. Historians might accumulate data and interpret the rise and fall of nations, the victory and defeat of armies, the enslavement and emancipation of classes, in terms of geographical or economic or technological factors, but Reformed leaders remained convinced that the basic Biblical symbols could still bind together the people of God and empower them for the particular tasks which He might call them to fulfil in any new age. If the state should become tyrannical and seek to enforce its will by creating new symbols to be acknowledged by all its members, the faithful could still maintain their integrity by renewing their own allegiance to the Covenant which called them to worship and serve God and Him alone.

Since the sixteenth century these two basic interpretations of the structure and operations of human society have vied with one another for acceptance as the norms of Western civilized life. The amazing scientific achievement of Thomas Aquinas seemed to provide an impregnable structural framework from within nature herself. The principle of hierarchy, governing the whole construction of the natural order, must, it seemed, be applicable to society itself. The principle of efficient casuality, binding together the whole physical world, must also operate in social relationships between man and man. These two principles were the all-important constituents of Natural Law and it is Natural Law which has provided the sanction for the order and the continuity which have been such impressive features of those societies which have retained their dependence upon and allegiance to the supreme Pontiff.

But where, as in England, what might be called a conservative Reformation took place, the chief factor tending to modify the Thomistic doctrine was the emotionally-grasped sense of national unity and national destiny. Patterns of unity and continuity could not be regarded as fixed *absolutely*. National boundaries might be adjusted, methods of work might change, breaks in the one universal order might gradually take place. Shakespeare and Hooker were no less insistent than Aquinas upon the necessity of *order*, but there were at least the beginnings of the recognition of change in history. In time the gradual extensions of man's knowledge of world-history and of the evolutionary processes operative in the natural world led to the construction of a more dynamic natural philosophy, stressing

still the principles of order and continuity but allowing also for
evolution according to processes of natural selection and for the
impact upon the universal order made by the new initiative of
individual leaders and their followers.

According to the second interpretation the amazing scientific
achievements of Galileo, Kepler and Newton seemed to provide a
universal structure within which an almost unlimited freedom of
operation for the human will become possible. If nature could be
conceived as a vast impersonal cosmic machine, operating according
to the laws of mathematics, and man could be conceived as possessing
a soul substance having no necessary relation to the vast mechanical
whole, then man, it seemed, was free to make what arrangements he
deemed most suitable for the organization of his social life. It is true
that those who believed that the Creator of the cosmic machine had
revealed His will for society through an inspired verbal revelation
felt bound to commit themselves to one another in the way that had
been ordained for them in the Sacred Book. They rejoiced in their
freedom from the authoritarian system of Natural Law but found a
new principle of social cohesion in willingly agreed conformity to the
terms of the Divine Covenant through which God had manifested to
mankind what was the quintessential pattern of social cohesion.

The importance of the covenant-symbol in the sixteenth–seven-
teenth centuries can scarcely be over emphasized. Men realized, as
they read the Scriptures for themselves, that the covenant had been
determinative in the call and subsequent career of Abraham, in the
ordering of the community-life of the emancipated Children of
Israel, in the reformation under Josiah, in the hoped-for restoration
foretold by Jeremiah. Moreover Jesus Himself had made a covenant
with his disciples and this covenant could be constantly sealed and
renewed in the sacrament of the Lord's Supper. Here was a symbol,
authorized by the history of God's people, which the Bible provided,
assuring men that God was to be known not as some far-off divine
autocrat but rather as one who bound Himself to men by covenants
of command and promise and who thereby provided them with the
foundation pattern of their own communal life.

But although the rule of the Saints according to the Covenant
once for all formulated in Holy Scripture seemed to many an attractive
alternative to the absolute authority of the Roman system, it was not
long before the sheer realities of man's life in relation to the physical
universe, coupled with the growing realization that the application of

historical methods to the Biblical record must inevitably lead to varieties of interpretation and application, brought about a relaxation of the absolute character of the Biblical revelation and the establishment of new Constitutions related to the actual demands of living situations. The most obvious illustration of this new development may be seen in the process which culminated in the Declaration of Independence by the American people on 4 July, 1776. In limited communities, such as existed in Geneva, in Leyden and in Boston, the all-inclusive pattern of social cohesion could be found in the Covenant inscribed in an infallible book. But for the organization of larger and more heterogeneous societies, experiencing varying conditions in their physical environments, compelled to depend upon one another for mutual security and welfare, something far more flexible was needed.

The basic principle of free commitment within the Covenant was in no way abandoned. As recently as January 1965 the American President could still speak in his inaugural address in terms of the Founding Fathers having made 'a covenant with this land. Conceived in justice, written in liberty, bound in union, it was meant one day to inspire the hopes of all mankind. It binds us still.' Yet the Constitution sought to allow the widest possible exercise of individual liberty, particularly in regard to the establishment of freely-willed social groupings whether ecclesiastical, educational, political or economic. None of these however could be granted an *absolute* authority for the operation of its own (admittedly freely-determined) commitments. Provision must be made for the relation of the group to the total society, for possible changes in physical and geographical conditions, for emergencies such as threats from outside to the nation at large. A written constitution, though an immensely powerful social symbol, is always in danger of becoming rigid and inflexible as in the case of the religious *contract* described in the previous chapter. Unless adequate provision can be made for changes which the onward march of the historical process (or of the pursuit of happiness) must render necessary, the constitution can become petrified just as really as the pyramid or the sphinx.

In countries retaining the strongest ties with *Catholic* culture emphasis has always lain on the ordering of social life according to *Natural Law*, with necessary modifications for growing knowledge of the structures of the natural order and for actual change in social relationships brought about by historical crises; in countries maintaining the strongest links with *Protestant* culture the emphasis has

rather lain on *Covenantal* or *Constitutional Law*, with necessary modifications for growing knowledge of the structures of man's life in society generally and for the continuities in the world of nature which inevitably limit complete freedom of social experimentation. The intertwining of these two emphases in Western civilization since the seventeenth century has greatly complicated the picture so far as the relation of symbols and society is concerned. Moreover a further complication has arisen in that the altogether dominating influence of religion in society through the thirteenth–seventeenth centuries has progressively declined during the period in question and today is probably dimmer in *feeling* and weaker in *intellectual theory* than at any previous time. It is this which makes the task of estimating the significance of the Christian Symbols which survive in our contemporary world so difficult to gauge. The importance of mathematical symbols is universally acknowledged: the appeal of certain artistic symbols is still immensely powerful. But the need for and the nature of *religious* symbols remain highly debatable questions.

IV

It remains to indicate briefly the effects upon religious symbolism which the developments, intellectual and psychological, of the seventeenth century, have actually produced. In the realm of pure reason and scientific observations and mathematical operations the consuming ambition was to integrate all knowledge within one encyclopaedic system. The universe would then be seen to be a vast harmonious structure whose modes of behaviour could be mathematically ordered and expressed. There was no need for traditional symbols to point to invisible realities. The constituent elements of the universe could be directly represented by mathematical symbols and their paths in space and time accurately determined.

If such a system could be gradually established in some kind of encyclopaedia of 'characteristica', the only place that remained for the mysterious, the indefinable, the unknowable was that which belonged to God Himself, the Creator and Sustainer of the universe. The early scientists did not doubt the existence of God as designer, creator, first cause, sustainer, goal-definer. If He was transcendent to His universe it stood to reason that He could not be finally grasped within any construction of the human intellect. He could only be spoken of in 'symbolic' terms, 'symbolic' here denoting that which

has some connection with human experience but forever transcends it. This means that in this context the only true religious symbol would be that used to name or direct the attention towards the One on whom the universe depended for its origin, its ordering and its end.

Within a Newtonian view of the universe it was impossible to envisage any other religious symbol for, *ex hypothesi*, all created elements were concrete objects pursuing their paths in the great empty areas of public space. But this ultimate religious symbol could take on various forms. The One could be spoken of as the Clock-Maker, the Designer, the Mathematician, the Mechanic. Or the symbol could be expanded in verse as in Addison's hymn:

> *The spacious firmament on high,*
> *With all the blue ethereal sky,*
> *And spangled heavens, a shining frame,*
> *Their great Original proclaim.*
> *The unwearied sun from day to day*
> *Does his Creator's power display*
> *And publishes to every land*
> *The works of an almighty hand.*

If all phenomena are expressible through accurate definitions and logical relations, then although the instruments of the analysis may be called 'symbols' they in fact point only to phenomena within the system itself—not to presences or activities or mysteries not capable of being expressed within the logical system. The only true 'symbol' is the word 'God' or its variants such as the One, the Ultimate, the Creator, the Architect, the Mathematician. It was a natural consequence that those who embraced the Newtonian scientific worldview and made it their ambition to construct a coherent logic of the universal machine, should have adopted a form of Deism or of Unitarianism or of Pantheism if they retained a desire to stay within a religious rather than a purely secular frame of reference. The worship of the One, conceived through symbols of transcendence which expand in proportion to man's discoveries of the wonders of his universe, is an exercise which man can engage in with integrity of mind even though it may often seem to be unrelated to other vast areas of human experience.

In contrast to the relatively few 'intellectuals', there has been a far larger number within the expanding scientific and industrial

civilization of the past three centuries who have been relatively un-
concerned about any comprehensive rational interpretation of the
universe but have sought satisfaction for their *emotional* needs and
anxieties in face of the perplexities which rapid changes have pro-
duced.

Of all these changes the most far-reaching in influence have been
emigration and industrialization. In each case vast numbers have
been uprooted from the land to which for centuries their ancestors
had been attached. However poverty-stricken conditions of life may
have been within this land, there has at least been a sense of security
and continuity through family and home. But the lure of betterment
politically or economically was too strong to be resisted and long-
standing domestic ties were broken. Wave after wave of the poor, the
oppressed, the adventurous, the curious, the hopeful went out to
seek their fortunes in other lands or in other forms of work.

It is true that most of the seventeenth-century settlers on the
North American continent carried with them the symbolic forms of
their European religious traditions—the Bible, the Book of Common
Prayer, books of religious devotion, catechisms—and quickly estab-
lished ministries and forms of worship such as they had known
before. But as the volume and speed of population movements in-
creased in the eighteenth–nineteenth centuries vast numbers were
involved who had no first-hand acquaintance with symbols of the
Word and whose relation to the symbols of the old natural order (the
village church, the festal seasons, the solemn celebrations of birth,
marriage and death) had now been virtually broken. The effect upon
human feelings was shattering. Old symbolic forms which had served
to produce coherence and control no longer existed. What new forms
could take their place?

In general the answer was: Forms which proved effective in actual
experience to reconcile and re-order human feelings within a co-
herent symbolic structure. Environmental conditions were new,
patterns of work were new, the rhythm of human living was new.
The major religious symbols for this new age proved to be a new form
of preaching and a new form of musical response. The sermon had
been important in Elizabethan and Commonwealth days but it had
then consisted mainly in the exposition of Scripture and its applica-
tion to public life. Now the new preacher was the *evangelist*. He was
mobile and flexible in his approach. He sought out lonely and rootless
individuals wherever they were. He declared to them the way of

salvation, a way conceived primarily in terms of the need of the individual soul. He spoke the language of the people and used images familiar to them. He preached with warmth and earnestness and lively comparisons. He so concentrated on the relation of God to the lost, the broken, the guilty, the lonely, the fearful, as to restore to men a sense of self-identity and hope. The essential Gospel which told of the coming of Christ into the very midst of conditions not unlike those of the new countries and the new cities, undergoing stress and strain and suffering comparable to that of many newly displaced persons, dying to one order of life and being resurrected into a new condition of freedom and power—this Gospel proved to be a symbol of immense effectiveness amidst the mixed populations of the new industrial age. It presented in dramatic symbolic form a sequence with which the human individual could identify himself. And those who had once identified themselves in faith with the saving purpose of God symbolized in the Gospel could then join themselves with others who had undergone a similar experience and a fellowship of the redeemed could come into being.

Together with the new form of preaching, a form which was vivid, dramatic, personal, a new form of corporate musical expression took shape. Wherever men were situated in space or time they could unite with one another in psalms, paraphrases, chorales and above all in hymns. Thus the essential ingredients in the new pattern of symbolic religious activity were the dramatic preaching of the sermon and the dramatic recitation of hymnody. With no knowledge of the theories of John Locke, individual souls found their feelings of alienation and anxiety controlled and re-orientated through the use of these new symbolic forms which expressed outwardly the resolution of the soul's conflicts and often led in turn to an inner reconciliation.

As mills and mines and machines proliferated in the north of England, as industrial towns leapt ahead in population and in monetary resources, comparatively little attention was given to those exercises of the human spirit which call for comprehensive vision, for expansion in space, for evolution in time, for corporate expression in and through regulated bodily activities. Instead attention was concentrated on emotive words and rhythmical sounds. People gathered together in buildings which allowed little play for visual exercise or bodily movement but which provided all that was necessary for sitting to hear and standing to sing. In such close togetherness words could almost be felt, emotion could be quickened and sustained. In

the process of hearing comfortable words and singing uplifting songs something akin to ecstasy was experienced. Away from the drabness and squalor of the week-day bodily environment, men and women could feel the warmth of their spiritual fellowship in Christ. They could taste already the delights of heavenly bliss as they heard afresh the message of redemption and sang of the precious blood by which their spirits had been cleansed.

It was an age of growing self-consciousness and self-confidence: it was also an age of social experimentation and social manipulation. Symbols which expressed and confirmed the individual's relatedness to God, symbols which promoted the spiritual integration of up-rooted individuals in God—these were deeply valued. In the main these symbols were colourful and rhythmical and harmonious *sounds*. They might be words alone, they might be words set to music. Alike they tended to separate the soul from the hard realities of ordinary secular existence. In a day when life in the world was all too often rigid, oppresive, mechanical, merely functional, such a policy may have been valuable, almost inevitable. But if times and ideas should change in such a way as to challenge the dichotomy between body and spirit, between hearing and seeing, between sacred and secular, between individual and society, then the inadequacy of this view of the nature and function of the symbol might well become apparent. The dominantly psychological would need to be set in a wider context.

SYMBOLIC STRUCTURES OF SPACE

SHORTLY before the opening of the exhibition of her sculptures at the Tate Gallery in 1968 Dame Barbara Hepworth gave an interview in which she remarked: 'I think the feeling of space comes before anything else'. In 1966 the architect Denys Lasdun, speaking of his work in a broadcast, said: 'the important thing about buildings of the past is the character that they give a place . . . without a sense of place there can be no sense of belonging'.

The feeling of space, the sense of a place—these are two basic human experiences which the artist struggles to express in a controlled outward form. In an intense and highly concentrated way this constitutes the work of the sculptor. But in a more general and more functional way this is pre-eminently the concern of the architect. He constructs models of space, contracting the immensities, but at the same time stretching up towards the transcendencies. Similarly he designs models appropriate to a particular place, honouring the past, but at the same time stretching out towards the future. It is my purpose in this chapter to explore those two basic experiences and the forms by which they have come to be expressed in more detail. In prehistoric times it was the sense of place which can be assumed to have figured most prominently in the human consciousness. There was no lack of space. Small tribes wandered over the great open plains or from oasis to oasis in desert regions. They hunted wild animals or in due course pastured their domestic animals on the sloping hills. The sky and the horizon were their only limits. But in such an open environment one all-important concern was the defining of significant places. A particular place might be an assured source of water-supply or a natural centre for safe-resting or a promising base for the acquiring of fresh supplies of food. Or it might have been associated with some particular manifestation of mysterious power—an encounter with storm or with a strange animal or with a supernatural presence. If a place had taken on special significance of this kind in the realm of the given, then it needed to be marked, remembered, recalled. A

great stone or a heap of stones could provide an obvious and easily constructed symbol which possessed the quality of permanency. A stake or pillar of wood, though easier to handle and decorate, was more vulnerable to erosion or decay.

Of all places which needed to be recalled to memory none could compare in significance with those in which a god himself or his emissary had manifested his power. The vivid Old Testament records of Jacob's dream at Bethel or of his wrestling with the angelic visitor at the ford Jabbok or of Moses' confrontation by the bush which burned with fire but was not consumed are sufficient to show how men with no fixed habitation associated special places with the divine presence. 'How awesome is this place!' Jacob cried; to Moses came the word: 'The place on which you are standing is holy ground.' Such experiences could easily awaken a sense of responsibility to fence in the sacred place and protect it from all profane uses. The very mountain on whose slopes a theophany had occurred could be regarded as a sacred mountain. A pillar, an altar, a high-place, a mountain; a pyramid of stones, a tower, a zikkurat: these were some of the symbolic forms which celebrated a sense of place. At the spot marked by one of these symbols the Divine presence had been revealed to a chosen man on a particular occasion. Henceforward it was a place to be remembered with awe and thanksgiving.

Possibly no single place has held so exalted a regard in the memories and devotion and anticipation of a whole people as has the summit of the sacred mountain of Zion. In Hebrew history various traditions tell of the significant events associated with the hill on which Jerusalem is built. It was captured by David, it became the centre of his kingdom, it was the place where God appeared to him, it was crowned by a sacred stone sometimes viewed as an altar, sometimes as the foundation-stone of the temple. In course of time this sacred hill and above all the rock at its peak came to be regarded as the centre of the whole universe,[1] the meeting-place of heaven and earth, the embryo from which creation grew, the spring from which the final regeneration of the world would be effected. Past and present and future have certainly been held together in the holy city of Jerusalem. But has man's potentially valuable and inspiring sense of a place here been pushed to such a limit as to become an obsession? Has the foundation-stone in Zion, instead of symbolizing the manifestation of a living presence to be constantly recalled, come to

[1] R. J. McKelvey, *The New Temple*, pp. 188ff.

represent the exclusiveness of the particular people to whom the manifestation was originally made?

The sense of a place can enrich and deepen human sensibilities. The symbol celebrating a particular place can bring together past and present in living relationship and strengthen hope for the future. It can stir the hearts of all kinds and conditions of people to realize that the living God has made Himself known to men in judgement and in grace. At the same time, unhappily, the symbol can be made to turn in upon itself, to become confined and concentrated within its original limits. The symbol then becomes a monument. It may still provoke admiration. It in no way leads to the worship of the living God.

In contrast to the sense of a place I have set the feeling of space. Psychologically it seems natural that when man is free to roam and wander as he will the balance of his emotions will be preserved by attachment to some cherished and relatively settled place. On the other hand, when he at length puts down roots and establishes an ordered community life within a particular area, something of the longing for the open spaces and for the freedom of his spirit is likely to revive. The benefits of civilization are such that few can resist their attraction. Yet the feeling for space cannot easily be quenched.

As we try to reconstruct the likely stages by which the ancient river-valley civilizations grew and developed, it seems obvious that the all-important factor was the dividing-up and parcelling out of the land available in manageable units. The area which had been inundated or which was at least open to irrigation was by no means unlimited. It had to be organized according to the labour force available for tilling, sowing and watering. But there must also be places for families to eat and sleep, to talk and trade and play with one another, to bury the dead, to engage in the duties of religion. Thus the total land-space was used in such a way as to provide sufficient for the production of the crops and at the same time to give space for domestic and public dwellings.

With gradual increase of population and consequent pressure upon land-space the natural inclination was to turn in imagination upwards and to look for a symbol which would in some way express man's aspiration for the beyond. Even the modest hut which housed the peasant and his family established the principle of reserving space for the minimal needs of human existence. And as society became organized in a hierarchical way—the way which best corres-

ponded, it seemed, to an agricultural economy—it was natural for
those higher in the scale to enjoy larger designations of space and for
the king-emperor to be granted the most extensive establishment of
all. Finally the house of the god, inasmuch as he was regarded as the
sustainer and integrator of the whole populace, must be allowed com-
plete pride of space. The temple must be spacious enough, in fact,
to include the whole complex of officials and activities which were
ancillary to the divine presence and mediated his energy and author-
ity to every department of the life of the city-state. In its most
impressive forms the ancient temple was a model of the heavenly
order, a total environment which provided a transition between man
and cosmic wholeness. It brought the immensities of space under a
certain control: at the same time it extended man's vision beyond his
immediate concerns to a realm of perfect light and life.

As has constantly been the case in human history, advances in
efficiency and durability of organization led in the ancient river-
valley civilizations to an over-emphasis upon the massive and the
monumental. Stone was readily available as building material. In the
dry climates of the Mediterranean it was little subject to erosion.
With growth of population and cheapening of labour vast building
schemes could be taken in hand. And ultimately the temple and the
palace within the walled city or the zikkurat and the pyramid on the
flat plain seemed to provide the epitome of strength and stability and
permanence. Yet the very character of monumentality and imper-
meability easily led to isolation from the natural environment to
which they had originally been related. In any organic system all
parts must maintain an active inter-relationship and the symbol
which expresses the living whole in abstract form must include possi-
bilities of adaptation to changing circumstances if it is to survive. If
no such flexibility exists it must sooner or later decay into irrele-
vance and a new symbolism must be found to take its place.

II

Christianity, in the first three centuries of its history, was given little
opportunity either to celebrate attachment to a particular place or to
externalize the organization of a particular space. Affection for the
earthly Jerusalem and the temple on Mount Zion had soon to be
transferred to a heavenly Jerusalem and a spiritual temple. More
even than Jews of the Dispersion, Jewish Christians were pilgrims

and strangers with no continuing city. It is true that they cherished
memories of the precise locations in Palestine where Jesus had taught
and healed and revealed His glory but there is no record in the first
century of any attempt to celebrate the sites as sacred. The place of
witness, wherever it might be, was the symbol of the place where the
Lord Himself testified and was crucified.

As far as the organization of space was concerned one early form
took on deep significance. It was, in the Gospel phrase, 'an upper
room', large enough to contain a substantial gathering, but always
within the semi-privacy of an ordinary dwelling-house. It was a
room into which the faithful temporarily withdrew, in which the
Lord's presence was specially manifested, and from which there was
a going-forth constantly into situations of stress and even danger.
For the moment it was small in dimension but it could aptly symbo-
lize either the growing body or the expanding temple, terms applied
to the Church as a whole by the apostle Paul.

For three centuries Christians had little opportunity to engage in
church-building themselves, though they lived under the shadow of
the marvellous architectural achievements of Greece and Rome.
When at length the Empire adopted the new faith and a new freedom
of expression was granted to the Christian society, the East began its
symbolic organization of space which was to culminate in the glory
of Hagia Sophia, the West, slower in progress, coming at length to the
noble achievements of Chartres and Salisbury. All this took place
within an agrarian economy and a hierarchical organization of
society. East and West held different theories about the relationship
between the respective heads of Church and State, but each was intent
upon organizing a total structure in which man and nature, society
and the land, human needs and the fruits of the earth were inti-
mately related to one another. Perhaps the East was more concerned
to build *into* nature, the West to build *out* of nature, but the depen-
dence upon rock and soil, upon moisture and fertility, upon slow
maturation and extensive preservation was common to both. The
superb organizations of space achieved in and through the great
churches of medieval Christendom symbolize the organization of a
whole society, rooted and grounded in the land, growing like trees
which have been duly watered and fed, tended and controlled by one
all-embracing providence, attaining its perfection ultimately in the
realm of the unseen and the eternal.

In such a context, where every separate element is integrated into

a single inter-connected whole, there is little disposition to focus attention on one particular place. Wherever the bread and wine are transubstantiated the Divine Presence is realized in a special way. And when the sacrament is reserved the focus is still more clearly defined. But there may be many altars in a great cathedral. The eucharistic sacrifice may even be offered outside its walls. Hence the symbolic representation of a single meeting-place of God and man in history did not belong to the conception of Christianity which characterized the Middle Ages. The consecration of space rather than the celebration of a place was the key-concept guiding the expression of religion at the time. The great church gathering into its symbolic wholeness the materials of a specific environment became a model of the heavenly sphere in which Christ the great High-Priest offered His perfect sacrifice in the presence of God.

The Renaissance and the Reformation brought little that was creatively new into the realm of church-building. The Roman Church moved further in the direction of the monumental and reached its apogee in the splendour of St Peter's. At the opposite extreme Calvin showed little interest in buildings as such. They were useful as places of prayer and of declaring the Word of God. They were dangerous and deceitful to the faithful if they contained images or other visual objects which could be regarded idolatrously. Luther was less severe. All the arts could be used in the service of God and there was no need to destroy medieval buildings or embellishments so long as a proper priority was accorded to the preaching of the Gospel through word and action. In England there was less emphasis on preaching. Existing buildings were taken over and re-ordered for the saying of the new liturgy and for the promoting of the new communion of the people. Often this created difficulty, for the great abbey churches and cathedrals had been designed within a different framework of reference. Probably few of the Reformers realized how great was the symbolic power of a total building. It was widely assumed that if a good building were already in existence all that was necessary was to take it over, remove anything offensive in its furnishings and then adapt it to a new use. That a building in itself could be a microcosm of a total religious outlook was seldom realized.

That which assumed far greater importance at the time of the Reformation was what I have called the sense of a place. Especially amongst Lutherans and Calvinists the pulpit took on an altogether

new significance. There had been, it is true, a revival of preaching in Catholic circles in the late Middle Ages but this was kept strictly within the bounds of authoritative sanction and orthodox doctrine. But now the Law and the Gospel were to be proclaimed simply as authorized by God's Word written and as related to man's salvation. The pulpit now became the place of God's special revelation. The preaching of the Gospel need not be confined to the assembly of God's people on the Lord's Day but it was nevertheless believed that on this occasion the glory of the Lord was revealed in a quite unique way: through His Word God spoke to His people and the place of this speaking was indeed 'holy ground'.

III

The invention of the telescope, the sail and the mariner's compass were to have revolutionary effects on man's conception of space and these changes received theoretical confirmation through the new mathematics of the seventeenth century. Man could now explore a vastly extended terrestrial domain: he could survey with his eyes remote objects in the heavens. Instead of the great dome of the sky resting upon pillars—a concept which he could himself represent by a small-scale model: instead of a great building gathering to itself its surrounding environment and thrusting it up in symbolic form towards the vault of heaven, man was now to become aware of an indefinitely expansive empty space in which vast numbers of material bodies journeyed on tracks which man could observe and represent in graphical form but which did not lend themselves to expression within any kind of symbolic building. The 'feeling' of space gained an altogether new intensity. The problem was to give it 'form' in any kind of three-dimensional way.

Again, man's sense of place was bound to be transformed in the light of his new discoveries. Even supposing a quite unusual event had happened in a particular place or that a more-than-human presence had been manifested in a particular spot, what reason was there to imagine that any permanent quality of sacredness henceforward belonged to this site? In the new conception of matter every object had its individual location and was made up of atoms which at least in their primary qualities did not differ essentially from one another. How then could there be any permanent configuration of the sacred? How could collections of atoms have any intrinsically

'holy' character? Did not the sense of a place depend simply upon individual or corporate memory or upon some agreed convention regarding the use of a particular spot?

The most obvious effects of the new scientific outlook so far as buildings and locations were concerned could be summed up in the two words functionalism and romanticism. As new industries began to develop, new buildings had to be erected to house machinery and to give shelter to workers. Sites were chosen according to the requirements for fuel, water and transportation and the major considerations were economy of expenditure and efficiency of output. Similarly churches began to be built to provide maximum seating for the minimum of expenditure and to ensure the necessary facilities for preaching, singing and fellowship, the religious activities which meant most in the rapidly growing cities with their populations drawn from far and near. Just as a house was designed as a machine for living in, so a factory was designed as a machine for operating in and a church or chapel as a machine for meeting in. It was for the mind and spirit of man, it seemed, to subdue and use material things in the most practical way possible.

But although in the new and industrial environments this bias towards functionalism and towards an increasing control of the material world was both natural and inevitable, in more traditional and sophisticated circles the tendency was to search out impressive models from the past and to reproduce them in modified or slightly modernized structures for the new age. It was the beginning of the great age of historical research. Two notable styles of architecture captured the nineteenth-century imagination and neo-classical or neo-gothic became almost mandatory for church architects. As Winefride Wilson has caustically remarked: 'With few exceptions the church architect of the nineteenth century hankered after a dream world that never was while bridge builders and rail-road engineers seized the initiative that should have been theirs.'[1]

It is easy at this stage to criticize the builders of the eighteenth and nineteenth centuries who had the task of constructing a symbol of the totality of space or alternatively of a place of significant en-

[1] *Christian Art since the Romantic Movement*, p. 42. Cp. pp. 26–8. It is perhaps significant that the two secular illustrations are taken from the world of communications. In that world the church was more related to movements of the times. In the matter of *community buildings* the secular architect was often no more successful than the religious.

counter, but in point of fact their task was of almost unparalleled difficulty. Europe after some four millenia of a relatively settled agricultural economy was being projected into the industrial age. The more mobile elements of this society—the traders, the bankers, the merchantmen, the adventurers—were being forced to come to terms with wholly new means of communication and transportation. In each case human energies, human plans, human controls were assuming ever larger significance and the quest for specifically religious symbols became ever harder to satisfy. No longer was God referred to as the Divine Architect. The most famous analogy which emerged from the period was that of God as the Divine Clock-Maker, but a church could hardly be built in the form of a clock—though the clock in the church-tower could be regarded not only as a common utility but as in some sense a community-symbol. Similarly in a rapidly expanding world it became less and less possible to return with any frequency to some particular hallowed place. Occasionally it might be feasible, but only with difficulty could an architect give symbolic expression to this need (as I have defined it) of the human consciousness.

Perhaps the functional and the romantic were the only viable practicalities in the nineteenth century. New community needs had to be met with the resources available at that time. Yet some continuity with the past had to be maintained unless the presence of the living Christ in former ages was to be repudiated. Men looked back and saw periods of creativity, of heroic virtue, of integrated life, and believed that these had been blessings bestowed by God Himself. To imitate the forms in which these gifts had been expressed was a natural impulse and whatever mistakes may have been made, the legacy of the nineteenth century does not deserve to be entirely jettisoned. It is a solution, however, which could not gain acceptance today. Bare functionalism and nostalgic escapism are alike antithetical to our present understanding of God's activities both in nature and in history.

IV

What then can finally be said about possible symbols of space and place in our contemporary world?

The first, and in many ways the most searching question, is whether the Church has any right to ask for or to acquire by purchase

or to defend by litigation its possession of *any* defined space in the world today. The question has its parallel in the field of mass-communications where 'space' is exceedingly costly and the ways and means by which the voice of the Christian can be heard at all are exceedingly complex. But does it benefit the Christian witnessing-community to have a definite 'slot' of space allotted to it without having to struggle to make its voice heard within the common arena of life? Can the Church, in other words, afford any longer to occupy given but segregated space? Should it not rather seek to be in the midst of the common ways of life, simply as a community with a special and overmastering loyalty to God and with no privileges of separate, undisturbed space of any kind?

This was a question which powerfully exercised the mind of Dietrich Bonhoeffer towards the end of his life. 'Are there', he asked, 'really no ultimate static contraries, no spaces which are separated from one another once and for all? Is not the church of Jesus Christ such a space, a space which is cut off from the world?' By framing his question in this way, Bonhoeffer was appealing to a tradition which extends backwards in time before even the birth of Christianity. A community attached to and dependent on the land has always deemed it right to set apart a particular spatial enclosure to be devoted to the god of the land. There has been sacred space and profane space. On the sacred space, structures from the utterly simple to the richly elaborate have been erected to correspond symbolically to the nature of the Divine possessor of the land. But that there should be a certain division of space has rarely been questioned. For the sanctification of the land and its occupiers a particular space must be reserved and used for holy purposes.

With the coming of a new industrial system and the growth of population, land-values in particular areas tended to increase and the automatic setting apart of a site for religious purposes was by no means taken for granted. It is true that the tradition in Catholic Christendom had become so strong that even dominantly secular communities hesitated to refuse space to a religious body which requested it. But if granted, the site was viewed in the nature of semi-private space to be used for the satisfaction of a dedicated few rather than for the sanctification of the total community. And as secularization increased and space became more limited, the question whether the Church could any longer expect to be granted the privilege of reserved space became ever more acute.

This was Bonhoeffer's final answer: 'The church does indeed occupy a definite space in the world, a space which is delimited by her public worship, her organization, and her parish life, and it is this fact that has given rise to the whole of the thinking in terms of spheres. It would be very dangerous to overlook this, to deny the visible nature of the church, and to reduce her to the nature of a purely spiritual force. It is essential to the revelation of God in Jesus Christ that he occupies space in the world. . . . The church of Jesus Christ is the place, in other words, the space in the world, at which the reign of Jesus Christ over the whole world is evidenced and proclaimed. It is the place where testimony is given to the foundation of all reality in Jesus Christ. . . . *The space of the church is not there in order to deprive the world of a piece of its territory*, but precisely to prove to the world that it is still the world, the world which is loved by God and reconciled with Him. The church has neither the wish nor the obligation to extend her space to cover the space of the world. She asks for no more space than she needs for the purpose of serving the world by bearing witness to Jesus Christ and to the reconciliation of the world with God through Him. *The only way in which the church can defend her own territory is by fighting not for it but for the salvation of the world.*'[1]

Bonhoeffer saw the problem clearly but there seems to me to be some confusion of thought in his answer. The space in the world occupied by Jesus Christ was simply that which His living body needed for its day to day activity. So far as we know, he owned no property, had no responsibility for land or production, did not even possess a house or home of his own. But he went about doing good, teaching, healing, rebuking, comforting. In this way the 'reign' of God was evidenced and proclaimed: in this way men and women were reconciled to God. It would, in fact, be more accurate to speak of the ministry of Jesus Christ in terms of our second category—the sense of a place. In the place where He acted—and this is true of any particular place in Palestine or of His total saving career in its historical manifestation—there was a meeting of heaven and earth, of God and man, of the Divine succour and human need, of the Divine command and human obedience. And it is in acting in His name to heal and reconcile the world that the Church manifests the presence of God in a particular place. To the reconciled person or

<hr>

[1] The quotations are taken from a valuable chapter in John A. Phillips' book: *The Form of Christ in the World*, pp. 137f.

persons that place is henceforward sacred, memorable, set apart. But no absolute quality belongs to this sanctity. As in the case of Jacob at Bethel a symbol may be erected to commemorate the encounter and the blessing. It will ideally be of a form consonant with the reconciling grace and this means above all the form of a continuing presence alongside others in sharing and service. From time to time there may be a return to the place where reconciling grace was experienced, but more fittingly the movement is forward from place to place, each place bearing the same symbolic pattern though never the same precise detail, the pattern of a life-situation reconciled to God through the humanity and the passion of His Son, Jesus Christ.

But to affirm this with full conviction does not, it seems to me, exclude the possibility of space being occupied by the church in her service of the world. The world needs not only to be taught and healed and reconciled: it needs to be renewed in life, to be nourished and sustained, to be ordered and properly inter-related and to this end it needs symbols of organic wholeness as well as of creative re-conciliation. Though, as I have already remarked, Jesus did not own property or undertake responsibilities within the community, He constantly in His teaching depicted the life of man-in-society as comparable to that of the natural order governed by the providence of God. The total inter-relatedness of the processes of nature, the total inter-relatedness of the processes of the human body, both point to an ultimate wholeness of which the Church as Body of Christ can herself serve as symbol. But she can be a symbol only insofar as she is related to the world in all its structures—not in occupying a space set apart as a model to be at best imitated, at worst ignored.

No model of the Church has held a more persistent or more honoured place in Christian history than that of the Body. Its employment as a symbol of a total society is not original to Christianity, but its development has been more extensive and detailed than is the case in any other context. In a remarkable way it has been intertwined in the human imagination with a second symbol, that of the temple-building, and this has facilitated the expression in spatial form of a structure which can act both as a place of assembly and re-creation and as a symbol of living growth and integration. The Church, in the teaching of Paul, is both temple and body, a building with foundation, corner stone and superstructure, an organism with many members, joints and the head. In this teaching the apostle stretches back to images of a total society formulated in

Egypt, India, Greece and Rome: he stretches forward to developments which are of the greatest significance in our own contemporary world.

The dual model of temple-body combines visual stability with co-ordinated movement. If too great emphasis is given to the first aspect, the building and the society and the total world-view symbolized becomes static and moribund: if too great emphasis is given to the second, the symbol fails to provide a sense of rootedness and security. Even so the danger is greater from the former over-emphasis seeing that priority must always be accorded to life, its renewal and expansion. Yet it is easier to organize and control a stable structure and it has always therefore been tempting to adopt the fixed building as the model for society and to suppress the organic elements which symbolize continuing life. In particular the architect finds it easier to design models of a geometrical kind whose shapes and stresses and constructional problems can be calculated with precision rather than those of a physiological character whose interconnections are complicated and flexible.

Within the world-view of the eighteenth–nineteenth centuries it was possible to organize and build a city of separate units—houses to live in, factories to work in, shops to trade in, schools to teach in, churches to worship in. According to the Newtonian–Lockean atomic individualism these units could operate efficiently as material structures without necessarily affecting the mind and spirit of man which, it was held, transcended material things. So a church, far from being integrated with the total life of the community or from providing moral guidance for its corporate activities, could be regarded simply as a convenient place of assembly for like-minded persons desiring to engage in particular forms of spiritual exercises. The building could be little more than a box amongst other boxes so long as it provided facilities for sitting and listening or standing and singing.

But such an overall conception is no longer viable. Biological and evolutionary models have assumed increasing importance. Even physical models have taken on the character of inter-related systems rather than of conglomerations of independent units. In our present understanding of the universe no structural form can be isolated within a sealed compartment. This means that a building shaped in an architect's mind and constructed on a prepared site without regard to the environment, natural and social, within which it is set

constitutes a complete anachronism. Only within a wide-ranging complex, only as part of an organic wholeness, can any building be assured of continuing vitality and usability. And this must above all be true of a religious building. Indeed its only, final justification for being denominated a 'religious' building is that it is organically related to every other building within its natural and social environment. And to be organically related does not imply domination or outward splendour but rather unimpeded connections for communication and service towards wholeness.

What I have sketched in this summary fashion can be confirmed by appeal to the speeches or writings of some of the leading architects of our time. For example, Reyner Banham in an address to the R.I.B.A. in 1961 urged that architecture must give the closest possible attention to the most powerful discipline of its own day, namely Human Science. In former ages it could be guided and influenced by philosophy or physical science or history, whichever was dominant. Today the human sciences are everywhere in the ascendant. Perception-studies, genetic-studies, sociological-studies, environmental-studies, communication-studies: all are concerned with the make-up of man and with his relation to his environment. Man gains an ever greater control over his environment, but the environment constantly increases its influence over man. It has been said that we make our buildings and then our buildings make us. In other words the day of the abstract theoretical blue-print has passed. The building must be made for man and in some respects even must resemble man. Man must flow into his surroundings and his surroundings, including his buildings, must be such as to expand and quicken his total life.

In his address Banham made special reference to schools and hospitals. Here architects have become specially conscious of their responsibility to involve themselves imaginatively in the needs and attitudes of those who will occupy the buildings. Such basic needs as light, colour, ordered space, ready channels of communication, temperature control, freedom to grow, quiet to rest, are characteristic of the human body itself but must also be incorporated into the living environment. In other words the more a building can include features which belong to a living organism the better it will serve as a suitable sphere of existence for the human person.

But if this is true of the school and the hospital should it not be even more true of the church if the church is indeed the symbolic

building which points towards the integration of man and society and the natural world? No longer is it necessary for the church to seek to achieve this integration by sheer size—in the perspective of the microscope a molecule can appear to have the dimensions of a universe. No longer need there be the passionate search for materials which will endure indefinitely or for techniques which will guarantee impermeability—man the destroyer is still stronger than man the creator. A church, if it is a true symbol, provides a model of man's universal environment within which man's activities towards God and his neighbour can be symbolically co-ordinated. The Middle Ages found it fascinating to imagine the church-building as a body, but the conception of the body was dominantly static—a fixed bone-structure within which members were distributed in due proportion and were graded according to the importance of the activity which each performed. Today no such static view is tenable. The body is a vast communications-system and in that sense is a microcosm of the universe itself. The body can only live insofar as it is in constant relationship with its environment and this relationship is only possible within conditions of spaciousness and flexibility. A church building then should live in relationship to its environment and if it becomes plain that no such relationship any longer exists it should be destroyed: the Christian witness to death and resurrection applies to buildings as well as to men. At the same time it should provide space for co-ordinated movement and communication within its own system—and if any legacy from the past is obstructing such movement and communication in the present, it too should be destroyed. The sense of space becomes real and intense when the conviction is born that the church is a vital part of a larger whole and that the pattern of its own order is a symbol of the total Divine cosmos.[1]

[1] In a recent article Gilbert Cope surveyed the progress of church architecture over the past 50 years and asked what patterns the future was likely to bring. In response to widespread mobility and change in society at large he detailed these likely developments in church building.

'Some "churches" are likely to be demountable temporary structures, some will comprise a suite of rooms in a large building block, some will form part of the amenity buildings of a town centre, some will be denominationally shared, some will consist mainly of housing for a group of "ministers", many will be system-built by consortia of ecclesiastical authorities, some will be incorporated in new schools or other social institutions. None will be built to last longer than the houses around it and all will be "serviceable" centres of Christian living.'— *The Times*, 14 Jan., 1967.

I have already touched upon the importance, in Christian witness and tradition, of the sense of a place. The solemn meeting with Jesus in the upper-room became a paradigm for much of early Christian worship. A room in a house large enough for the assembly of the faithful: a table as a place of offering and distribution: a designated seat for the president—these were the essentials and remained such until the fourth century A.D. and the beginning of the Church's great expansion. Thereafter the sense of personal meeting tended to decline and greater emphasis came to be laid on symbolic objects—the altar, the throne, the cross, the painting in the apse—and these became ever more prominent as foci of attention and devotion by the use of such devices an enlargement, elevation, embellishment and heightened illumination. When relations between the members of the congregation were less directly personal and intimate, the emphasis on the outward object to serve as focus of vision and devotion was natural and inevitable.

But the urge to renew commitment to a common purpose, to celebrate a common interest by coming together in one place and engaging in common exercises, has manifested itself again and again in the course of Christian history. Monks and friars, guilds and crafts, colleges and schools, pilgrim adventurers and journeymen, wayfarers and warfarers —all such have framed their buildings more directly for activities of inter-relationship than for rituals of a more impersonal kind. The style of the large-scale building may be in accord with the fashion of the age but the chapel or small church or meeting-house used by the specialized group will have scope for intimacy and for personal meeting which is not readily sensed in the church of the whole community.

As a result of the great change which took place at the time of the Reformation, many cathedrals and parish churches in Europe were taken over and re-ordered so that they might become centres in which the whole community might be instructed in and disciplined in the Word of God. Here the emphasis was less upon personal meeting, more upon a direct submission to the law and doctrine of the true God. Now the all-important symbolic objects were the pulpit and the Bible resting upon the pulpit desk or upon a separate lectern. Devices were once again used to intensify the significance of these focal objects—height, lighting, an over-arching canopy, richness of carving. The ordained minister performed the liturgy in the pulpit rather than at the altar, but the participation of the total con-

gregation was on the level of obedience to prescribed rules rather than of a full personal participation in the celebration of common interests and purposes.

Since the coming of the era of toleration at the end of the seventeenth century, church buildings have arisen in vast numbers in most parts of Western Christendom, but especially on the North American continent. The altogether characteristic feature of these churches has been their concentration upon worship as *meeting*. It is all important for the faithful and their families to come together, to be renewed in a common purpose, to sing together, to engage in charitable works together, to learn together, to aspire together. The shape of the building has been important as promoting the sense of togetherness but there has been little emphasis upon focal external symbols. Most commonly a charismatic individual has been accorded the central position in leading the worship and his ability truly to meet with his congregation through word and gesture has been the measure of his success. To countless individuals in the eighteenth and nineteenth centuries new lands, new experiences, new occupations, new homes gained order and significance and became manageable because of the existence of a place of worship, a place of vivid community participation, a place where they could meet fellow-Christians sharing their own particular social outlook and using the same language about matters of ultimate concern. In most cases the architecture as such was quite undistinguished. It was plain, functional, economical, often a rather pathetic attempt to emulate traditional patterns. But it was a Bethel, a Zion Chapel, an Emmaus room, a Patmos retreat. Here in a heightened way men joined with one another in celebrating what God had done for their souls through Christ.

The growth of cities, the expansion and increasing mobility of population, the advance of standards of living, the revolution in methods of communication have all tended to weaken the sense of the symbolic character of a particular place. Older generations may cling to memories of past experiences associated with particular church buildings, but their successors move on and find no resting-place. The reunion at the family home or the college campus or the fair-ground is fading in significance. The regular coming-together in a particular theatre or concert-hall is largely a thing of the past. Today the chief occasions for coming together in one place are the conference, the convention and the special celebration. Large numbers are often involved and various ways have to be devised of

organizing the assembly within smaller units. But normally some meetings at least take place in which all are involved and this has led to the erection of large tents or to the building of tent-like structures by means of modern methods and materials. Where a large Cathedral-like building exists it can discover a new role within this context and can become, like Jerusalem or Mecca, a centre of pilgrimage for the great occasion. But Jerusalem and Mecca each possessed a sense of history. Each was regarded as a place where God had met with man in a special way. It is far from easy in our modern world to join the facilities for meeting belonging to a historical site with the needs of those who desire to come together for conference and celebration.

'The main problem of modern church building', Abbé Debuyst has written, 'is probably to find the type of real house which today offers the deepest and most human kind of hospitality, and to think how best to adapt it for the purpose of church architecture.'[1] Perhaps I may be allowed to substitute 'conferences' for 'architecture' as the final word of the sentence. The desire to meet together for special conferences shows no sign of abating. The occasion of meeting can be of decisive importance in the life of a group or of an individual. But the place and the configuration and arrangements of the place are of quite exceptional significance. The time to be spent is relatively short. The centre should be such as to promote easy communication and participation for all concerned, a sense of space and relaxation and quiet, above all a sense that this is a place where men have met with one another in the presence of God and that God has come near to them through a renewal of His revelation in Christ. The focal point may be a chapel or a room of quiet, a simple cross, a kneeling figure. No such places can be guaranteed as holy by human hands or by human designs. In other ages other conditions may have promoted the sense of place. But for today I think Debuyst is right. Wherever in a parish-church situation or in a cathedral-situation or in a common-enterprise situation or in a holiday-conference situation a deep and sensitive hospitality exists and expresses itself in symbolic form, whether in dining-room or conference-room or worship-room, there the Christ of the Emmaus room is present and at least one *place*, in this vast unbounded universe, becomes transfigured with light.

[1] *Modern Architecture and Christian Celebration*, p. 31.

This little book seems to me one of the most perceptive and constructive of all modern treatments of the subject.

SYMBOLIC STAGES IN TIME

IN the life of the agriculturist the periodicity of seasonal rhythm is of outstanding importance. He is well aware of fluctuations in weather conditions and of disasters wrought by marauders and pests, but normally he can depend upon the phenomenon of *repetition*: 'seed-time and harvest, cold and heat, summer and winter, day and night' do not cease. This is his basic experience of *time*. Even death in its varied manifestations can be held at bay through this assurance. The sun dies at night but rises again in the morning: the moon dies at the end of the month but soon re-appears: the crops die at the end of the year but spring brings a resurgence of life. A time symbol is designed to celebrate this 'periodicity of the seasonal rhythm' and to defy what appears to be the irreversibility of time.

On the other hand in the life of the hunter or the nomad it is the meeting time that is of primary importance, whether this meeting be with a god or an animal or with a fellow-human. Many encounters may appear to be no more than casual, many events of only fleeting interest. But certain meetings take on the character of turning-points—from failure to success, from bondage to freedom, from anarchy to order. Time is punctuated by these decisive happenings. How the meeting comes about may be of minor importance but once the event has occurred and its consequences in a measure realized, celebration takes place through some *time memorization-symbol*. In the encounter death in some form seemed imminent. But death has been overcome and life has assumed a new significance. The past experience recalled in the celebration becomes not the experience of one life only but that of many generations.

In each of these contexts man has tried to establish some kind of order within the totality of his experience, past, present and future. But the process has never been a simple one. He has constantly been exposed to the danger of making this order too rigid, too inflexible. For example the Maya civilization of Central America used stone not only for their temple pyramids but also for their public calendars.

'They carved astronomical and calendric information, and possibly historical data too, on their *stelae*, which served as annals carved in stone. These stones reflect the Maya preoccupation with time. Astronomy or astrology was studied by priests as an aid in measuring time, for predicting the future, or for fixing the propitious dates for sacrifices or important undertakings.'[1] Such a calendar was regarded as universal, unchanging, detailed and obligatory. Instead of serving as a means of providing order in social life, it easily became the means of establishing a tyrannous control over social life. And what was true for the Mayan empire was true also of the Babylonian and Roman. Designed originally to serve the needs of a dominantly agrarian civilization, the calendar became oppressive and restrictive, a means of imposing an imperial will. It is not without significance that amidst modern reforming movements in the Roman Catholic Church, the revision of the calendar in 1969 was intended, it was said, to remove a large number of annual celebrations which were held to be 'universal and obligatory' and to allow them to be classified henceforth as regional and optional.

On the other side the danger is that of 'freezing' a particular symbolic occasion into pure sterility. Nowhere has this been more obviously achieved than in Pharisaic Judaism. The Sabbath, early interpreted as marking the encounter with God in the decisive covenant-making ceremony, became the regular weekly occasion for the cessation from the burdensome toil of secular days. But the desire to make Sabbath different from other days easily developed into a rigid separation of Sabbath from all the ordinary concerns of life. Every moment in it was related to the Law which governed man's relations with God. Again, intended to be of service to man in the ordering of his time-experience ('the Sabbath was made for man') it became oppressive and restrictive, a means of subjecting man to what was claimed to be a Divinely-given order ('man made for the Sabbath'). And what gained expression in late Judaism has been reproduced in certain forms of Puritanism, in Seventh Day Adventism and in other modern exclusive sectarian forms of Christian piety.

These four possibilities of time-symbolism were all represented in the major groupings of Western Christendom in the sixteenth century. All regarded Sunday as a day of symbolic importance: about the observance of other days there was wide variety of theory

[1] *The Listener*, 25 April, 1963, p. 710.

and practice. Whereas the Roman Church insisted upon the celebration of a host of holy days, fast days and saints' days, the Church of England severely limited the number of such days for special observance and concentrated its attention upon providing a calendar authorizing scripture-reading, psalms and prayers for every day of the year. In Lutheranism there was preaching and singing on weekdays as well as on Sundays, but in Reformed circles the tendency was to concentrate heavily on the obligations of the Lord's Day, with the assumption that prayer and scripture reading would be the daily practice of families in their homes, but that work would command the full attention of the community as such. The Lutherans continued to celebrate major festivals but in the Calvinistic tradition they found little favour.

For all, Sunday was the essential time-symbol. For all, its claims to regular observance were firmly grounded in the Genesis Creation-narrative and in the fourth of the Ten Commandments. The very beginnings of the created order included a rest day: every week of the present order should include the same. But the question still remained of what nature that rest should be. It could not surely be complete inactivity. It must include activity directed towards God. And whereas in Roman and Anglican circles this activity was conceived primarily in terms of the offering of sacrifice and prayer and praise, amongst the Lutherans and Reformed the emphasis was rather upon proclamation and response. The corollary followed that whereas for the first pair, the 'rest' of the eternal world to which Sunday pointed included movement and colour and general rejoicing, for the second it was associated more with solemn assembly, with the memorial of redemption, with complete abasement before the holiness of the Divine majesty. For the first the general experience of time was conceived as being fulfilled in symbolic form through the celebrations of an earthly Sunday, in reality in the joys of paradise: for the second, time gained symbolic meaning in and through the redemptive exercises of an earthly Sunday, its full final meaning in the new heaven and the new earth in which toil and labour would no longer be necessary.

II

The crucial question which now arises is how far this general Christian attitude to time as it came to be formulated in the sixteenth

century—a considerable degree of unity in regard to Sunday, but a variety of attitudes to the other days of the week, especially in the matter of their festal observance—is any longer viable in our present stage of history. At the time of the Reformation the relative slowness and steadiness of the agricultural cycle was already being affected by the accelerating pace of life in trading and manufacturing circles. In the latter context decisions have to be made more quickly, for the spirit of competition is abroad and the man who decides quickly, even at personal risk, is more often than not successful.

In these circles, too, the invention of more accurate means of time-measurement was of outstanding significance. In the Middle Ages the passage of time was marked by the ringing of bells, by the movement of the shadow on the sundial or in rare instances by water-clocks. But in the fourteenth century counterpoise clocks brought the beginning of the mechanization of time and in the middle of the seventeenth century the invention of the pendulum clock marked a further notable advance. By the year 1700 London and Geneva were the two chief centres of the clock-making industry (it is of some significance that Calvin's sense of historical destiny was communicated to a city which was to produce such fine craftsmanship in the manufacture of clocks and watches), and life, it was said, was being cut into little pieces. The universe, Kepler affirmed, was similar to a clock. God, men were saying, was the supreme clockmaker. The *consciousness* of time—its passage, its division, its measurement, its value—was steadily increasing in the community and with the making of watches the individual could construct his own time-schedule in a way which had never before been possible.

It would be difficult to exaggerate the importance of the clock in the history of the Western world over the past three centuries. Man now possessed an instrument by which he could organize time for himself and, if he had the necessary power, for his fellow-men. Small-scale enterprises could indeed be carried on without undue attention to time. Anything on a large-scale, however, demanded regularity, synchronization and proper divisions. All these the clock made possible. But not only was man now able to organize his own time without being dependent upon the given-ness of water, the movements of sun and moon and measurements sanctified by tradition. He became more and more conscious of time as associated with the large-scale impersonal process of the industrial machine.

The clock was, in a sense, the master-machine. Other machines could be geared to it. And man himself could not fail to be conscious of his own dependence on machines within the increasingly impersonal, man-created system.

But the new scientific attitude of the seventeenth century was to bring about another revolution in man's conception of time. At first scientists worked within the generally accepted framework of an ordered universe which had come into existence some four millenia before Christ and which was destined to continue in being until God's plan for the human dispensation had been completed. As Stephen Toulmin has made clear, this assumption was based not only on calculations arising out of Biblical references to numbers and years. It was the natural corollary of man's dependence for his knowledge of the past on verbal traditions and written records, none of which took him back beyond the third or fourth millennium B.C. 'Events which lay beyond the reach of human tradition were beyond the grasp of knowledge also. The scope of memory and legend set a limit to their possible knowledge of history, creating a "time-barrier", beyond which men's imaginations could move only into a world of speculation and myth.'[1]

This 'time-barrier' was breached in the first instance by the work of geologists who, as they examined rocks and fossils and compared what they found with the results of physical and chemical experiments, finally came to interpret stratification as a kind of clock which could enable man to calculate the age of different sections of the earth. From the notion of a few millenia the human imagination was led towards staggering ideas of unnumbered millenia. From the conception of a fixed order, established at a not-too-far distant point in time past and destined to continue until a not-too-far distant point in time future, the human imagination was led towards ideas of a universe which had developed over a period of almost unlimited length and which could well continue developing indefinitely into the future. From one point of view this involved a vast expansion in man's conception of time—the wonder of this ceaseless flux: from another point of view it involved a shrinkage—how could meaning possibly be found in a system which seemed to contain 'no vestige of a beginning, no prospect of an end'.[2]

[1] *The Listener*, 21 Jan., 1965, p. 98.

[2] Professor Frank Kermode remarks that when Archbishop Ussher's time-scale collapsed, 'the sciences one after another turned to the temporal. Geology

Two urgent questions concerning time have thus forced them-
selves on man's attention during the past three centuries. With so
much of human activity depending upon precise measurements of
time which apparently correspond to the exact measurements of the
universe itself, how can man fail to become geared, in more and more
details of his life, to the clock-time of the great universal machine?
And secondly within the complex of such conceptions as 'expanding
universe' and 'light years' and 'continuing creation', how can man
possibly discover *meaning* in the brief life-span of himself or even
of the civilisation to which he belongs?

III

The two basic issues so far as *Christian* time-symbolism is con-
cerned may be expressed in this way:

(1) Has the Christian Year any useful contribution still to make
as a sanctifying framework for the calendar of modern man? and

(2) Has the Christian Sunday in particular any significance to
contribute to man's search for meaning in the midst of the pure
undifferentiated succession of days in which modern life so often
seems to consist.

I shall attempt to consider these two questions in turn.

(1) The gradual erosion of the traditional Christian year in this
century is a familiar fact. The observance of Ash Wednesday and
Ascension Day, for example, has markedly declined. The seasons of
Lent and Advent scarcely affect the regularities of public life any
longer. Rogation Sunday and Whit Sunday differ little from
ordinary Sundays and strong movements have been made towards
the establishment of a fixed Easter—that is, an Easter Day governed
by the secular rather than the ecclesiastical calendar. As for Holy
Days and Saint's Days, a vast number even of Church people would
have difficulty in identifying their dates of celebration and in 1969

was first and then in mid-century Darwin temporalized the spatial classifications
of biology. The other sciences, including astronomy followed. . . . "No vestige
of a Beginning, no Prospect of an End", said James Hutton as early as 1790. For
literature and its criticism this created problems we have not yet solved.'—*The
Sense of an Ending*, p. 167.

The chief problem for literature, Kermode points out, is that whereas
formerly literature could assume that it was imitating an order, in the new time
perspective it must undertake the task of creating an order.

papal authority was exercised to remove a large number of lesser days from the calendar of universal obligation.

The major reason for this change is undoubtedly the passage from a dominantly agricultural to a dominantly industrial economy. The effect of the Reformation, associated as it was with a mercantile and commercial economy, was in some parts to curtail the number of days to be observed, in more limited areas virtually to exclude the celebrations of the Christian Year. But where such an exclusion was made, the significance of Sunday was actually enhanced and to this aspect of things I shall come later. Over much of Europe the general framework of agricultural life was maintained but at the beginning of the nineteenth century the power and the effects of the machine were being increasingly felt.

The essential characteristic of the steam-operated machine, in the context both of production and of communication, was the regularity of its rhythm. If properly adjusted and charged with fuel it would continue its rhythmic motions, regularly and efficiently, without need for pauses or breaks. The succession of day and night, of summer and winter, of wet and dry, of wind and calm, were all irrelevant to the smoothness of its operation. Its one obvious dependence was upon the man who fed its fires and the man who applied its energy to useful purposes. But if it was dependent upon them they were also dependent upon it, more obviously even than upon the good earth which supplied their daily bread. The new combination was man-and-the-machine rather than man-and-the-land: man and the model of steady, immutable performance rather than man and the model of partly irregular, often uncertain organic life. The rhythm of the machine was input-output: the rhythm of the land was much more complex. The rhythm of the mechanic was that of daily clocking-in and clocking-out: the rhythm of the agriculturalist was related to the whole year with its recurrences, its similarities but never its exact identities.

For a long time—at least until the First World War—the rhythm of the countryside maintained a powerful hold upon men's imaginations in the Western world. It governed the established observances of the Catholic tradition, it influenced the music and poetry of the Romantic movement, it was associated with treasured memories and hopes in the national consciousness. But the tentacles of industry were stretching out ever more widely and its rhythm rendered old observances, especially for the male population, impossible. Above

all was this the case for week-day celebrations but even the great Sunday festivals began to be affected. They were useful as marking the occasions for universal holidays. Their *religious* significance steadily declined. The seasonal variations of dark and light, heat and cold became for many city-dwellers the only substantial markings for the passage of time from one year to another.

Perhaps the most significant attempt to establish new symbols for the celebration of an annual-cycle has been that authorized by *national* feeling and command. In England, the Day of the Royal Accession, 5 November, Trafalgar Day, Empire Day, Armistice Day, D-Day, V-Day; in America, Thanksgiving, Memorial Day, 4 July, Labour Day, George Washington's Birthday: a cycle is established symbolizing the continuing life of the nation rather than the continuing life of the land. Such days may be given religious colouring or may be observed in purely secular ways. Even in this context, however, the process of erosion is evident. The impact of present events is so strong and compelling that it becomes increasingly difficult to give pre-eminent significance to days celebrating events which happened long ago.

Is then the time-symbolism which belongs to the regular annual cycle doomed to eventual extinction? If we examine the Judaeo-Christian tradition we find that when Israel became established as a nation in its own land the celebration of symbolic times assumed a dual form. The existing festivals of nature—New Year, First-fruits, completion of the grain harvest, General Ingathering—were combined with (some would say superseded by) festivals of history or at least of significant community-events—the Deliverance from Egypt, the Giving of the Law, the settlement in Canaan, the establishment of the Kingship. Similarly, only in a reversed order, Christianity in due course took its own time-cycle originating from the birth, the testing, the passion, the death and resurrection, the enthronement of Jesus, and combined it with the cycle of nature-observances which formed part and parcel of the annual regimen of Mediterranean peoples. Emphasis might be laid on one aspect or the other of this symbolic complex, but until the coming of the industrial and scientific revolution such a combination remained generally viable.

For the age of the machine, however, the cycle of the year is immaterial except in relation to the growth and decline of man's own powers. It could be argued that man is more prone to sickness in the cold months of the year or that his vitality is less in the period

of darkness and therefore that there is in industry a periodic cycle
of production. Again it might be claimed that the major crisis of
human affairs arose when man emancipated himself from the
tyranny of exploitation by the few and that some annual celebration
of this deliverance is therefore in order. But apart from this single
rhythm of change from under production to full and free production
there are no obvious variations worthy of celebration in the indus-
trial world. Holidays are indeed significant and have tended to be
associated with traditionally symbolic days already marked in the
annual cycle. But as agriculture becomes more mechanized and as
industry becomes increasingly an international phenomenon, there
seems less and less justification for the retaining of time-symbols of a
natural or of a national-historical kind. Whatever is of general
convenience and acceptance in the total industrial order becomes the
all-important criterion. A fixed Christmas, a fixed Easter, a fixed
weekend at the beginning and end of summer, staggered holidays—
these are likely to be the significant markings on the annual calendar
as industry becomes the all-important agent in the organization of
human life.

The only factor, it appears, that can arrest this process of com-
plete secularization and regularization of the calendar is that which
is derived from the rhythm of the whole life of man himself. There
are the rhythms of waking and sleeping, of work and recreation,
of uniformity and change, of learning and operating; do these
rhythms, it may be asked, call for some kind of *annual* cycle of cele-
bration? Are there social factors such as the demands of the family
or of older members of the community: are there physical factors
such as the fatigue of materials or the necessary overhauling of
machines which could point to the retention of an *annual* time-
symbolism? It is very hard to see how such claims could be sub-
stantiated. That man himself is subject to a certain bodily rhythm is
evident, but this rhythm is primarily of a daily, secondarily of a
weekly, thirdly of a wider-than-annual character (moving towards
maturity and then declining). Man in community is subject to a
rhythm but this is bound to depend upon the dominant charac-
teristics of the economy to which the community is related: for the
agrarian the year is pre-eminent, for the trading nation less so, for the
total life of industry hardly at all.

It seems therefore that the Christian must be prepared to see less
and less attention paid to the *religious* quality of his own time-

symbolism in the general organization of human life. Advent,
Christmas, Lent, Easter, Ascension, Pentecost, has constituted a
richly-varied series, corresponding to the stages in the manifesta-
tion of the Son of God to mankind, corresponding to the stages in
man's apprehension of the ultimate truth of his own existence. For a
long period in the life of Christendom it seemed possible to make this
cycle a constitutive symbol for the organization of man's total *social*
life. It is doubtful however that this can any longer be the case.[1] The
Christian will, it seems, find himself compelled by the organization
of social life to focus his attention more and more upon the one
rhythm which has the quality of permanent and universal rele-
vance—the rhythms of life and death, death and life. The time may
well come when Good Friday and Easter Day, possibly Holy Week
and Eastertide, becomes the only sequence which can be retained in
his annual calendar for concentrated celebration. A quite different
form of time-symbolism to which I now turn may prove to be of
greater significance in our contemporary situation.[2]

IV

(2) I turn to my second question concerning Sunday. In the Christian
tradition one day in seven has been associated with two inter-
connected but distinct conceptions. On the one hand the whole day
has been kept as a *rest*-period, the other six days being regarded as
designed by God for steady and regular work. On the other hand a
particular section of the day has been kept as a *worship*-period for

[1] 'The church is important only at crucial turning-points in the life-cycle or
else where a secular festival overlaps an ecclesiastical one.'—David Martin, *A
Sociology of English Religion*, p. 92.

[2] 'The church cannot seek to impose its own rhythms and structures on the
world it is called to serve in the name of the Lord. As a matter of fact its own
rhythms and structures are not so much the necessary expressions of its own life
and message as they are reflections of the rhythms and structures of pre-industrial,
pre-urban society. An important element in the repentance to which also the
church is called must be its willingness to give up outmoded patterns that have
become a hindrance to its ministry to men in today's world. And an important
element of the renewal of the church will be the development of forms of con-
gregational life and of ministry more fitting to the life of contemporary society?
Introduction to Horst Symanowski, *The Christian Witness in an Industrial
Society*, p. 22.

the whole Christian community, whatever may be done by indivi-
duals or families in more private ways. In considering this dual
tradition Willy Rordorf has pointed out in his valuable book *Sunday*
that early Christians found themselves in a situation where two
rhythmic cycles of time were already in existence—the Jewish week
with its enormous stress upon the Sabbath and the week of the
Greeks and Romans. The latter was closely associated with astrologi-
cal beliefs in the potency of the seven planets and no special stress
was laid upon a particular day, though ultimately Saturn's day
gained a slight pre-eminence. Christians, whether belonging to
Jewish or to Graeco-Roman contexts, naturally regarded Sabbath or
Saturday as the appointed day of rest.

But besides participating in the seven-day cycle of work and rest,
Christians were concerned to celebrate a particular event. This was
the moment of the new creation, the resurrection of the Christ. No
precise timing of this event could ever be possible. But their tradi-
tions associated it pre-eminently with the first day of the week and
it was on this day therefore that the new Christian celebration took
place. This was the *Lord's Day*. On this day praise and thanksgiving
were offered, both in the prayers and at the breaking of the bread.
Whatever importance the seventh day may have held as the day of
rest, of far greater significance for Christians was the first day, the
day of resurrection, the fulfilment of all that had gone before, the
anticipation of the great Day of the Lord yet to come.

Rordorf's conclusion after the most careful investigation is strong
and positive. Down to the fourth century, he affirms, the idea of *rest*
played no part in the Christian Sunday. Christians, like everyone
else, worked on that day. It was only when Constantine the Great made
Sunday the statutory day of rest in the Roman Empire that Christians
tried to give a theological justification for the rest from work on
Sunday which was now demanded by the State. But this apologia
needed to be more substantial than that provided by the fourth
commandment of the Decalogue or by Jewish tradition. The whole
relation of the Christian to time needed to be taken into account and
a pattern established within which both the work-rest division and
the celebration of the central and critical event of all time could gain
adequate symbolic representation.

As far as the work-rest division of time is concerned this obviously
depends intimately upon the general character of the labour economy.
In an agricultural and pastoral economy, the regularly recurring day

of the week is not an outstandingly important occasion. Feeding, protecting, healing, watering are activities which cannot simply be abandoned or omitted on a particular day of the week. In many respects the critical seasons of the annual cycle call for more direct celebration than does the regular succession of Sundays. Seed time and harvest, breeding time and lambing time, are of more significance than any particular Sunday.

On the other hand in a nomadic, trading, mercantile economy one rest day in seven is not only possible: sheer empirical experience has proved that it is desirable. During one whole day drives can be relaxed and energies re-created. The nature of commerce is such that as a result of common agreement it can be suspended for any particular period. The only proviso is, of course, that the agreement should be all-inclusive. If some are working while others are resting they may thereby gain some temporary advantage. If some relax while others are working, they may thereby disturb the total economy. But activities in this total context are more abstract, planned, geared to mutual convenience. If work depends on agreed conventions, so too can rest. The sheer division between labour and rest need not depend upon a divine ordinance.

It was the changing economy of Europe in the sixteenth century that made possible the introduction into Christendom of a strict division between work and rest. It had remained a cherished part of Jewish time-symbolism but had never been accorded pre-eminence in Christianity until Calvin in particular, and other Reformed traditions to a lesser extent, made the strict observance of Sunday as a rest day mandatory. The new focusing of attention upon the Ten Commandments led inevitably to a deep concern about the Fourth: the new historical approach to the Biblical literature meant that for the Reformers the constant references to the importance of the rest-day could not be circumvented by mystical or allegorical interpretations. Thus for the time being the rest day was observed with varying degrees of strictness, with many forms of compromise allowed in Catholic circles but with a rigid prohibition of any kind of work in Puritan theory and practice.

The coming of the scientific and industrial revolution did not immediately affect the pattern of Sunday-observance. A mathematical ratio of 1 in 7 obviously corresponded to the phases of the moon: experience seemed to show that a release from labour during one day in seven was necessary for the maximum health and efficiency of those

labouring in industrial enterprises. But the sense of dependence on a Divine ordinance gradually declined and the precise demarcation of one whole day in seven seemed less and less important. If the carrying out of a mechanical enterprise called for infringements of the day of rest, if the progress of industry could allow an extension of the 24-hour limit, if it seemed desirable for some to work while others relaxed, no inflexible Divine commandment must be invoked to prevent adjustments from being made.

The Puritan time-symbolism has been gradually eroded and the process is likely to continue. The question still remains, however, whether the rest category is the altogether important one in the Christian tradition. If Rordorf is right it was not until the fourth century that it gained a place of real prominence. In the beginning the utterly significant time to be recalled and celebrated was the time of *resurrection*. Resurrection rather than rest, a positive affirmation rather than a negative prohibition, the celebration of a significant moment in time rather than the painstaking sanctification of a regularly recurring day—this, it could be claimed, was the specifically Christian concern. I have stated the contrast in absolute terms, though in point of fact each side of the contrast could be related to the other. But the day, the rest, the fourth commandment, the promise, the calendrical convenience, the tradition, have so conspired to emphasize one side of the contrast that the other, the more important, has easily been relegated to the background as the justification of the community time-symbol.

Let us assume that the moment of Resurrection is the all-important time-symbol within the Christian understanding of reality. How can such a moment be related to the rest of man's apprehension of time? Until quite recently the two most popular, most easily imagined models of time have been the circle (or variants such as the wheel or the revolving sphere) and the straight line (or variants such as the forest-track or the river). Settled man is vividly aware of *recurrences* such as day and night, new moon and full moon, summer and winter, and for these the circle provides an appealing and appropriate symbol. Migratory man is vividly aware of significant *stages* in time: yesterday and today and tomorrow, the time of the beginning, the time of the middle and the time of the end: the source of the river, the flow and the outlet in the sea—for all these the line provides a simple and straightforward image. In the circular image the centre is the unique point: it alone remains still while all else

revolves. In the straight line the mid-point between beginning and end, the point where a vertical intersects the horizontal is all-significant: it remains relatively fixed while time's arrow moves inexorably on. The Christian has not found it difficult to identify the moment of the Incarnation or of the death of the Son of God or of the Resurrection with one or other of these significant points. T. S. Eliot has written of the moment of Incarnation as the still point of the turning world, Edwin Muir has spoken of the world revolving around the day they killed the Son of God. Here, it is suggested, is a symbolic moment which can give significance to the whole.

But what is the situation with industrial man? He is aware of recurrences, but they are the man-made recurrences of factory opening and closing, of machines operating and silent. All is governed by the clock and the only significant moment is that which marks the end of a production-operation or of a labouring day. Or again he is aware of the general assembly-line character of his objective world in which no particular moment is of unusual significance except that in which he himself encounters the advancing structure and makes his own contribution to the ongoing process. In the first model the significant moment is that which completes one operation and begins another: in the second model it is that which marks the meeting of man's action with the over-all planned operation of the Juggernaut machine. The problem is that in each case such moments recur again and again. For the moment, the moment is significant. But immediately it passes and the next comes. Thus it becomes increasingly difficult to imagine that a unique critical moment amongst all these moments could be a symbol of the total meaning of the passage of time. And if this is the case in the world from which man derives his constant experience of time's movement how can he discover a way of symbolizing the meaningful moment in the passage of universal time?

The way towards a solution seems to be that of first recognizing frankly that the precise definition of an instant in time may be too limiting to be useful for the interpretation of general experience. It is probable that the human consciousness itself cannot apprehend divisions of time beyond a certain microscopic limit of measurement. Certainly if the moment in general experience is to be meaningful there must be a certain wider context within which it is set: it must in fact be not just a naked, isolated moment (if such were even conceivable) but rather *either* a moment of turning *or* a moment of

meeting. It must be seen within the context *either* of 'counting-down' and 'blasting-off' *or* of 'approach' and 'connection'. Let us look at each of these in turn.

The whole world in recent years has become familiar with the model of a vast and intricate system of operations being directed towards a moment in time. In a sense the whole previous history of scientific experimentation has been the prelude to the drama of the final count-down. Gradually years of planning are directed towards a particular moment in time when in a blinding flash of explosion preparatory structures are destroyed and a new dynamic career is inaugurated. This is perhaps the most dramatic example (which has been enacted before the eyes of millions) of preparation and fulfilment, of regeneration and transformation, of (in a certain sense) death and resurrection. Much which has cost incalculable expenditures of time and energy is simply jettisoned in the process. All is carried through under the conviction that the moment at the end of a vastly extended series is the beginning of a new adventure into experience and knowledge. The structure of the universe is such that at least under certain conditions a moment of time can mark in a symbolic way the passage from potentiality into actuality, from 'running down' into 'soaring up'.

But we have also seen that an isolated capsule performing an orbit in space, though an impressive phenomenon, is limited in value and significance. The altogether spectacular advance has been made when *encounters* have taken place between two controlled systems. Here again a vast expenditure of time and energy is needed to plan the operation accurately. Finally the situation is directed towards a particular point in time when one object in space approaching nearer and nearer to the other makes contact, establishes connection. The approach strategy is carried forward with the utmost care. But the moment comes when the approach is transmuted into *connection*. This is the most significant moment in the whole operation and symbolizes the opening up of possibilities for immense creative advance. In fact a moment of time marks in a symbolic way the joining of two trajectories and the emergence thereby of positive continuing life.

The symbolic turning-point: the symbolic meeting-point. Today these are being dramatized before our eyes according to a scale of exact measurement never even contemplated in previous ages. Yet the essential symbolism of the turning-point is no different from that

which was derived from the observed planting of a seed into the depths of explosion-creating forces within the soil and the soaring up of a plant towards the attainment of its ultimate fruition. The essential symbolism of the meeting-point is no different from that which was drawn from the observed conjunction of man and woman in sexual union resulting ultimately in the emergence of new and continuing life. And I suggest that the all-important concern for the Christian Church today is not the necessity of retaining in their detailed form time-symbolisms derived from other cultures in other ages but rather of ensuring that any celebration of time shall be of such a character as to bring vividly before the human imagination *either* the moment of supreme turning, the Resurrection, *or* the moment of supreme meeting, the Incarnation. In point of fact these *are* the two great festal celebrations which have retained their significance beyond all others in our modern world. If what I have suggested is true they belong to the very structures of the universe in which we dwell: they correspond to the two human experiences which are universal in their incidence—Birth and Death. To celebrate the moment of conjunction issuing in Birth, to celebrate the moment of turning issuing in Life—these are still the two most meaningful symbolisms in the Christian relation to crises in the passage of time.

How this may best be done is not easy to define. So far Christmas and Easter have retained their pre-eminence in the annual cycle, not only as natural festivals associated with renewal of life and the overcoming of death but as specifically Christian occasions celebrating the birth of the Divine Son and His resurrection. Within the weekly cycle both motifs are to be found in the celebration of the Eucharist. The moment of the Consecration corresponds to the handing over to death and the transformation into new life of the gifts committed to man's trust: the moment of Communion corresponds to the promise of new creativity emerging through the conjunction of participants in a common act. Whether under modern conditions time's crises can be celebrated with full solemnity every week may be open to question. But that the Lord's Day has in some sense been the supreme day for celebration throughout Christian history can hardly be denied.

An indication of what may happen in the Christian world at large has been provided by recent developments in Ceylon. With independence and the new sense of nationhood there came, in due

course, the decision to instate Buddhism as the official religion. But within the Buddhist calendar there is no place for a regular observation of the Jewish Sabbath or the Christian Sunday. The days of rest and celebration are the poya days which occur irregularly in relation to our Western week, though within any particular span of time their number is not dissimilar. In such circumstances are Christians to work on Sundays and rest on poya days, to worship on poya days and not on Sundays or how is the week to be organized? So far the practice has been generally accepted to conform as early Christians did to the state calendar, so far as work and recreation is concerned, but still to find time for worship on the traditional Lord's day, even though worship may have to be celebrated either before or after the day's work.[1]

The situation is fluid in most parts of the world. The pressures of work-patterns can scarcely be resisted. Yet somehow the Christian will seek occasion to celebrate Incarnation and Resurrection. Whether it be Christmas Day or Easter Day or certain definitive moments on the Lord's Day—so long as some symbolic forms are retained pointing to the meeting of God and man at a moment in time, so long will the distinctiveness of the Christian Gospel be proclaimed within the mysterious yet inescapable dimension of time.

[1] Since writing this paragraph I have learned that the sheer pressures of international business have compelled the Ceylon Government to revert to the regular release from work on one day in seven.

SYMBOLIC PATTERNS OF SOCIAL ACTIVITY

*'In six days of war Israel saved what had been created in 1948.
This year we will celebrate the twentieth anniversary of that
creation. It will be celebrated in songs and dances and pageants
and speeches and parades. Why not? That's the way national
anniversaries are usually marked. And in Israel there is much
to celebrate.*

*'A country has emerged from desert and malarial swamps to
flourish in the face of constant peril. So you can be sure there will
be lots of singing and dancing and parading. There'll also be the
biggest Purim Festival ever held in Tel Aviv. . . . A Torch
Relay Race from the Maccabean Caves to Jerusalem. The
Bringing of the First Fruits Ceremonies in the Jezreel Valley.'*

AIRLINE ADVERTISEMENT

THE St Thomas' Day lecture given at Blackfriars, Oxford, in 1968,
bore the intriguing title 'The Contempt of Ritual'. In it Dr Mary
Douglas, drawing on her knowledge and experience as a social
anthropologist, sought to show how important ritual practices are in
the life of a particular society even when to the outsider they may
seem of little significance. The relaxing of the rule which forbids the
eating of meat on a Friday could have a quite disruptive effect on the
whole social structure of the Bog Irish in London. For the sake of
cohesion and continuity in any social group some kinds of ritual
patterns seem to be essential.

Beside the witness of social anthropologists to the importance of
ritual in tribal communities we can set the attempts of leaders in
modern secular societies to devise new symbolic forms to replace
those which had been rejected as relics of the age of religion. Parades,
displays, gestures, initiation and marriage ceremonies, the veneration
of secular heroes and 'saints'—all have found a place in the revolu-

tionary new societies of the twentieth century. It has even been reported that at Easter time young atheists have flocked to watch the ceremonies of a great Moscow monastery, perhaps out of curiosity, perhaps with a vague sense that ancient symbolic rituals possessed some secret power which society still needs today.

In her lecture Dr Douglas drew an important distinction between the ritual forms of closed social groups and those of tribes continually on the move. Obviously in any society there must be a minimal organization of basic activities if life is to continue at all. Food and water must be made available, shelter and protection must be provided, mating and child-care must be regulated. All of these involve bodily movements which must be disciplined and co-ordinated towards the desired end—which is of a quite practical kind. But the curious thing is that man has felt a compulsion not only to organize but also to celebrate. He has declined to confine himself to eating and drinking and sleeping and toiling in a monotonous unending routine. Instead he has worked out patterns of gestures and movements which, on the face of things, seem aimless and wasteful but which have, to say the least, been of immense significance as couplings binding together his whole social system.

What then has been the general nature of these celebrating movements and activities? According to the distinction made by Mary Douglas the first is rooted in and firmly attached to a particular land-area. This area is bounded and may often be approximately circular in shape. The activities of the community must be organized in such a way as to promote fertility, secure irrigation, provide for sowing and reaping and storing, defend against marauders, make equitable distribution—the normal activities of an agricultural economy. But besides these routine activities which man can organize and control there are actions to be performed in relation to the mysterious powers operating within the total environment and it is of primary importance that these should be regularly fulfilled.

Man and society and the land and the surrounding environment form one indivisible totality. There are differentiations of function within the system but there is one cosmic order and a single life-energy surges through the whole. Ideally the continuity between man and nature, between the world of men and the world of gods, should be unbroken. But just as man has to labour in the empirical world to sustain the life-cycle, so he must perform the necessary ritual-actions in order to maintain the harmonious working of the

cosmic whole. 'This continuity, which assumes an ongoing linkage of human events with the sacred forces permeating the universe, is realized (not just reaffirmed but literally re-established) again and again in religious ritual. For example, in the Great New Year festival of ancient Mesopotamia the creation of the world is not only represented (as we today might understand it in terms of some sort of symbolism) but once more realized, made a reality, as human life is brought back again to its divine source.'[1]

Of all forms of ritual employed in this context none compared in importance with *sacrifice*. It was believed that the creation of the world had been effected through sacrifice: in the world of nature and of human life death was a reality which needed to be constantly reversed and no force it was believed was more potent to this end than sacrifice. The fruits of the earth, animals, even humans could be offered in sacrifice in order that through life poured out life might be renewed. Though the precise motivations and theorizations may be obscure, that the central religious ritual in the closed society was some form of sacrifice seems certain. The cycle of birth, decay, death and rebirth which characterizes an agrarian culture gained its focal ritual celebration in a sacrificial offering, death, and transmutation. Through sacrifice man could, as it were, gear himself in to the total rhythm of the universe.

Sacrifice occupies a central place in the pattern of community activities which forms the symbolic cycle of movement for any *organic* society. It is the supreme institution through which man comes to terms with the menace of death in all its forms. But other ritual-forms have an important part to play and none more so than those which have come to be designated *rites of passage*. At certain stages in the life of any individual ritual actions are performed by the society at large in order that he, the individual, may be incorporated afresh into the order (nomos) which belongs to the whole. To quote Berger again: 'Every nomos confronts the individual as a meaningful reality that comprehends him and all his experiences. It bestows sense on his life, also on its discrepant and painful aspects. Indeed, . . . this is the decisive reason for the establishment of nomoi in the first place. The nomos locates the individual's life in an all-embracing fabric of meanings that, by its very nature, transcends that life. The individual who adequately internalizes these meanings at the same time transcends himself. His birth, the various

[1] Peter Berger, *The Social Reality of Religion*, pp. 113f.

stages of his biography and, finally, his future death may now be interpreted by him in a manner that transcends the unique place of these phenomena in his experience. The point is made dramatically clear in the case of rites of passage, in primitive as well as in more complex societies. . . . The social ritual transforms the individual event into a typical case, just as it transforms individual biography into an episode in the history of the society. The individual is seen as being born, living and suffering, and eventually dying, as his ancestors have done before him and his children will do after him. As he accepts and inwardly appropriates this view of the matter he transcends his own individuality as well as the uniqueness, including the unique pain and the unique terrors, of his individual experiences. He sees himself "correctly", that is, within the co-ordinates of reality as defined by his society. He is made capable of suffering "correctly" and, if all goes well, he may eventually have a "correct" death. In other words, he may "lose himself" in the meaning-giving nomos of his society.'[1]

Initiation-rituals, fertility-rituals, sickness-rituals, punishment-rituals, funerary-rituals are all included within the general category of *rites of passage*. While the 'nomos' represents a living symbolic structure which corresponds to the rhythm of the living universe its rituals remain flexible and capable of gradual change. It is when the nomos takes on the qualities of rock and stone, impermeable and unchanging, that the rites of passage become stereotyped and undeviating and while providing a sense of security do so at the cost of growth into fuller maturity.

II

The second type of society described by Mary Douglas has no firm attachment to any bounded territory. It is continually on the move. It may assume the character of a satellite to a more settled community, as for example the Pygmies of Central Africa have done in relation to land-based Bantu farmers. But, in general, societies of this kind move freely in what Dr Douglas calls an 'uncharted, unsystematized, bounded social world'. They are sensitive to moods of the forest, of the mountains, of the wide open spaces, and they respond in song and dance. They do not strive for absolute possession or security in any one place, but rather move on just as the seafaring

[1] Op. cit., pp. 54f.

man elects to face out the storm in the open sea rather than in the vicinity of fixed land-contours.

But does this mean that such societies have no 'nomoi', no structures within which the individual or the family can find confidence and meaning? Obviously this is not so, for man cannot long endure anarchy or total disorder. In a word it may be said that the 'nomos' is structured according to processes of *communication* rather than according to processes of organic life. Or to express it in another way, in the mobile society man exists within the context of *intentional interchange* rather than in the context of *patterned growth*. It is true that interchange can lead to forms of growth and that growth is only possible through certain forms of interchange. But the primacy or priority of emphasis remains. Those without a settled habitat can survive only if their existence is held within the framework of conscious loyalties and promises and interchanges which are simply not required within a total organismic situation.

What kind of rituals, then, belong to this second type of social existence? As we shall see in the next chapter language has come to play an extraordinarily significant part in all systems of human interchange but this does not mean that actions are redundant. The patterned gesture can prepare the way for the word, it can seal the word. An exchange of gifts can be the first step towards the creation of mutual trust within which words of promise and commitment become meaningful: equally an interchange of words gains its first observable consequence when objects of value, hitherto possessed by independent parties, are shared in some kind of formal transaction. And these patterns of action between man and man provide a natural fountainhead of symbolic forms appropriate to the expression of relationships between man and his god.

Of all forms of ritual which took shape in this context none compared in importance with the *covenant*. And no records of the corporate life of mobile societies give us a clearer view of the nature and form of covenant-making than the Old Testament itself. Both the etymology of the Hebrew word *karath* and the actual records of covenant ceremonies indicate that some kind of *cutting* or *cutting off* was essential as first stage. If an animal had been captured in the chase the cutting may have been a simple division of the carcase and a sharing of the spoil. If however (and this seems more appropriate in the Old Testament context) domestic animals were concerned, the cutting may well have been the cutting off of a section of the animal

belonging to one party and the exchange for a section of the animal owned by the other party. Or the cutting off may have been related to a general sharing of that part of the animal which had been severed from the whole carcase. Still further, records exist of parties to a covenant cutting a wound in their respective bodies in order that there might be a mutual sharing of blood.

Whatever the precise details of the ceremonial may have been in any particular case, the centrality of some kind of *cutting* seems firmly supported by the evidence. Through a *decisive* (a word whose etymology is concerned with 'cutting') act each party relinquishes its hold over some part of its possessions. There is a totality which constitutes *me*, my body, my family, my tools, my flocks and herds, my possessions. By a deliberate act I may cut off some section of that which constitutes *me* and offer it to the other. Similarly the other may make a comparable gesture towards me. It is in mutual acceptance followed by mutual use or mutual consumption or some other kind of mutual sharing that the covenant is sealed and consummated.[1]

For the consummation of the covenant no pattern of activity could compare in importance with a feast of celebration. In the history of the people of Israel the annual passover celebration came to be the supreme occasion for recalling the decisive moment in their national existence when God came forth to rescue them from the oppressor and when they in turn committed themselves to His allegiance in an altogether new way. Each household offered its lamb and then shared in the feast. But all was done solemnly, as in the presence of the Divine Redeemer, and through the offering and the sharing the covenant was renewed. In certain respects the ritual had links and affinities with that of sacrifice and it was not unnatural that through the assimilation of tribal traditions and practices the covenant ceremony came often to be regarded as a sacrifice of a particular kind. But within the total social setting, at least in its earliest form, there is a definable difference between sacrifice and covenant. The former is the central symbol of life renewed through death, the latter of life enhanced through interchange, an interchange which may indeed involve some element of deprivation or even death for each of the parties concerned.

[1] The origins of the ceremony of circumcision are uncertain, but clearly 'cutting' was a central feature and covenant terminology was employed in relation to it.

III

The all-important ritual actions to which clear reference is made in the New Testament are baptism and the Lord's Supper. Single dramatic actions such as the procession into Jerusalem on the First Palm Sunday and the washing of the disciples' feet on the first Maundy Thursday never became regular forms of corporate celebration. But baptism, with its prototypes in Old Testament events, in John's baptism, and in proselyte baptism, became the regular form of Christian initiation; eucharist, with its prototypes in the Passover, in the desert-feedings within Jesus' own ministry and above all in the ceremonial of the upper-room, became the regular form of Christian community celebration. Details of the way in which early Christians performed the rituals are scanty, but motifs are elaborated and it becomes clear that baptism took the place of circumcision, eucharist of passover within the new dispensation. Moreover the terminology of covenant was associated with the Lord's supper and that of 'cutting off' or 'putting off' with baptism. In regard to sacrificial and rites of passage terminology the evidence is less easy to interpret. There may have been the beginnings of tendencies to frame the Christian rites according to this social pattern but it is only after the apostolic period that the 'tendencies' emerge into clearly established process. From the second century onwards the Christian Church maintained its social cohesion to an ever increasing degree by organizing its corporate life according to a definite ritual cycle. The eucharist became the central symbolic sacrifice: other symbolic rituals—e.g. baptism, confirmation, anointing of the sick—gradually established themselves as the symbolic rites of passage of Christendom.

A comprehensive title for the ideal and practice of the whole Christian Church in its ritual activities, at least from the third century A.D. to the eve of the Reformation, could well be the New Testament phrase: *The building up of the Body of Christ*. It was the sanctification and fulfilment of the ritual pattern which had characterized agrarian societies from the early days of the river-valley civilizations. In these the whole community was concerned to establish and maintain a total organic life by combining two essential forms of activity—farming and building. In farming man identified himself with the cycle of nature—sowing, watering, tending, reaping: in building he used available resources—wood, rock, clay—to

protect and preserve the fruits of his labours and the society which depended on them. The essential ritual-form, patterned according to the processes of the natural-cycle of earth, was sacrifice: the essential ritual-form, patterned according to the structure of the heavenly world, was temple-building. The offering of the eucharistic sacrifice and the building of the house of God—the new temple—were the twin ritual activities which for centuries in the life of Christendom enabled men to sanctify the natural order and to unify their social life within a structural symbol.

On the other hand no single element in the great upheaval of the Reformation was more significant than the re-discovery of the meaning and experience of *Communion*.[1] It represented an authentic restoration of a central Biblical perspective, it corresponded to new and powerful ideas which had been germinating in the political and social life of Northern Europe and it tallied with the change of emphasis in many quarters from organismic processes to new techniques of communication. A comprehensive title for the ideal and practice of the Reformed Churches in their ritual activities could well be a conjunction of New Testament phrases: *A communion in the Body and Blood of Christ*. It was the transformation and fulfilment of the ritual pattern which had characterized nomadic and pastoral societies from the earliest days of their roaming in the wide open spaces. Each social unit was concerned to strengthen and sustain its bonds of community by combining two essential forms of activity—surrender and participation. A portion of that which is possessed by each party is surrendered: the whole community shares in the common gifts, usually in and through a common feast. Offering and sharing were the twin ritual-activities which now became altogether more prominent in the life of Christendom, enabling the newly-established social groupings to strengthen their sense of togetherness within a common calling and destiny.

IV

Modern science brought about revolutionary changes in Western man's ways of thinking, methods of communicating, structures of living and techniques of producing. In the total picture of change one model occupies an altogether central place. It is the model of the

[1] This was pointed out long ago by Father A. G. Hebert in his influential book *Liturgy and Society*.

machine. Elementary mechanical devices had indeed been con-
structed far back in human history, engines to assist man in lifting,
in throwing, in transporting. But these had played a relatively small
part in his activities of farming and building or of hunting and fight-
ing. They were called upon in special circumstances—they did not
belong to the regular life-pattern and work-pattern of his society.

The only substantial incursions of the machine before the
eighteenth century were brought about through the invention of the
clock and of the printing-press. The clock, though manufactured by
man and continually rewound by man, yet had a certain regular cycle
of its own: in certain respects it controlled man and made him more
conscious of the recurrence of time. The printing-press, though
invented by man and programmed by man, had a certain inexorable
message of its own: in certain respects it programmed man and made
him more conscious of his predetermined destiny. Actually the
principles of exact repetition of a mechanical motion and exact
repetition of a programmed message were to prove fundamental in
the technological developments of the eighteenth–twentieth cen-
turies.

Their importance so far as man's ritual activities were concerned
can, I think, best be indicated in this way. Every human society has
created for itself a certain unity and continuity of common life. One
of the chief ways of doing this has been through the development and
the maintenance of ordered ritual practices. But these practices have
not normally been of an entirely different character from those of the
existing common life. Some sequence of activities, which is an
essential part of ordinary living, is taken and invested with special
significance. It becomes the symbol of the total well-ordering of the
social group. Its repetition keeps ever before the eyes of the corporate
imagination the nature of the harmony which was inherent in the
original creation of the group within its environment and which dis-
closes the nature of the ideal towards whose attainment all must
aspire.

In agricultural societies closely related to a particular area of land,
the ritual has normally consisted in some form of manipulation of the
fruits of the land and some form of building construction. In nomadic
societies, united in a common quest of the means of subsistence, the
ritual has normally consisted in some form of manipulation of the
prey and some form of participation in a common feast. There have
been many variations on these basic themes, many subsidiary accom-

paniments and many refinements in the actual rituals performed, but the pattern of activities in the sacred ceremony has corresponded reasonably closely to the pattern which characterizes life in the secular world. The only major distinction is between the rituals of settled societies which enact in a solemn and dramatic way the regular processes of the workaday world and those of mobile groups which enact dramatically the pattern of special critical events in the folk-memory, events however which are not unrelated to the mode of living which the group pursues.

What happened with the advent of the machine was that countless families left their homes in rural areas and took up residence in densely packed settlements in the neighbourhood of factory and mine and dock. Raw material had to be collected, transported, processed, transformed, distributed, all by operations which became increasingly mechanical and impersonal. The whole cycle seemed in no way dependent upon transcendent powers or upon mysterious energies inherent in the life of nature. The raw material came either from underground caverns or from regions unknown—it was alien stuff, unrelated to the immediate environment. Already the assembly-line process was taking shape, the process in which man himself simply becomes a link in an unending chain, a 'hand', an 'operator', an 'employee', in the vast impersonal mechanical concern.

This was to be the new method of production which would ultimately be geared even to the processes of field and farm. It was spectacular in its results—speed, accuracy, efficiency, expandability were unmistakable. It could not be resisted except spasmodically. Its centre of operation could be circumscribed by climatic and geographical conditions and for a long time this meant that the type of social behaviour associated with rural areas and market towns was not seriously affected. But industrial and manufacturing enterprises gradually expanded and with the growth of population and new facilities of transport the new civilization established itself as the dominant pattern in large areas of the Western world. It was only a matter of time before it would spread to Africa and the East.

But what could be the place of religion and religious ritual in these new conditions of life? The industrial city had little regard for the mystique of the land, little interest in preserving traditional patterns of community life. The machine must be fed, tended, repaired, at length replaced. This was the controlling factor in the new style of living. There was no part of the process which could be extracted or

simulated and then sacralized and brought to symbolic fulfilment. Rituals, it seemed, could only be rituals of contrast and escape, rituals belonging to dreams and fantasies and nostalgic memories rather than to the stuff of conscious daily living.

So the industrial age witnessed the development of new secular rituals and to a limited degree of new religious rituals. Secular rituals were organized through the dance-hall, the public-house, the fair-ground, the sports arena, the seaside resort. These were pre-eminently rituals of escape, but they provided invaluable means of chanelling public emotion and did much to preserve community life. Prominent in these rituals was an essentially *cyclical* structure. There were stages which had to be repeated on each occasion. A certain basic expectancy had to be fulfilled. Through the ritual man could experience a certain re-uniting with 'form', though in the case of secular rituals the form had no reference to transcendent and eternal realities.

In the main, the great churches of Christendom which had emerged from the cataclysm of the sixteenth century failed to relate themselves to the new age which had dawned. This is in no way surprising. Through much travail they had developed their own distinctive ritual-forms and these had provided powerful energies for their new community-life. It was natural to imagine that the order which each possessed could 'contain' these new secular develop-ments. Was not the ritual for the sanctification of man's life on the land adequate for the sanctification of his life in industry? The old ritual-forms continued, and although the Roman emphasis on instru-mentality had some links with the operationalism of a mechanical civilization, the mood of the Churches was dominantly conservative with the assumption that if church-buildings, with their attendant ritual organizations, could be established in the new centres of industry, the religious needs of the populace would be adequately met.

The only substantial development of new symbolic forms of action was in the realm of musical expression. It is true that later in the nineteenth century attempts were made to re-introduce into the ritual of the churches forms and practices derived from the Middle Ages, such as processions and ordered bodily movements. But these were a revival of a past glory rather than a creative response to a new situation. In the case of music it was a different matter. In Lutheran-ism, in Methodism, to a degree in Anglicanism, above all in the

new sectarian forms of Christianity, music and congregational sing-ing became the chief form of lay participation in corporate worship.

It is an interesting question how far this was related to the coming of the machine and the emergence of the new industrial structures. Man was now caught up in the rhythm of the machine: at the same time he was deprived of the rhythms of the land and largely of the seasons. When he came out from mine or factory there was little of beauty to strike his eye, little of cultivable land to give scope for activities promoting growth and fruitfulness. The only outlet seemed to be in song. The impersonal rhythm of the machine could be countered by the intense sense of personal relatedness created by the rhythm and harmony of community singing. There was no complete dissociation between the two spheres of activity. It was as if some-thing at least could be redeemed and sanctified.

What then of the long-standing tradition within Christianity of the eucharist as sacrifice? Unhappily the leaders of thought at the time of the Reformation had so focused their attention upon a single narrow interpretation of sacrifice as a propitiatory offering that for a long period the alternative seemed to be either the retention of the idea of sacrifice in the oblation of the Mass or its complete abolition from worship except in what was regarded as a purely spiritual sense. Attempts were made in seventeenth-century Anglicanism and in the eighteenth-century hymns of the Wesleys to restore a more compre-hensive view of sacrifice and these attempts led to the incorporation of a sacrificial pattern within one family of Anglican liturgies and to the expression of the pattern through a group of Methodist hymns. But it was not until the twentieth century that movements and gestures related to sacrifice gained fuller acceptance and under-standing within the worship-practices of Reformed Christianity.

Today it seems evident there is still need for ritual ceremonies to celebrate the main stages of human life, ceremonies akin to the rites of passage of former days. Even in secular societies and in anti-religious national régimes there are initiation rituals, youth dedica-tion rituals, marriage rituals and death rituals. Less often there are rituals for restoration to full standing within the society and for admission to special office within its ordered life. The need for rites of passage *in some form* is widely acknowledged. But are the tradi-tional Christian rites—baptism, confirmation, marriage, burial and on rarer occasions penance and ordination—derived as they are from the context of an agrarian society, meaningful or acceptable today?

Dipping in water, anointing with oil, scattering ashes are actions sanctioned by long practice in the life of agriculturalists. But except in areas untouched by industry and the machine—and these grow fewer and fewer—or in those artificially created by conservatively-minded groups, these actions have little claim to be regarded as community symbols.

Is there any way forward? All rites, it may be held, should be living activities within the symbolic process of the *building up of the Body of Christ*. In the Middle Ages the body was conceived primarily as a hierarchical system and the building of society was to follow this pattern. In the eighteenth–nineteenth centuries the body was conceived rather as a physical mechanism with its many parts performing particular functions, and the building of society was envisaged as the structuring of units into functional wholes. But through the extraordinary biological advances of this century it now seems appropriate to regard the body as a most intricate communications-system and to proceed from this to a new conception of society in the same image. To build up the body is to allow its basic genetic code to gain its full and unhindered development by continuing interaction with its environment within a given principle of integration. The body can live only in relation to its total environment: the body can survive only through its capacity to change: the body grows to maturity as it remains under the control of what has been called 'a super-ordinated principle of integration'.

In the normal span of bodily existence there seem to be four critical stages—birth, puberty, parenthood, death. Within an agricultural economy these correspond intimately with the germination of the seed, the growth to maturity, the ripening and shedding of the fruit, the death of the plant. Rites of the body can therefore be symbolized by the visible processes of nature and the whole complex of man and his environment can be held together within a single symbolic whole. When however the body is regarded merely as a physical mechanism the stages which I have defined lose much of their significance. In an industrial economy the raw material is fed in, passed through the mill and lifted out as the finished article. There is no return to the beginning. When the article is worn out it is finished. Does this mean that all that can be said about the career of the body is that semen is fed in, processed and then turned out as the finished article, which in time will die and perish? If so bodily rites have little significance. Stages may be marked in the life of *the spirit*,

but what is done to or for or through *the body* itself has little if any ultimate significance. A strict body-mind or body-spirit dichotomy spells death to ritual activities of a bodily kind and leaves little meaning in the idea of *building up the Body of Christ*.

But in the new conception of the body as an intricate communications-system the connection between body and mind or body and spirit is powerfully restored. A programme for a body acts within an environmental complex: vital and continuous inter-actions with the environment lead to the growth and development of the body: at length it reaches a stage of maximum harmony with its environment: it transmits messages which are the codes of new life-units: it declines and ultimately dies. In the whole cycle it remains intimately related to what is happening in the universal integrating system. Only when an absolute equilibrium is reached between any parts within the whole does death ensue. This means that critical stages can again be symbolically celebrated, but this will normally be done through a series of dramas in each of which the individual is given significance not just through a word but through the simulation of a particular style of life.

Thus at the time of birth there must be the enacting of a drama celebrating the *potentiality* of life: at puberty the assumption of the *responsibilities* of life: at marriage the actual *reproduction* of life: at death the *transmutation* of life. The particular form of the ritual drama cannot afford to be rigid and inflexible. If the whole universe is to be regarded as an evolving organism, provision must be made for evolution in its symbolic ritual dramas. That which is appropriate to the life-conception of one culture may be inadequate within another. For example water-rituals have varying significances in varying geographical and cultural conditions. If water is still to be used in the West in a ceremony symbolizing the potentiality of life, any idea of cleansing from a taboo must be discarded and the positive significance of water as life-bringer and life-sustainer must be powerfully represented. Water in the Fourth Gospel is pre-eminently associated with generation and renewal of life. It should not be impossible in our own day to construct a symbolic drama in which water has some part to fulfil within a ritual representing the potentiality of *life* within God's family and domain.

The rites of passage, I have suggested, may be re-ordered in accordance with our new conceptions of *life* in nature and man. Through these rites men *celebrate* (and do not merely take for

granted) their privilege as participators in the one Divinely-given ongoing life of the total organism. Through celebration the emotional crisis associated with each of the major transitions of life is accepted and transcended. Through the dramatic ritual the individual is more fully integrated into the society, the society renews itself through the individual. But a crucial question still remains. Is there any place for a *sacrificial* drama within such a re-ordering of rites? Sacrifice is one of the oldest of all ritual-forms. Is it outmoded in the light of our new understanding of the natural order?

Far from being outmoded it has in a real sense gained a new centrality. Terms such as 'the travail of creation', 'the cost of creation' are freely used by scientists. The older phrase 'There is no life except through death' should perhaps be adjusted and more accurately stated as 'There is no reproduction of life except through a destruction of life', but the principle remains. It is carefully expounded by Professor Carl Pantin in his Tarner Lectures: 'Perhaps the most striking feature of the physiological analysis of the activities of living creatures', he wrote, 'was the continual proof that if we consider the whole system of the combustion of the food they use as fuel and the mechanical and other work done, as well as that for all else they are doing, the thermodynamical rules are absolutely obeyed, as far as accurate quantitative measurements can tell us. The one thing we can say is that the increasing organization of living structure is built up at the expense of still more increasing disorder elsewhere; so that though we have no evidence in the whole system that the second law is contravened, in a sense living organisms grow by accumulating order or negative entropy; and like certain machines they do this by guiding the increase of a much larger quantity of entropy. Like the machines, they are parasitic on the increase of entropy, but, unlike them, the result of their activities is to produce more similar machines. Organisms delay and guide the degradation of energy to give limited amounts of ordered system which do this very thing.'[1]

Living organisms have to be 'fuelled' constantly 'at the expense of', by being 'parasitic on' other systems of order, other sources of energy. And this has been the case from time immemorial. In earlier times man saw himself more directly and obviously taking life from the animal world, consuming life from the vegetable world, cutting into the earth's surface to sow his seeds. The grasping of life-energy

[1] C. F. A. Pantin, *The Relation Between the Sciences*, p. 36.

was an activity which produced a marked heightening of his emotions. To discharge the emotion, to escape harm from what had been a dangerous enterprise, to ensure the restoration of life to that which he had plundered, man engaged in the dramatic ritual of sacrifice. Through a symbolic death, the total harmony of life could be restored.

Professor L. C. Birch writing primarily as a biologist touches on this theme more than once in his published works. In a section on St Paul's reference to the travail of creation in Romans 8 he speaks of a 'cross-pattern' as 'woven deeply into the texture of the whole of creation'. And in an essay on 'creation and the Creator' he concludes a section on The Travail of Creation by remarking that 'Christianity reveals the Cross as central to the meaning of human life. Evolutionary studies are revealing the same cross pattern deeply woven into the very fabric of creation.'[1] In and through the symbolic offering of the energy derived from the natural order, in and through the symbolization of new life through death as enacted by the Son of God in the sacrifice of the Cross, the Body is built up even as the symbols of the body are constantly offered and consumed.

This is perhaps the greatest mystery of human existence. The scientist sees the principle of life through death, order through an increase of disorder, operating throughout the organic world. The historian of religion sees the principle ritually represented in countless cult-systems which man has devised. This is the kind of world in which we live and from which there is no discharge. The Christian-cult, especially as expressed in the Eucharist, may be rejected or simply allowed to fall into desuetude. The question remains whether such a denial of its religious ritual will not lead to the breaking in of strange rites and orgiastic ceremonies through which the emotions related to this universal characteristic of the human organism can gain release.

V

Man can be viewed as an amazingly complex organism living in constant relationship with his natural environment. He can also be viewed as an astonishingly complex memory-system moving from a

[1] *Science and Religion*, Edited by Ian G. Barbour, p. 214.

past of historical experience towards a future of uncertain, though in some respects predictable, kind. Viewed in this way organic life, and the major recurring stages of organic life, assume less importance: in the foreground now is man's *cultural* inheritance from his particular past and from the critical historical events which had a major influence upon his past and may still be significant for his future. By celebrating these special events he attaches a meaning to the totality of the history of his society and reinforces his own and his community's hopes for the future.

Normally the outstanding event or complex of events in the past is associated with the exploits of a particular hero. An expert historian investigating a chosen period sees many forces—economic, political, social—at work determining human activities. But in the last resort it has usually been a creative individual who has succeeded in effecting a radical change within a limited period of time. Whatever ripeness there may be for action, it is he who acts, often in the face of entrenched forces and so at risk of his own life. He it is who is remembered when most of the contributing factors are forgotten.

Until the beginning of the nineteenth century, history, its changes, its crises, its spectacular events, its heroic figures, had in the main been interpreted and celebrated within some comprehensive *religious* context. What a hero had done, it was believed, had not been done in his own name or by his own unaided strength: it had been done in the name of Divine Power. This power had equipped him, had hindered his enemies, had manipulated natural forces on his own and his people's behalf. The exploits of the hero were acclaimed and recalled but always within the context of a divine providence which was worthy of final honour and praise.

Within such a context and outlook celebratory rites were altogether appropriate. If a god had acted in a particular cluster of events which was being recalled, the re-enactment of the event would bring about a special sense of communion with the divine actor: it would at the same time confirm the celebrants in the conviction that the god who had at some earlier stage acted in a particular way would in similar circumstances so act again. He who had been the human mediator of the Divine salvation in the original event would be given special honour in the solemn re-enactment, and the hope of the advent of another hero of comparable stature would be revived. But within the purview of the *secular* historian there was no need to look

for special divine providences or interventions. The notion of miracle had increasingly come under fire of criticism and the need to view historical events *sub specie aeternitatis* was increasingly discounted. The task of the historian was to search for the *facts*, to record the facts and in general to give some kind of orderly arrangement of the facts. He might see them strictly in terms of cause and effect or of a pattern of dialectial relationships or of progress towards a humanitarian ideal. But there was no necessity to look for divine purpose in history nor for an overall direction in history. Moreover, it was felt, the role of the great man could be exaggerated. Just as in nature an impersonal process of natural selection had been operating over thousands of years, so in history an inexorable process of man struggling with his circumstances had brought society to its present stage. There was no cause for special celebration. The only policy open to mankind was to press on.

Although such an interpretation of history has been entirely possible in theory, it is in the last resort an individual and a subjective interpretation which can only with presumption claim to represent ultimate truth. The memory of the community into which an individual is born has been conditioned by particular events associated with outstanding individuals in the tradition of the community (especially if, in line with the distinction to which I have often returned, the community looks back to nomadic rather than settled agricultural origins). The very dynamism of the community has sprung out of such events, its survival has depended upon their renewal. The actual ascribing of the events to the operations of a divine purpose may become a mere formality or may be omitted altogether. But that history in the widest sense has brought particular privileges to and opened up a special destiny for this particular community is still held with tenacity and deep conviction.

Within such a general conception the community is essentially a *redeemed* community. It has been delivered from a state of bondage or oppression or poverty or threatened disaster into a condition of freedom and purpose and hope. It has normally owed this deliverance to the heroic leadership of an outstanding individual who has not emerged unscathed from the struggle. It has rarely entered immediately into a complete reversal of its former unhappy condition: normally battles have still had to be fought to preserve what had been hardly won and these have demanded qualities of devotion and heroism within the community's life comparable to those which

characterized the primal hero who led his people out into the new redemption.

The paradigmatic example of this view of history has been that of the Jewish people looking back to their deliverance from the slavery of Egypt under the leadership of Moses. Thereafter all who belonged to this community, whether by birth or adoption, were admitted by a particular ceremony of initiation (circumcision, though possibly near the beginning of the Christian era this was in some cases relaxed and proselyte baptism was substituted) and sustained in their allegiance by a particular ceremony of remembrance (Passover, though to a minor degree every sabbath was a memorial of redemption). The same general pattern of rites celebrating initiation and recall was adopted within primitive Christianity and again became the determinative ritual-pattern of communities of radical reform in the sixteenth century of our era. But in the Christian context the memorial aspect of the rites has been supplemented by a stronger emphasis upon the *communion* aspect. To a degree it was possible to speak of the Israelites as having been baptized into Moses and as having communion with Moses in their total community existence. In a far higher, indeed in a unique way, it was possible to speak of those who had been redeemed by God's Servant, His Messiah, as having been baptized into His death and resurrection and as having communion with Him in His Body and Blood. In Baptism and the Lord's Supper two supremely relevant community rites re-enacted the creation and the preservation of the redeemed life.

Passover was an intensely dramatic re-enactment of the exodus from Egypt. The setting, the gestures, the words spoken, all were designed to bring vividly into remembrance the night when the destroying angel passed through the land and Israel was saved. But the central part of the whole ceremony, when the ritual actions reached their climax of emotional intensity, was the actual consumption of the lamb. Originally this festal meal must have marked the yearly renewal of flocks with the birth of lambs in the spring. Now, however, a new springtide was being celebrated. It was the rebirth of a particular people. On a critical night blood was shed, flesh was eaten, there was in a real sense communion in the body and the blood of the lamb. Within the Christian context there was a new night of critical deliverance, a further adaptation of the spring ceremony, the provision of bread and wine as symbols through which

the new Israel could continually participate in the communion of the body and blood of the Messianic Saviour. Again the meal constituted the high point of the total ceremony. In and through it there was to be an intense consciousness of communion with the Christ and with one another.

Amidst all the changes in social customs and conventions which have come about through man's increased awareness of the material conditions which determine so much of his history—climate, natural resources, geographical variations, pests, disease—there has been little obvious decline in the popularity of *the communal meal*, the banquet, to celebrate what is regarded as a notable and determinative occasion in the life of the community. The annual dinner, the anniversary feast, is regarded as the most appropriate way of combining remembrance with communion. Only those who in some way share in the heritage of the event are privileged to take part: those who share in the remembrance renew their bonds with one another in a commitment to re-enact in their own age what was effected on their behalf at some earlier time.

This being the case it is not surprising that within Christendom at large there has, over the past few decades, been a marked renewal of emphasis upon the Eucharist as a common meal, a memorial of redemption. Even within the great Church whose traditional emphasis has lain upon the Mass as sacrifice, a leading theologian has exclaimed: *Le Repas, c'est tout*. Sometimes the formal arrangements of the Eucharistic service have so been transformed as to give central prominence to the note of sharing in a common feast: sometimes the Eucharist has been followed immediately by a general participation in a common meal. Probably at no point at the present time does the traditional Christian ritual come nearer to what is regarded as an appropriate symbolic-form within the world at large. This is not surprising when it is remembered that in face of the inexorable, mechanical forces which dominate so much of man's daily life and shape it into the repetition of a flat routine, the chief remaining way of relaxing together and celebrating together is by sharing in a meal of more than ordinary quality and form. Perhaps the chief problem from the Christian point of view is to retain a *weekly* service of this character when society at large seems geared to less frequent celebration.

So far as *initiation* is concerned the problem seems more difficult. To share a common meal with those who share a common memory

and a common gratitude—and then to return to take one's part in the ordinary ways of the world: this seems an acceptable form of behaviour. But to be initiated into a group which gives the impression of being a secret society or a closed shop or an exclusive club immediately raises suspicions and questions. What right has any body of men and women to cut themselves off from the wider society? Normally they depend on the wider society in economic ways: often in welfare and education: usually for protection and defence. The cutting-off from the wider society is only justified if it makes possible some intensification of learning and experience which can ultimately be of benefit to all.

The symbol which emphasizes separation has always been a danger signal in relations between Jews and their neighbours. It has often been a danger signal when used by Christians to emphasize apartness, specialized knowledge and privilege, an exclusive destiny. Yet a symbolic rite designed to recall an event in history when a particular group was cut off from or set apart from or delivered from some larger unit of society cannot fail to stress the note of exclusiveness within the life of the individual to whom it is applied. He is made a member of a privileged and so in some sense a superior group.

Such a form, it would seem, is only justified if the symbolism of cutting off is immediately counter-balanced by a symbol of identification with, if the symbolism of death to a former servitude is immediately succeeded by the symbolism of resurrection to a new service in freedom. And this, at best, has been the emphasis within Christianity as stemming from the initiation of Jesus Himself. He withdrew, but only in order to return: He submitted to John's baptism, but only in order to identify Himself with a mission of salvation: He made a decisive break with the village community of Nazareth, but only in order that He might devote Himself to the welfare of a wider society. Any form of Christian initiation which does not belong to this definitive pattern cannot be regarded as authentic.

One question however still remains. Does any form of *water-ceremony* have the power of expressing this essential symbolism in the world of today? Many sectarian groups since the sixteenth century have insisted upon immersion in water as being the necessary form of Christian initiation, but although this pattern of ritual undoubtedly possesses a marked dramatic quality it has tended to stress the note of separation and exclusiveness rather than that of

commitment to service of which I have spoken.[1] Other patterns of initiatory rite have been the clothing with a particular form of symbolic dress (in universities and schools, in legal contexts, in police and postal services, etc.), the signing of the name within a renunciatory and promissory framework, the payment of a due. An early practice in Christianity used the sense of drama engendered by a passage through darkness into light. Probably the prominence of the water-ceremony in the Christian tradition is largely due to the great deliverance through the Red Sea having come to be regarded as the prototypal event of which the death-resurrection event in Christianity was the great fulfilment. But if in any particular age a ceremony not associated with water seems more apt to symbolize within the idiom of the day the essential motif of death to the past order and of new life in the Kingdom of God, there seems no reason why it should not come to be used as an authentic Christian symbol.

In face of the growing automation and computerization of man's life in the world today, youth in particular seems to be searching for a symbolic rite by which it can celebrate its defiance of these vast impersonal forces—akin to mighty Empires or to imposing systems of Law or to inexorable determinacies of Fate—and be transported into a new realm of freedom and even ecstasy. Certain charismatic figures—Castro, Che Guevara, Mao—who seem to have led a resistance out into a wilderness have been accorded semi-divine qualities and have become the symbols of a new order. Initiation into their fellowhip has been through protest, demonstration, the march, the sit-in, a break with the 'establishment' and the vast impersonal technological order, a commitment to some unknown future in which the only certainty will be a communion in personal intimacies with those who despair of ordinary processes of rational criticism and reform.

The temptation has been strong for those with some knowledge of Christian history to see Jesus in the role of zealot-leader or messianic revolutionary and to seek initiation into His deepest fellowship by joining in freedom marches, by burning draft-cards, by fasting: or, at a more positive level, by giving generously to poverty programmes, by service in the ghettoes, by sharing technical know-

[1] There are obvious striking exceptions to this generalization. I have specially in mind the heroic career of William Carey and of the great number of lesser-known Baptists who have poured out money and service for the redemption of men and women throughout the world.

ledge with the peoples of underdeveloped countries. All these have a certain quality of renunciation of the world as it is and of commitment to the world as it may be in the power and spirit of Jesus the Christ. But no interpretation of the Jesus of the New Testament simply in terms of political revolutionary leader is tenable unless all the records are arbitrary fabrications—in which case no possibility of ordered Christian life and witness is conceivable.

It may be that any rite of conscious commitment within the Christian context[1] must be kept flexible and variable. Variety is to be found within the actual unfolding of Christian testimony in history. The archetypal form dramatized in the New Testament is that of withdrawal and return, renunciation and commitment, death and resurrection. Symbolic rites dramatizing this form may be shaped by the historical circumstances of a particular time and place. Initiation may need to be renewed in a new form under new conditions. The all-important feature of any rite, initiatory or re-affirming, which is worthy of the name Christian is that it shall in some way recall and represent His death and resurrection: 'always bearing about in the body the dying of the Lord Jesus, that the life also of Jesus might be made manifest in our body. For we which live are always delivered unto death for Jesus' sake, that the life also of Jesus might be made manifest in our mortal flesh' (2 Corinthians 4:10f.).

[1] As distinct from the more regular rites corresponding to the regularities of the natural cycle.

SYMBOLIC FORMS OF LANGUAGE

IN all human societies, language has come to be the chief symbolic medium of connection between man and man. A child, virtually from the moment of birth, begins to ejaculate sounds which will gradually be moulded into speech. These sounds I suggest, assume two basic forms—what I shall call the *coo* and the *cry*. The coo is the reiterated, re-echoing sound which corresponds to a relatively settled and structured rhythm of existence: it is the expression of a world which is secure and harmonious, the response in sound to an over-arching maternal protection and care. The cry, on the other hand, is the sharp and concentrated sound which corresponds to some break in the established order of things: it is the surprised reaction to an incursion into the child's world, sometimes expressing alarm, sometimes delight, sometimes hunger, sometimes pain. It is no exaggeration to say that the gradual expansion and elaboration of the coo, together with the periodic extension of the range and reference of the cry, constitutes the dual process by which the child advances in the science of direct and effective communication with others.

The earliest expansions of the coo may be detected in the reiteration of simple phonemes and in the introduction of variations in the form of jingles and rhymes. The earliest extensions of the cry manifest themselves as acquired words are used to express a widening range of emotions in reaction to events. Still further the very naming of persons and objects is a way of making bricks for the building up of a stable symbolic verbal structure: the very relating of unusual events is a way of taking the event into, and thereby extending, the existing symbolic word-system. Naming increases the sense of relationship and responsibility: recital of dramatic event extends the range of experience and anticipation.

In the realm of religious symbolism this distinction may be readily recognized. On the one hand the coo receives expanded form in the solemn recapitulation, the cry in the dramatic proclamation.

As far back as we can penetrate into the religious history of mankind we find devotees expressing a sense of world-harmony through liturgical recapitulations: at the same time we find countless examples of shamans or prophets reacting to significant events through exclamations and proclamations. Man does not find it enough simply to 'seek and find and feast': he celebrates a state of euphoria through liturgical hymns and prayers. Similarly he is not content to react to the unexpected and unknown simply by reliance on his own resources: he cries out for the help of transcendent Power or proclaims how that Power entered his situation to redeem and save.

The recapitulation and the proclamation of which I have just spoken receive their most sophisticated and externalized formulations in the literary genres of myth and history. The most characteristic form of myth is the creation-myth and this is the expression in language of the total pattern of ordered regularity as observed and experienced by any particular cultural group in its own particular geographical location: this may be regarded as the supreme example of the human coo. On the other hand the salvation-history is the expression in language of the total series of significant crises as recalled and re-experienced by a particular ethnic group in its own particular memory and hope: this may be regarded as the supreme example of the human cry. But whereas no society is totally lacking in links with a special locale, no society is totally devoid of significant memories, myth and history may often mingle and overlap. At the same time it has usually been the case that the one or the other has been the typical literary form in the life of any social group at any one time.

The dangers inherent in both forms are obvious. Myths have all too easily crystallized into fixed linguistic forms and Christendom has not avoided this tendency. A fixed canon in the Latin language, a fixed creed in Greek, are examples of mythical fixation which may seem to provide a haven of supra-temporality but which may instead promote what Philip Rahv once called a state of permanent insomnia. On the other side the historical record may focus upon a single event in isolation, no attempt being made to relate it to any wider historical context. Words are accepted as literal representations of events which took place in precisely defined ways. Sometimes translation is allowed, but for the orthodox the record in the original language is venerated as the symbol of the actual incursion of Divine power into the historical order. Regenerative-myth and

salvation-history have been the two most valuable verbal religious symbols in human experience: the fixed canon and the verbally inspired scripture have been potentially the most dangerous.

II

Christianity was born into a world strained and torn by opposing cultures. The Hebraic and the Hellenistic, each possessing a marvellous collection of symbolic linguistic treasures, faced one another, sometimes touched one another, sometimes even mingled with one another. With enormous courage a group of scholars translated sacred Hebrew scriptures into Greek: others employed Greek methods of interpretation to extend the range of reference of their sacred words. Thus assimilation had already begun when Jesus was born in Bethlehem and it seems clear that this process was particularly active in Galilee where Jesus' ministry was chiefly located. Jesus Himself used language forms which, although not altogether strange to the Jews, did not conform to the established pattern of immutable laws which was their verbal stock-in-trade. Indeed the 'coo', which had tended to become a rigid conservatism in Pharisaism, could only be met by a 'cry'—the cry which returned to and sprang out of prophetic proclamation—the cry which recalled the breaking down of past systems of human self-sufficiency and the opening up of a highway for the living God. At the same time, to a people living in the midst of crises and tensions, wars and rumours of wars, Jesus could also speak the word of comfort. Be not afraid, He said, this is God's world: God's rule is the encompassing reality: it has affinities with the regularities of the world of nature and of society: the myth of the Kingdom of God is one within which man can live at peace with himself and his neighbours. Seek ye first the Kingdom of God and all else shall be added to you.

Yet it is hardly open to question that the earliest Christian proclamation was pre-eminently in the nature of a cry. An utterly shattering event had occurred. If, as the psycholinguist George Miller has claimed, original combinations of elements are the very life blood of language, then nothing could have been more original, more life-giving to language, than the proclamation of *a Messiah crucified*. Here was the ultimate paradox, if not the ultimate contrary. *Messiah*, the encapsulation in a single word of the noblest memories and highest hopes of the Jewish people: *estauromenos*,

crucified, the encapsulation in a single word of the lowest depths of human degradation imaginable in Hellenistic culture. The Gospel was a herald's *cry*—Messiah died for our sins—which cast a light backward upon every agonizing struggle for righteousness in the history of the past and which threw a light forward to interpret the tribulations which would still afflict the people of God before the end of the age. *Messiah anathema—Christos estauromenos—Rex crucifixus*—in these amazing verbal contraries the extremes of all human experience were brought together, the greatest antinomy of human history was momentarily resolved. This was the key which Christians could now use as they went forward into new adventures and new confrontations with the world's language-systems. This key had unlocked the door of alienation which had hitherto barred the way to the reconciliation of man with his world, man with his fellows, man with his God. Christ crucified, the Lamb slain—they believed that this unique combination could serve to interpret meaningfully every agony of individual experience and every alienation of corporate existence. The language of the paradox, the absurd, the contradiction was already set at the very heart of the Christian faith.

Yet this is not the whole story. There was a famous word in the Greek language with which early Christians, in so far as they used the language of this particular culture, would sooner or later have to come to terms. It was the word *logos*. This, in a certain sense, was the supreme coo of Greek culture. It was the expression of an expansive confidence that the Beautiful and the Good are in ultimate control, that there is an ultimate harmony in the universe, that the logos in man can respond rhythmically to the logos in the universe, and that in the correspondence of logos with logos the very fullness of life can be enjoyed.

Before the collection of books which we call the New Testament was complete, the utterly daring identification had been made. The Son of God, who had actually come into the world as man, who had actually assumed all human attributes, was, it was claimed, Himself the Logos. In the eternal order of things He is the Logos of God: in humanity He is the Logos who gives meaning to the total human situation. By Him all things were created: in Him all things cohere: through Him all things move forward to their true destiny. This identification was in its way as daring and as far-reaching as the earlier identification of Messiah with the helpless victim of a brutal

crucifixion. It claimed the universe for Christ. It claimed Christ as the interpreter of universal human existence.

Language-wise this meant that forms both of dialectical interplay and of harmonious integration would soon gain full recognition within the developing Christian enterprise. This would in no way be easy just because the earliest Gospel had been so firmly set within the Hebraic tradition of proclamation rather than of dialogue, of protest rather than of assurance. It is doubtful if so great a transition could ever have been made had it not been for the availability of an already existent language-tool of immense subtlety and potential usefulness. This was *allegory*, already in use where Hebrew and Greek cultures were trying to live together and soon to become of still greater significance as Christians sought to interpret both the universe itself and their heritage of the Hebraic Scriptures in terms of the Logos. It is possible to claim that allegory was the preeminent linguistic tool used in the fashioning of what could be called a specifically Christian culture in the millennium which followed the Constantinian settlement.

As Curtius has pointed out, the method of *allegoresis* grew naturally out of a fundamental belief of Greek religious thought—the belief that gods express themselves in cryptic form, in secrets or in mysteries. The essential task of the religious devotee was to penetrate through the veils and coverings to the truth and wisdom which are concealed from the eyes of the crowd. What distinguished Christian allegory from, for example, Homeric or Philonic *allegoresis* was the steady conviction that the final check and at the same time the all-sufficient clue within any process of allegorical interpretation was to be found in the Logos Incarnate. He Himself had been hidden beneath a veil of flesh. But those who recognized Him could move forward confidently to apprehend the total universe in terms of the revelation of which He was the source and the end. Through an amazing combination of analogical and allegorical methods Aquinas, for example, was able to construct the most imposing theologia of medieval Christendom.

But the new era of the word which dawned upon Northern Europe in the fifteenth century soon grew impatient with allegory even though it did not discard the use of logic. Instead of *allegoresis*, the chief tool was now to be the *translatio*, the grasping of the meaning belonging to ancient words in their actual contextual situations and expressing that meaning through words actually in use in living

contemporary cultures. No longer was the emphasis laid upon truth hidden behind language-forms of majesty and mystery but rather upon truth coming to open manifestation through language-forms of vigour and even of vulgarity. Did not the eternal Logos manifest Himself amidst the dung and the hay of a common stable? Why should not the Word of God be expressed through the common homely vehicles of story and song? Logic might still hold its place of distinction in the construction of theological systems but for the proclamation of the good news the form which in broadest terms can be called *the story* would now take pride of place.

III

The use of linguistic symbols in Western Christendom is still strongly influenced by the fourfold division in the sixteenth century to which I have frequently referred. Patterns were then set which have only begun to receive serious breaches in this present century. It will be instructive to look at this division once again and particularly from the perspective of forms of language.

Those who remained faithful to the Roman allegiance clung tenaciously to the Latin tongue as the official religious language. Matters of everyday interest and concern, matters affecting the work and recreation of the common people, could be dealt with in the vernacular. But the language for matters of the intellect (philosophy, law, etc.), and above all for matters of religious knowledge and worship was Latin. The fact that the Scriptures had been translated into Latin and that the Vulgate possessed immense prestige amongst all other books naturally helped to give its language the ascendancy. In addition, however, the fact that the Roman liturgy had established itself in a place of eminence in the West and that the Canon had crystallized into a form of words which was not open to change meant that the most solemn moments of all religious experience were associated with a particular Latin formula which in itself suggested a dimension of religious majesty and awe.

Thus the twin mountain peaks which dominated men's verbal activities in late Medieval Europe were the Vulgate and the Canon of the Mass. At lower levels there were lectures, expositions, disputations, sermons in monastic and secular schools of learning, all in Latin. At still lower levels there were songs, popular sermons, manuals of devotion in the vernacular. In keeping with the tradition

of antiquity, the hierarchical pattern of society was reflected in the pattern of language used within the varying grades of social activity.

Grammar and Logic were the necessary preparatory disciplines for the supreme task of language which was to achieve a final and universal consistency in expressing in systematic form God's relations to man and the world—'final, inasmuch as thought penetrates to the nature of things and expresses realities and the relationships of realities; and universal, in that it seeks to order and systemize all its concepts, and bring them to unity in a Summa—a perfected scheme of rational presentation of God and His creation.'[1] This general conception of unity and universality was determinative for the Roman Church in the Middle Ages and it became almost an obsession when challenge and even rebellion became overt in the sixteenth century. A single universal religious language, an unalterable text of sacred scripture and an unchangeable canon of sacred liturgy, a summa of religious knowledge constructed by the aid of the one, universal instrument, logic—this was the official language-system of Roman Christianity. It is true that the inheritance from Augustine and the Middle Ages of a more mystical, devotional, poetic tradition meant that a different kind of language still had a place in limited areas. But in the main the orderliness, the rhythm, the dignity, the logical connections of Latinity prevailed. It bound together the whole community within one universal form of religious expression.

The critical change linguistically, so far as the Church of England was concerned, was the substitution of English for Latin in the regular reading of Holy Scripture and in the regular recital of the liturgy. A translation of the Bible combining vigour and dignity was already available in the sixteenth century and was to attain its definitive and classical form early in the seventeenth. The gradual introduction of worship-forms in English was made complete and uniform for the nation when the First Book of Common Prayer was issued. The remarkable thing was that both Bible and Book of Common Prayer attained a standard of linguistic excellence whose quality has rarely been questioned. It combined the dignity and sonority of the Latin with the directness and concreteness of Anglo-Saxon common speech. The influence of the past, including the particular contribution of ancient Greek writings was preserved: the growing confidence of the present in the potentialities of the

[1] H. O. Taylor, *The Mediaeval Mind*, II, p. 365.

vernacular was manifest. English had closer affinities with Latin and the Romance languages than was the case in Germany and Scandinavia and this made for a more conservative break with tradition. The clergy were still required to be proficient in the Latin tongue. But the whole emphasis was upon English as a language capable of expressing the deepest religious truths and the highest religious aspirations in a symbolic form in which the whole nation could be united. The nation hearing the word of God, the nation joining in a common language of prayer, represented the double ideal of the English reformers.

When it came to the language of theology and instruction, the situation was less clearly defined. There was no attempt to produce a single confession of faith in the sixteenth century, the Articles of Religion being framed to deal with specific matters of controversy in a reasonable way. Such a book as Hooker's *Laws of Ecclesiastical Polity* gained considerable fame but no official status. Homilies were made available for reading in Church, having been designed principally with the ends of practical religion in view. And it may be assumed that preaching, which was strictly controlled by authority, was also normally intended for the edification of the life of the Church. There was variety and controlled experimentation. In this way language could develop organically, growing out of a long cultural tradition, relating itself to the needs and aspirations of a whole people, drawing upon the patterns of the natural environment, open to minor changes in harmony with what in England has been the slow evolution of social patterns. In contrast to the single universal logic of the Roman Church, the Church of England sought to establish a regional uniformity of language which combined faithfulness to tradition, open-ness to new knowledge and readiness for conservative experimentation. Moreover the language was as far as possible to be heard, learned and recited by the people at large. By becoming familiar with common symbolic language-forms, the nation could grow up into the pattern of life to which it had been destined in God's design.[1]

[1] Dean W. R. Matthews has told me that half a century ago Rudolf Otto stayed with him in London. He went about from place to place on his own, trying to sense the quality of the general life of the English people. At the conclusion of his stay he said: 'The English are still the most religious people in Europe. What is the chief reason? It is the existence over the centuries of the Book of Common Prayer.'

The most radical break in language-symbols at the time of the Reformation was that of Martin Luther. As we have seen, he deliberately moved amongst ordinary people engaged in their common tasks and listened to the forms of language in common use. His native German was less influenced by classical structures than had been the case with the Romance languages and when it came to translating the Bible into his own tongue the very sharpness of the contrasts—in ways of thinking and in word-forms—made for freshness and vigour of impact. He was familiar with the humanist scholarship which was restoring the contributions of the original Hebrew and Greek, but his main concern was to use language in such a way as to arouse, challenge and lead to decision. Through sermons, lectures, pamphlets, translations, and hymns he brought the living Word of God into the very midst of the common life of his people.

In a valuable study of the new hermeneutical method which appears in Luther's early lectures, Gerhard Ebeling contrasts the Reformer's exegesis with that of the schoolmen.[1] He shows how Luther revised the method of investigating the fourfold sense of Scripture and in particular came to regard the old distinction between letter and spirit, between the literal, historical sense and the spiritual meaning in a quite different way. The literal, historical, was not merely a preliminary sign pointing to something far more important. It was important in itself. It corresponded to God's actual entry into historical reality. Still more significant however was Luther's view of language, not primarily as a means of taking possession of a 'packet' of information, but rather as a means of communicating, a speech event between person and person. Thus the words of Scripture are to be received not primarily as symbols clothing inner divine mysteries but rather as actual speech-forms through which the Word of judgment and promise comes to men. Thus, as Ebeling concludes: 'the Hermeneutical task can only consist of the fact that we devote ourselves to the service of the word-event in such a way that the word becomes truly word, and that it occurs as pure word in the fullness of its power.'

Still another attitude to linguistic symbols appears in the work of John Calvin. Without question Calvin was a man of genius—in legal, logical and linguistic scholarship. His written Latin attained the highest degree of excellence and his influence upon the developing

[1] *Theology Today*, April 1964, pp. 34ff.

French language was profound. But in this case there was no obvious conflict or contrast between the classical and the vernacular. Latin and French both symbolize movements of thought from first principles to particular cases. They are clear, precise, logical, though not necessarily unemotional. But it is emotion held under control and channelled into well-defined forms.

The great contrast between Calvin and the scholastics is that whereas for them there were *two* Books to be studied and interpreted—the Book of Nature and the Book of Revelation—for Calvin *one* Book was all-important and all-sufficient: it was the Bible, Holy Scripture, the book, inspired by the Holy Spirit, the perfect compendium of the doctrine of salvation, the sacred text of which a 'good and right understanding' is man's highest blessing. Calvin gives little evidence of having ever been deeply interested in the world of nature. He had from his earliest years been instructed in the classics and in legal documents. The ideal of teacher and learner seems to have been with him from the beginning. God had, in his own words, at some critical moment subdued his own heart to teachableness. Now it was his supreme aim to guide and teach others who desire to be 'instructed in the doctrine of salvation'. The very word *Institutio*, which stands as the title of his greatest work, means 'instruction' or 'education'. It is a book designed as 'a key to open a way for all children of God', as the paving of a road on which all may walk who desire to understand Scripture. It is essentially an *orderly* arrangement, a guide to a sure path. And although Calvin was constantly engaged in preaching and teaching publicly, it is by his *writings* that his teaching was to assume its supreme influence for future generations. Within the Calvinist tradition the written Word, the Bible, has been primary, the Institution and Confession of Faith, secondary, the work of preaching and teaching and catechizing and administering the sacraments next, being all dependent on the Word and its correct interpretation. Calvin, like Luther, turned away from the scholastic method of fourfold exegesis. Instead the all-important concept was the way of salvation. The people of God had been called by the Holy Spirit to walk in the way leading to eternal life. It was through words of instruction written, taught, learned, obeyed, that this end could alone be attained.

For the scholastic theologians, words, whether referring to the natural order or to the salvation-history disclosed in Scripture, were symbols pointing to and in some measure revealing the unfathom-

able depths of the Divine Mystery. But in the Tridentine decrees
they had become direct signs and formulations of Divinely-given
authority. For Anglicans in the sixteenth century words read from
Scripture, together with words recited in common prayer, sym-
bolized the living intercourse between God and man leading to the
building up of the body corporate according to the pattern of Christ.
For Luther words were symbols of God speaking to man, directly
and creatively, in judgement and in grace, and calling forth from
man the true response in faith. For Calvin words, above all in their
written form, were regarded as symbols of God's perfect and com-
prehensive plan of salvation. So awesome were these words that often
man could only respond by submitting himself in silence to the
majestic will of God.

IV

Common to each of the four religious systems which I have just
outlined[1] is a single framework which Erich Auerbach has called
'the Christian figural-schema'. This was an awe-inspiring succession
of events: 'the complex of the Fall, of Christ's birth and passion,
the last Judgment.' However important the events of earthly exis-
tence might seem, they were always overshadowed by the heavenly
drama. There might be varieties of ways of viewing the place and
significance of symbolic forms but that symbols were necessary to
point to the realities of the transcendent order was scarcely open to
doubt.

'Then', Auerbach writes, 'in the course of the sixteenth century,
the Christian figural-schema lost its hold in almost all parts of
Europe. The issue into the beyond, although it was totally abandoned
only in rare instances, lost its certainty, and unmistakability. And at
the same time antique models (first Seneca, then the Greeks also)
and antique theory reappeared, unclouded.'[2]

But the influence of antique models, though powerful in archi-
tecture and literature, was only a temporary revival which scarcely

[1] In the case of the third I have focused attention on Luther himself and his
creative contribution to language rather than upon the more systematic language-
forms which established themselves in Lutheranism. These would reveal a
larger emphasis on the polarities of law and gospel, the Kingdom and the Church,
justice and justification, i.e. the *dialectical* form rather than the existential which
characterizes Luther's own activity of communication.

[2] *Mimesis*, p. 279.

affected this loosening of the link with the beyond. In the West man's interest was turning first to the natural order in which he lived and which he was destined increasingly to control and secondly to the social order which he inherited and which he was destined increasingly to change. The new language of the natural order was to be natural science: the new language of the social order was to be history. And each of these languages would have less and less place for symbols pointing to a *transcendent* realm of being. In contrast to Auerbach's figura-conception, in which 'an occurrence on earth signifies not only itself but at the same time another, which it predicts or confirms, without prejudice to the power of its concrete reality here and now', and in which 'The connection between occurrences is not regarded as primarily a chronological or causal development but as a oneness within the divine plan, of which all occurrences are parts and reflections', the new emphasis would be on the concrete reality, here and now, and on chronological and causal connections within a this-worldly complex rather than within a divine plan. The notions of miracle in nature and special intervention in history would be increasingly difficult to maintain.[1]

Expressing this epoch-making change in a slightly different way, we may say that until the seventeenth century the dominant concern of European culture was what Ernst Curtius has called the 'reverent reception and faithful transmission of a precious deposit', this deposit being derived from classical and Christian literature. Then came the great revolution in thought and action. Instead of the reverent reception of a deposit came the confident exploration of an immediate reality. Instead of the transmission of a particular interpretation of human history came the detailed search for independent facts. Things in themselves would be the scientific mind's right object. Events in themselves would be the legitimate goal of the historian's search. The new instruments of measurement would facilitate the first enterprise, the new chronology would direct the second. Things and their connections would be represented graphically, mathematically. Events and their connections would be represented historiographically, chronologically. The idea would be an objective, impersonal, exact definition, whether of the thing or of

[1] Reverting to my initial distinction between the coo and the cry, men will now increasingly seek to establish the coo either in terms of a universal mechanism represented in mathematical form or in terms of universal history expressed in some kind of linear, sequential way.

the event. And the more the language used could conform to this pattern the more useful and universal an instrument it would be.

But how could *change* and rates of change in the natural order be expressed mathematically? The invention of the calculus made this for the first time possible. How could change and speed of change in the social order be expressed in writing? The daily newspaper (monthly and weekly were variants, but the daily came to be the accepted standard of measurable change) with its trained reporters whose whole art was devoted to the detection of change—the new, the 'news'—gradually developed a new kind of language appropriate to its particular function. A newspaper certainly included reflection and interpretation, but unless it could focus attention on particular events, new events, potentially important events, its chances of survival were negligible.

So from the seventeenth century onwards there has been an ever growing volume of scientific sign language representing the world of nature—its elements, its connections, its changes, its ordered patterns. Similarly there has been a growing volume of historical sign-language representing the world of human society—its factual past, its inter-connections, its order, its patterns of change. Each system has given the appearance of being self contained and the language of each system has tended towards abstraction, quantification, one-to-one correspondence. There has been little place for symbolic-language in the sense of language which points towards transcendent realities and activities.

Yet in spite of these powerful tendencies towards objectification and abstraction in describing man's natural and social environment it has never been possible to eliminate the subjective and personal aspects of any process of observing and experimenting and reporting and recording. Man only exists *in relation to* his natural and social environment. Man only speaks *in relation to* his natural and social environment. There is the language not only of measurement but also of sensitive appreciation, not only of recording but also of interpreting. Man has continued to express his appreciation of the natural order through the language of poetry: he has carried forward his task of interpreting history through the language of the drama. Poetic language is essentially the response in words of the sensitive spirit to the world of nature: dramatic language is essentially the response in words of the imaginative spirit to the world of human relationships. Poetic language assumes the *forms* of myth, epic,

lyric, song; dramatic language the *forms* of the play, the novel, the biography, the story. In each case the subjective-objective dialectic is in constant interplay while the language-form is taking shape and even in the final written form the words can still retain something of the dynamism operating in their construction. In other words they bear something of the character of symbols pointing towards realities (objects or events) which cannot be expressed through precise, definable, one-to-one correspondences.

The contrast I have drawn between scientific and chronological objectivity on the one side and poetic and dramatic dialectics on the other has been partially narrowed in the twentieth century by the recognition that observation, experimentation, and recording are all *personal* activities and that all knowledge is *personal* knowledge. The personal factor can never be entirely eliminated. Yet while this has come to be recognized in theory the actual means of abstracting, encoding, and programming information have multiplied in a way which would have scarcely been dreamed of at the beginning of the century. Language describing the construction and processes of the natural order has become increasingly technical, mathematical and impersonal: language describing the structure and processes of the social order has become increasingly statistical, collectivist, and again impersonal. Yet through the mass-media of communication the use of the language of poetry and drama in film, play, novel, opera, song, ballet, story, travelogue is more widespread and is reaching wider audiences than ever before. From one point of view technical and mathematical signs seem to be the language which man uses to control his world: from another point of view poetic and dramatic symbols seem to be the altogether powerful agents which influence the human psyche.

V

At the beginning of the twentieth century, natural theology had little place for symbolic language except when trying to speak of the transcendent God as originator of the physical universe or of the immanent God as the life-force of the biological universe. Numbers, geometrical forms, laws of motion, observational data were the order of the day. God and the Symbol became increasingly remote.

Historical theology also had little place for symbolic language except when trying to speak of the transcendent God as Lord of

history or of the immanent God as redemptive agent within the historical process. Dates, causes-and-effects, archaeological and documentary data, seemed all-important for the plotting of the ascent of man from his lowly origins to his present state. God and the Symbol appeared less and less in the writing of universal history.

But as the twentieth century has progressed the earlier specialization and departmentalization of the sciences have come increasingly under criticism. The ever-increasing concern is for inter-relationships and inter-actions, for ecology and eco-systems, for the total organism of which man himself is a part. It is, of course, still possible to abstract particular configurations for examination and representation in terms of mathematical formulae. It is even possible to entertain the hope of finding a formula which will encompass the whole universal process. But it must still be affirmed that the formula cannot gain expression nor can it function in isolation. Always it is a matter of *man-and-the-formula*, man discerning and using the formula, man testing and correcting the formula. In other words every operations-system consists of the Self and the Symbol, the mind and the simulated model. Each interacts with the other within a continuing process.

If this is true so far as man and his relation to the world of his own experiencing is concerned (and in using the singular 'man' I do not suggest that the individual can act in isolation—his models and hypotheses must constantly be checked and re-checked by intercourse with his fellows) it becomes possible to extend and extrapolate this process to a unifying limit where God is conceived as relating Himself constantly to a total organismic model, integrating within its embrace all the symbol-systems proposed by man for the unification of his own experience.

Perhaps the most ambitious attempts in modern times to devise language-forms which could be employed in this way have been those of A. N. Whitehead and of Teilhard de Chardin. Their language is analogical, simulatory, even mythical. It lays hold of terms in common use in scientific disciplines and stretches them towards the limit where God and the all-comprehensive Symbol together represent the total organism whose living processes man perceives only partially and fitfully. It has been said that the language of Teilhard is poetic rather than strictly scientific and there is a measure of truth in this charge. But it is difficult to see how any other kind of language can be used when a writer attempts to stretch

beyond the limits of direct observation and experiment towards a total embrace. The poet seeks to create a new, though limited, world through his words. The religious man, absurd as it may seem, seeks to use language which will encompass the whole universe. He may use such terms as logos, primordial, omega. In the specifically Christian tradition the whole created order is described as far as its essential structure is concerned in terms of cosmic man, archetypal man, the divine organism: as far as its activating energy is concerned in terms of creative, dynamic, life-giving spirit.

The struggle for words adequate to expresss the Christian's faith that the universe is not a self-contained system but is and has been for ever dependent upon a living God never ends. Yet the simplest analysis of the empirical world in terms of structure and energy can by analogy be extended to an expression of ultimate structure and ultimate energy and if this is done there seems no reason why the time-honoured language of logos and pneuma, cosmic man and creator spirit, should not continue to be employed. There will be expansions, interpretations, imaginative reconstructions. But there is surely still a place in human affairs for the poet who wrestles with words and seeks to symbolize through them the ultimate coherence of the universe in relation to the God who creates and sustains and directs towards a meaningful goal. That 'He is the image of the invisible God, the first-born of all creation; for in Him all things were created . . . through Him and for Him' is a symbolic state-ment still capable of assuming rich and satisfying meaning: that the Spirit is the energizing agent of life and creativeness is likewise symbolically suggestive and eloquent. Organic and dynamic symbols are still appropriate when seeking to relate the universe as we know it to ultimate reality.

VI

What then can be said about man the individual in relation to the total *social* complex of which he is a part? How can he make the leap such as will enable him to interpret the mind of *the other* from within his own stance? How can he even do this in an immediate situation within his own culture, much less when confronted by the task of interpreting a communication from a situation in a culture long past? To communicate, to interpret, to translate—these are the most formidable operations for which man is responsible at any stage of human development.

Obviously if man is to achieve any communication with his fellow, whether that 'fellow' be a figure who lived and spoke in the past and whose words have somehow been preserved or a figure confronting him in the immediate present, there must be some common properties possessed by each. Many attempts have been made to define these common properties, but they have often been vague and speculative. Today the concentration of attention seems to be upon the most conspicuous of all common properties going beyond the basic capacity to breathe, eat, drink, move, react and reproduce offspring. It is the capacity to employ rule-governed language.

'*Every human group* that anthropologists have studied has spoken a language. The language always has a lexicon and a grammar. The lexicon is not a haphazard collection of vocalizations, but is highly organized; it always has pronouns, means for dealing with time, space and number, words to represent true and false, the basic concepts necessary for propositional logic. The grammar has distinguishable levels of structure, some phonological, some syntactic. The phonology always contains both vowels and consonants and the phonemes can always be described in terms of distinctive features drawn from a limited set of possibilities. The syntax always specifies rules for grouping elements sequentially into phrases and sentences, rules governing normal intonation, rules for transforming some types of sentences into other types.'[1]

Here is one basic property which appears to be common to all mankind. But there is a second. Besides the primal rule-governed structure there is the capacity to make novel combinations. 'Original combinations of elements', Miller writes, 'are the life blood of language. It is our ability to produce and comprehend such novelties that makes language so ubiquitously useful. As psychologists have become more seriously interested in the cognitive processes that language entails, they have been forced to recognize that the fundamental puzzle is not our ability to associate vocal noises with perceptual objects, but rather our combinatorial productivity—our ability to understand an unlimited diversity of utterances never heard before and to produce an equal variety of utterances similarly intelligible to other members of our speech community.'[2]

Basic structure and combinatorial productivity, rules and novel associations, grammar and metaphor—these are the indispensable

[1] George A. Miller, 'The Psycholinguists', *Encounter*, July 1964, p. 34.
[2] Op. cit., p. 33.

pairs within any living language. And it is through the medium of living language that man enters into relationship with his fellow, whether that fellow be the author of the book of Genesis or of the Iliad or of the plays of Shakespeare or of the article in the morning newspaper or the man talking to him in the privacy of his own room. It is true that other factors are involved when communication is effected face to face. Language always operates within a certain context and it was with that context that I was largely concerned in the earlier part of this section when discussing man in relation to his world. But the language-event as such is to be viewed in the light of the pairs to which I have drawn attention. Structure and energy in language are the indispensable ingredients if communication is to operate as a living process.

In this process of inter-communication man is constantly seeking to interpret his own and his fellow's experiences within some coherent and ordered scheme. He looks for sequences, correspondences, patterns, similarities: he also becomes aware of discontinuities, contraries, changes, contrasts. The first group fits the emphasis on grammatical structure, the second the emphasis on metaphorical dynamism. Even a seemingly commonplace piece of writing or spoken conversation contains elements of both. But a more comprehensive coherence and meaning normally finds expression through a narrative in which ordered structure and unexpected correlations alike find a place.

A final question, however, remains. Is human language capable of bearing witness to the coherence and meaning of the *total* historical process, to the final reconciliation of all apparent discords and contraries within a significant union? It has been the age-long affirmation within the Christian tradition that human language can, through the use of certain symbols, bear such a witness. The grammar, it is said, is the Gospel of Christ: the agent of the combinatorial productivity is the Spirit. Many attempts have been made to define the Gospel precisely. But a rigid and inflexible rule-structure quickly becomes a straight-jacket. The rules are, as it were, acquired through learning and digesting the total 'given-ness' of the New Testament Scriptures. Here is to be found within its governing structure the story interpreting the total history of mankind.

At the same time the Spirit is the life-giving *energy* of language. It is through the Spirit that the task of translation and interpretation can be carried forward. From the purely physical point of view

breath is the medium through which a spoken word becomes articulate. Breath relates the mouth of the speaker to the ear of the listener. And this simple fact of physical experience can be extended indefinitely in a symbolic way. Spirit relates one culture to another, one language to another, one age to another, one structure to another, through a never-ending process of word relationships and combinations. The reconciliation of opposites or contraries is accomplished through a metaphor, a paradox, a dialogue, a parable, a dialectical system in which no finality is claimed but in which a momentary harmony, which is both rest and challenge, is achieved. In the Christian context the message is the Gospel, the medium is the Spirit, and although the two can never be identified they are nonetheless inseparable. The promise of Jesus that the Spirit, the Divine interpreter would 'take what is mine and declare it to you' has been fulfilled down through the ages as ever-fresh language-forms have been employed to relate the good news of Christ to the minds and consciences of men.

The only situation in which this Christian task of relating the Gospel to new conditions would become *impossible* would be one in which the minds and languages of men had become entirely mechanically controlled. That there are threats of such a development it would be idle to deny. The importance of symbolic logic, the need to programme computers, the increasing attention being paid to coding and systems analysis—all these are factors of immense significance in the contemporary world and everything suggests that this significance will increase rather than diminish. In face of this threat there are evidences of a swing to the other extreme—the abandonment of logical discourse, the retreat from the word (George Steiner's vivid phrase), the surrender to slogans which stir the emotions but do nothing to discipline or expand the mind. These are sinister threats if they begin to assume totalitarian tendencies, and the very 'bigness' of our modern world encourages dependence upon such forms of language.

There is no final guarantee that the Christian language-symbols will remain viable and powerful in human society. The Christian can only affirm that through Word and Spirit, through Gospel and reconciling Agent, both structure and living energy have been given him by which he can interpret his own history and the history of mankind in a way which at least to him seems meaningful and is ever open to further enlightenment and enrichment.

SYMBOLISM IN THE CONTEMPORARY WORLD

THE all-important features within what may be called a symbolic situation are the throwing together or the holding together or the associating together of two worlds—the world of man's ordinary experience and apprehension and the world which lies beyond the range of his immediate sensation and comprehension. But how does he do this?

Leaving aside for the moment the question of transcendence and ultimacy, let us glance at the ways in which the natural scientist and the social scientist are employing symbolic forms at the present time. In each case the root concern is for *order*. The natural scientist is not consciously seeking some abstract end which he calls 'truth'. Rather he is seeking to organize his own and others' experiences[1] within some kind of ordered system, a system which he expresses in symbolic form. Once such a system of symbols has been constructed the scientist gains a sense of control: not *absolute* control but sufficient to proceed confidently to the next stage of his enterprise. He is prepared to encounter variations, even a certain random-ness, so long as his overall symbolic system seems to correspond in a maximal degree with the structures of the universe which he is investigating and harnessing to his advantage.

The most striking division in the scientific world today is between those who become obsessed with the conception of ordered system, controlled system, mechanically functioning system, man the slave within the system—all this being expressed through an exact, univocal, one-track system of conventional *signs*—and those who are prepared to work with an open system, a system in which indeterminacy, randomness, disorder, uncertainty are not only tolerated but are seen to have an essential part to play for the continuance of life and creativity—all this being expressed through a system of

[1] I.e. his observations of and experiments with the empirical world.

symbols which allow scope for personal imagination and guess-work in the human consciousness as well as for probabilities and indeterminate processes within the empirical world.

I have used here the distinction between 'sign' and 'symbol', which has gained wide acceptance in recent years, to represent the division between the two attitudes which I have tried to analyse. No such distinction, of course, can be absolute. Often 'sign' is used when 'symbol' might be more appropriate and vice versa. But the distinction seems to me a valid one when used in the context that I have described. 'Symbol', 'symbolon', is a word which from earliest times has suggested a dynamic inter-relationship, an open situation, a personal dialectic. 'Sign', 'signum', on the other hand, has suggested direct correspondence, unambiguous relationship, efficient instrumentality. In man's attempt to discover order in his universe there is undoubtedly a place for both 'signs' and 'symbols'. But if the sign-system once gains the pre-eminence it gradually reduces man to a function of its own operations. The closed system becomes the master rather than the servant and the search for and movement towards a complete correspondence between 'sign' and 'operation' becomes a movement towards equilibrium and death. Thus I believe it is true to say that in the field of natural science today the deepest conflict is between the reductionist and the expansionist, the positivist and the organicist, the slave of the 'signs' he has organized within a closed system and the interpreter of the 'symbols' by which the universe has been given a measure of organization and control but which remains open to an ever expanding complexity.

Turning now to the social scientist, he also is concerned to discover *order* within his own and other societies and to discern the principles by which order is established and maintained. Two fields of study are open to him—the history of earlier cultures and civilizations on the one hand, the present organization and operations of societies on the other. He may decide to direct his attention to one of these rather than the other but no absolute division is possible. The past is known only through 'symbols' which have survived into the present: the present is inevitably related to the past out of which it has grown.

Again the most striking division amongst social scientists today is between those who interpret social existence and development solely in terms of definable cause and effect, of environmental stimulus and response, of genetic programming and resultant operations—all this being expressed through an ever more exact linguistic

sign system corresponding to the structures of a particular social complex and the stages of its development—and those who are prepared to work with an open system, a system in which personal intuition and imagination, dialogue and dialectic, the human negative as well as the human positive, criticism and appreciation, all have a part to play, a system which gains outward expression through a system of linguistic '*symbols*' which are constantly receiving fresh interpretation within the ongoing process of life.

Just as in the total enterprise of natural science there is the division between the open and the closed system, so it is in the disciplines concerned with the interpretation of social history and present structures of social relationships. It is entirely possible for the investigator to concentrate his attention upon dates, events, artefacts, records, quantities, statistics, the '*signs*' which still remain from the life of past societies, the 'signs' which control so many aspects of human life today and to weave all these into an impressive system in which the controlling factors are laws of causation and continuity. Social order it is inferred is created through 'hard' signs—tools, buildings, patterns of work, media of exchange which are unambiguous, quantifiable and compelling.

On the other hand it is possible for him to focus his attention upon structures of community, inter-relationships, communications which can never be capable of final and definitive interpretation and yet which may be regarded in their *symbolic* expressions as the most powerful factors in social development and integration. Men are undoubtedly *limited* by their environment, but this does not necessarily mean that they are rigidly *controlled* by their environment so far as social organization is concerned. Clearly interaction and intercommunication are essential elements in social experience and these express themselves in *symbolic* forms. Thus the study of ambiguous symbols may be more important than that of hard signs. The interpretation of symbols may be more significant than the recording of signs. To say this is not to deny all value to the study of signsystems and to the setting up of sign-structures as means of exercising social control. It does however imply that if man is to retain any vestige of freedom within his social organization primacy must be accorded to the symbol which is flexible, open to new interpretation, and capable of expansion through dialogue and other forms of interchange. The model for the organization of society is not the machine with all its parts strictly tabulated in sign-language but the drama

with parts scripted and assigned yet open to unlimited variations and re-interpretations within the dialectic between the actors, their particular circumstances[1] and one another.

II

The distinguishing mark of all symbol-systems of which we have knowledge up until roughly the seventeenth century of our era is that they are constructed within an essentially *religious* context. We find man relating himself to his universe and to the society of which he is a part, but always with the sense that the world and society are dependent upon a transcendent Being or beings, that they are not self-existent but created, that they are not self-directing but providentially ordered, that they live and move and have their being within a circumambient context of supernatural, super-human powers. The relation of the world and society to the higher order might be variously expressed. The general conception of the two orders was rarely questioned.

Symbols then were ideally *reflections* of a *given* manifestation of Divine reality. In a dominantly agricultural society man sought to imitate through his actions and words the operations of the Divine in the cycle of the heavenly bodies, the seasons, the life and death of the crops, seedtime and harvest, fertility and decay. He might do this in a markedly instrumental way through a system of 'signs', he might do it through a markedly open and expansive way through a system of 'symbols'. In each case he believed that he was reflecting through his own system that which existed in perfect form in the realm of the Divine order.

Or again in a dominantly nomadic society man sought to reflect through actions and words the operation of the Divine in overcoming the forces hostile to true social harmony—demons, forces of nature, wild animals, barbarous tribes, social deviations of any kind. He might do this in a primarily legalistic way by establishing a strict system of mandatory 'signs', he might do it in a more free and open way by creating 'symbols' pointing to the overcoming of otherness. In each case he believed that he was reflecting through his own system that which gained perfect expression in the realm of Divine activity.

[1] This model has been powerfully elaborated and expounded by Professor H. D. Duncan in his book *Symbols in Society*.

Within the specifically Christian context and tradition, as we have seen, four major systems gained definitive form in the sixteenth century of our era. They were not by any means wholly new. They depended on precedents derived from the symbol systems of Old and New Testaments, from pre-Christian and post-apostolic reflections of reality in the Hellenistic world and from the legal customs and language of the Roman world. In their definitive form they may be described as the *monumental* (the majestic stone-buildings, the invariant celebration of ritual sacrifice, the strict system of logical propositions), the *organic* (the process of forming and reforming in act and word, the relation between sacred and secular, the active participation of the parts within the context of the whole), the *covenantal* (the old and the new, the Law and the Gospel, the word and the sacrament, the individual and the society), and the *contractual* (the exact legal ordering of time, of social action, of verbal response). I do not for a moment suggest that these systems existed as entirely water-tight compartments, though the first and fourth by their very nature tended to be exclusive. All who lived within these systems worshipped the one God, gloried in their redemption through the one Christ, believed in the inspiration and testimony of the one Holy Spirit. But their humanly created systems of signs and symbols could be distinguished from one another in approximately the ways I have suggested. Within an overall religious context these four major social groups developed their symbol systems[1] and thereby established their separate identities and manner of life.

The altogether revolutionary change in Western society since that time has been the gradual erosion of religious assumptions, religious references, religious sanctions, religious frameworks. Man has multiplied his efforts to discern and express order as it exists in his natural environment, but has decreasingly felt any need to relate this order to a supernatural agency. And the same has been true in his attitude to his social environment. He has built imposing systems of signs and symbols to assist him in controlling nature and in ordering society, but these have in no essential way depended upon *religious* beliefs. For the first time in history, so far as we know, systems of signs and symbols have existed in a religious vacuum, in what has been called a desacralized cosmos. Those who may have wished still to acknowledge some religious ultimacy were at liberty to develop systems of their own which need have little or no refer-

[1] The first and the fourth approximated to 'sign'-systems.

ence to the interpretations of nature and society accepted by the generality of their neighbours. The world and society were being atomized and fragmentized and no final principle of integration and harmonization seemed to many to be necessary.

This was the revolutionary change. But a second change of outlook also affected the construction of symbolic systems. It was the change from regarding nature and society as stable systems of givenness whose variations and fluctuations could be regarded as due either to divine providence or to a host of malevolent forces, to the new view that nature was essentially a moving structure, circling or evolving, and that society likewise was constantly in motion, a motion either of a cyclic or a linear kind. It might be held by some that it was a powerful *divine* energy that was moving the stars, promoting organic growth and driving man forward in his historical development, but such an assumption seemed in no way *essential*. Signs and symbols representing and expressing motion rather than permanence, change rather than fixity, novelty rather than tradition, were increasingly employed. But again the reference to transcendence or ultimacy seemed in no way necessary.

In the new era inaugurated by these changes the Christian symbol-systems of the sixteenth century maintained an increasingly precarious existence as the secular systems advanced both in the confidence they elicited and the functional efficiency they produced. Gradually four distinct secular systems emerged, corresponding in some measure to the four Christian systems to which I have already referred. The first might be named the *mechanistic*: the universe is represented by a system of codified signs corresponding exactly to the mechanical operations which constitute its total movement. The second I shall call the *evolutionary*: a symbol system is devised which gives the primacy to the life-process in man and in the universe itself, a process of continuous interaction between man's own biological activities and those of the universe of which he is a part, a two-way process of unlimited complexity, a process which gives full attention to the mechanistic elements in the universe yet includes them within the open-ness of emergent evolution. The third, focusing attention now upon man's life in society, may be called the *dialectical*: social organization, whether in government, business, welfare or culture follows an ongoing dialectical pattern in which free exchange of ideas, dialogue, debate, constant interaction between past and present, between present and future, between groups within society,

are woven together into an unending interplay of symbolic forms. The fourth is the *totalitarian*: social organization is geared to the pattern of a communications machine under a single absolute control, with all functions and operations strictly defined by a system of signs which allows no place for deviation or criticism but which is governed entirely by the terminus or end to which the society is being directed. These four appear to require no transcendent reference: they all emphasize the *progressive* character of reality, the most distinctive emphasis of the modern world.

III

How far, then, is it possible to conceive of a coming together in mutual understanding and enrichment of the *symbol*-systems of Christian tradition and those of the modern world? Is it conceivable that the organic and the evolutionary, the covenantal and the dialectical, can not only co-exist but be related to one another in fruitful and constructive interplay? Can the emphasis on permanency and the emphasis on novelty become partners rather than enemies? Can the modern system which appears to be independent of any Divine reference open itself to a new conception of God in relation to the world and society?

In approaching these critical questions I find it most instructive to examine again the work of the artist and to ask what are the implications of his use of symbols. The symbol, so far as the artist is concerned, is never a thing in itself, an inert tool to be employed for an arbitrary end, an object without any necessary connection with that to which it is being related. Long ago Coleridge affirmed that the symbol actually partakes of the reality which it renders intelligible. It is equally true that the artist himself actually participates in the symbol which he selects or creates to externalize his own emotion. The artist, the symbol and the reality constitute an indivisible trinity. As was finely stated in a review article of *The Times Literary Supplement*,[1] 'in matters of art (as, surely, much more widely in our experience) comprehension is not a consequence of apprehension but an aspect and integral part of it. The power and richness, the sense of strange depths and mysterious affinities, which is the direct reference of the word 'symbol' in art, veritably *is* the cognitive aspect of the symbol: leading the mind onward not by logic and inference

[1] 1 February, 1963.

to a statable message but less rigidly, by intuition and exploring awareness, to that same dimension of the mysterious and radiant as runs more generally (and it runs everywhere) through reality.'

The artist, according to this description, is all the time engaged in a process of symbol-making through which he both projects himself towards reality and receives communications from reality. The process never ends. His own selective and creative powers on the one hand are derived from the wholeness of his biological origins and his historical past: reality on the other hand must embrace the wholeness of the natural order and of human experience, past, present and future. In between are symbolic forms, ever in process of reformation, transformation, multiformation. They express strange depths of the human psyche, mysterious dimensions of the reality which exists over against the human psyche. Through these symbolic forms the mystery and the glory of that which has no definable limits gain expression within the limits of space and time. In all true art there is tension: in all true symbols there is tension. And this is not surprising seeing that neither the life of an organism nor the inter-relationships of individuals within society are possible apart from tension, 'feedback', dialectical interplay.

The outstanding difference between the open-ended Christian symbolist of the sixteenth century and the open-ended non-Christian symbolist of today is that whereas the former believed that he lived within a universe whose vertebrate structure and within a society whose ultimate destiny had been conceived within the mind of a creative and redemptive God and had come to symbolic expression in the incarnate body and saving actions of the living Christ, the non-Christian symbolist today holds that the universe *is* a constantly developing process, universal history *is* a constantly unfolding drama, and that in neither case is there need for any central symbol to provide an interpretation of the total process or a meaning to the finished drama. The non-Christian artist seeks constantly to participate in the process and to create *particular* symbols for his own time and circumstance. But that there can be a *universal* symbol, a symbol integrating the whole structure of the natural order, a symbol reconciling the communications tensions of the social order, he finds either difficult or impossible to believe.

I have stated the contrast as clearly and as honestly as I can. I am profoundly impressed by the symbols of the modern artist which express and convey 'hints of transcendence', a 'sense of an ending'.

I find myself responding at once to such a statement as the following from Wallace Stevens' *Essays on Reality and the Imagination*: 'The paramount relation between poetry and painting today, between modern man and modern art is simply this: that in an age in which disbelief is so profoundly prevalent or, if not disbelief, indifference to questions of belief, poetry and painting, and the arts in general, are, in their measure, a compensation for what has been lost. Men feel that the imagination is the next greatest power to faith: the reigning prince. Consequently their interest in the imagination and its work is to be regarded not as a phase of humanism but as a vital self-assertion in a world in which nothing but the self remains, if that remains. So regarded, the study of the imagination and the study of reality come to appear to be purified, aggrandized, fateful. . . .

'Poet and painter alike live and work in the midst of a generation that is experiencing essential poverty in spite of fortune. The extension of the mind beyond the range of the mind, the projection of reality beyond reality, the determination to cover the ground, whatever it may be, the determination not to be confined, the recapture of excitement and intensity of interest, the enlargement of the spirit at every time, in every way, these are the unities, the relations, to be summarized as paramount now.'[1] Symbols dance and sing in his poems, revealing the very 'extensions', 'projections', 'enlargements' of which he speaks. They unify, they relate—but all this, Stevens would say, takes place within the exercise of the imagination. This is no time for 'faith'.

Yet can the human spirit rest for ever in a multiplicity of symbols which are the fabrications of individual artistic imaginations? Is there no principle of universality and unification which can be expressed symbolically? Is there no ultimate resolution and reconciliation which can be expressed symbolically? Must we assume that symbols, which enable man to organize his own experience of the world and of society in an orderly way, are not themselves subject to any kind of ordered arrangement? Have man's symbolic systems no structure of development, no direction towards a goal? At least it does not seem unreasonable to imagine that such a structure, such a direction, *could* exist. This is not to seek for dogmatic certainty nor even for the seeming security of the 'sign'. *It is to suggest that symbols can gain in range and in power if they relate to one another through a*

[1] 'The Necessary Angel', pp. 170f.

common relationship to a central Symbol from which all lesser symbols emanate and to which they all return for renewal of life.

It has been the unique and peculiar claim of the Christian faith[1] that the incarnate Christ is the ordering symbol of *universal nature*, the dying and rising Christ is the ordering symbol of the *universal history* of mankind. A body, a living organism, not a monument nor a machine, is the symbolic structure which for the Christian integrates and co-ordinates all other 'natural' symbols. Whether it be conceived in its hierarchical structure as was the case until the sixteenth century, or in its more dynamic, circulatory or evolutionary pattern as has been the more recent emphasis, the body remains a remarkable and powerful symbol to connect man with his world and to provide a model for the interpretation of the total universe of which he is a part.

Again a critical conjunction of death and resurrection, not an omnipotent determination of life and death, is the symbolic sequence which for the Christian gives final meaning to all other 'social' symbols. Whether the gospel of death and resurrection be conceived in more other-worldly terms as it was until the sixteenth century or in its more this-wordly, inter-racial, inter-social, interpsychic patterns as has been the more recent emphasis, the death-resurrection dialectic remains an impressive and appealing symbol to relate man to his wider social world and to provide a model for the interpretation of the whole drama of social history and social destiny.

I have proposed the *Body of Christ* as the integrating symbol between man and his universe: the *Death-Resurrection of the Christ* as the symbol of reconciliation between man and the total social order to which he belongs. If this proposal be accepted, it becomes possible in principle to work it out in more detail in ways suggested earlier in this book. The organization of space and place, the period and the moment, the cycle and the event, the coo and the cry, will be related on the one hand to the Body and the Death-Resurrection, on the other hand to the demands of particular place, time and circumstance. And it is this ever changing and developing process that the Christian sees as the continuing work of the Divine Spirit. Throughout Christian history the Spirit has been associated with such

[1] Key passages in the New Testament are Colossians 1:13–17 and Ephesians 2: 13–18.

dynamic operations as invigorating, inspiring, empowering, interpreting. Through His energy the symbol-making and symbol re-making process continues. As a Chinese axiom puts it: The spirit has no form; yet that which moves and transforms the form is the spirit. In Christian terms: Where the Spirit of the Lord is, there is Liberty. The letter (the sign) kills: the Spirit (through the symbol) creates and re-creates expanding life.

And if it finally be asked *how* the Spirit works, the words of the Fourth Gospel are still pertinent: the Spirit, like breath, like wind, moves where it wills and no one can tell whence it comes or whither it goes. Yet it is also clear that through the creation of symbols the Spirit is constantly performing two operations. First the Spirit is persuading man to *extend* his knowledge and experience, to move towards new horizons, to expose himself to that which lies beyond the boundedness of his present system. Man was made to embrace that which transcends his present limitations. Through symbols of integration he gains a momentary grasp of a world which lies beyond his present world, the world whose builder and organizer is God Himself.

In the second place the Spirit is ever persuading man to *relate* himself to his fellow through the conjunction of two images, of two languages, of two traditions. T. E. Hulme likened the coming together of two images to the impact of stones: fire is struck between them, a new quality which neither in its independent state could produce. It is true that fire can be destructive: the symbol is never free of ambiguity. But fire is also creative and the great forward movements in the social history of mankind have taken their dynamic from some reconciliation of opposites, some conjunction of contraries, whether these be traditions, languages or customs. Through symbols of reconciliation man gains the vision of the final reconciliation in which God reconciles all things to Himself.

So for the Christian the central symbol of integration, the final symbol of reconciliation is the Christ. Through Him is life, through Him is peace. In His Body and in His Blood ultimate symbols of divinity are to be found. Symbols of organic wholeness, symbols of critical conjunction—both classes are to be found in the earliest Christian tradition: both can be translated into the idiom of today.[1]

[1] Modern process-theologians emphasize the former class, modern radical-theologians the latter.

It is impossible to set out a detailed blue-print of symbolic forms which will be valid and effective in tomorrow's world. The Christian can only affirm in faith that the two focal symbols—the Body and the Cross—will in some way provide the framework within which man's glimpses of ultimate grace, together with his gestures towards ineffable glory, can alike be expressed.

Index of Subjects